W9-BKJ-838

BE MORE
JAPAN

BE MORE
JAPAN

the art of japanese living

日本人の暮らしの形

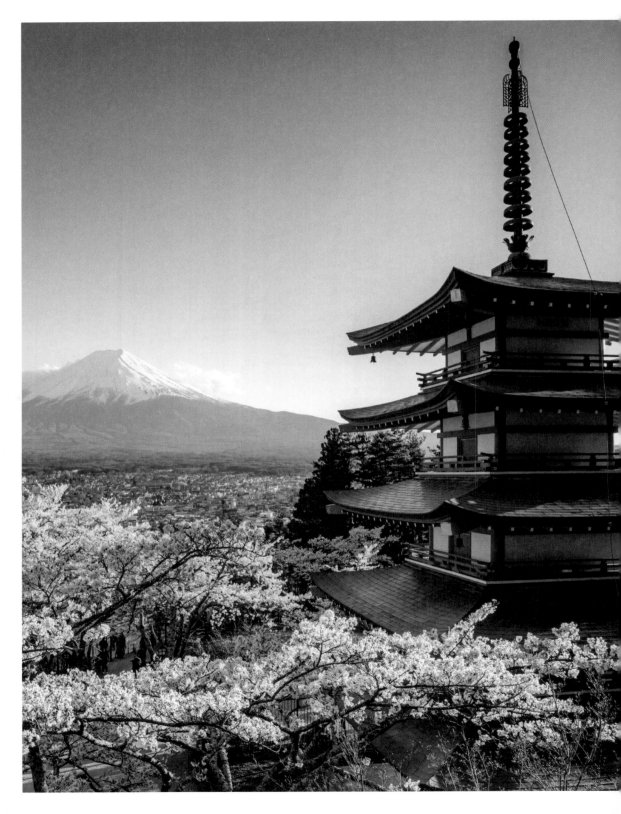

‹ *A stunning view of Mount Fuji and the Chureito Pagoda.*

目次
CONTENTS

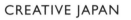

> *The bustling Shibuya crossing in central Tokyo.*

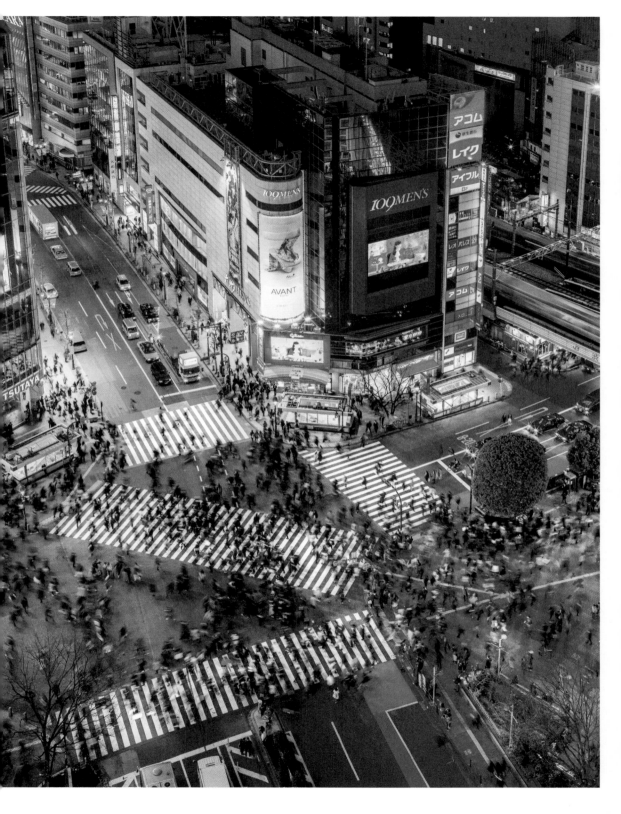

‹ *An apprentice geisha in Kyoto.*

もっと日本

INTRODUCTION

The art of Japanese living

In the summer of 1853, four American ships sailed into Tokyo Bay, ending Japan's 200 years of self-imposed isolation. The extraordinary, insular country they found immediately captured the world's imagination, sparking a craze known as *Japonisme* that changed Western art and aesthetics forever. Today, Japan continues to fascinate and delight; a country of startling modernity and of ancient traditions, where elegant geisha, robe-clad priests, J-pop megastars, and visionary engineers all make up a part of the authentic face of Japan.

Be More Japan takes you on a journey of discovery by exploring the art of Japanese living: the delicate balancing act of holding onto timeless traditions while enjoying all the benefits of modern life and looking fearlessly into the future.

We invite you to absorb a little Japanese wisdom into your daily life by experiencing its kaleidoscope of contrasting pleasures— enjoy the fleeting beauty of the cherry blossoms, join in a raucous summer festival, savor the precision of the tea ceremony, belt out your favorite song at karaoke, or soak in a hot spring with a jaw-dropping view of Mount Fuji. There are countless reasons to fall in love with this beguiling country, and with *Be More Japan*, you'll find even more excuses to travel again and again to the land where the sun rises.

日本へようこそ

WELCOME
TO JAPAN

Japan stretches from the frozen edge of Siberia down to the tropics. This archipelago of thousands of islands is home to an incredible array of disparate landscapes—not only ultramodern cities and smoldering volcanoes, but also remote beaches and lush valleys. What unites the range of climates, geographies, and outlooks are the rhythms of the seasons to which the heart of the country still beats, dictating the ever-shifting weather, cuisine, and cultural life of the country's 127 million inhabitants. And binding it all together is an astonishing transportation network, which makes it easy to get there and explore—whether by bicycle, plane, bullet train, or ferry. If you're planning a trip to Japan, want the afterglow of your stay to last a bit longer, or simply wish to indulge in some quintessential Japanese experiences, the culture has never been more accessible: whether it is eating sushi in London or enjoying blossom viewing in San Francisco, you are closer to Japan than you know.

地図の上から

ON THE MAP

Exploring Japan's regions

Lying to the east of mainland Asia and curving across 1,900 miles (3,000 km) of Pacific Ocean, Japan is made up of thousands of islands. Mainland Japan is typically defined as the five largest islands in the archipelago: Honshu, Hokkaido, Kyushu, Shikoku, and Okinawa. These islands are divided into 47 administrative units called prefectures, which in turn are informally grouped into eight different regions. Each region has its own distinct character, with local customs and culture shaped by the country's highly changeable weather and geographical features.

127M

people live in Japan, making it the eleventh most populated country in the world.

PREFECTURES

HOKKAIDO
1 Hokkaido

TOHOKU
2 Aomori
3 Akita
4 Iwate
5 Yamagata
6 Miyagi
7 Fukushima

KANTO
8 Tochigi
9 Ibaraki
10 Saitama
11 Tokyo
12 Chiba
13 Kanagawa
14 Gunma

CHUBU
15 Niigata
16 Toyama
17 Ishikawa
18 Fukui
19 Nagano
20 Yamanashi
21 Shizuoka
22 Aichi
23 Gifu

KANSAI/KINKI
24 Hyogo
25 Kyoto
26 Shiga
27 Osaka
28 Nara
29 Mie
30 Wakayama

CHUGOKU
31 Tottori
32 Okayama
33 Shimane
34 Hiroshima
35 Yamaguchi

SHIKOKU
36 Kagawa
37 Tokushima
38 Ehime
39 Kochi

KYUSHU-OKINAWA
40 Fukuoka
41 Saga
42 Nagasaki
43 Oita
44 Kumamoto
45 Miyazaki
46 Kagoshima
47 Okinawa

KANSAI/KINKI REGION
Referred to as both Kansai and Kinki, this region is the historic and cultural heart of Japan, where tradition and buzzing nightlife thrive side by side.

CHUGOKU REGION
Chugoku, or "the middle country," is a region of two halves, with bustling cities in the south and a quieter pastoral feel in the north.

KYUSHU-OKINAWA REGION
Kyushu-Okinawa combines the active volcanoes, rolling grasslands, and bubbling hot springs of Kyushu with the laidback tropical paradise of more southerly Okinawa.

SHIKOKU REGION
Sleepy Shikoku offers a glimpse of the country as it used to be, with rural charm and historic towns and temples.

ˇ 47
400 MILES (640 KM)

HOKKAIDO REGION

Hokkaido is a region of fire and ice, characterized by fertile plains, looming volcanoes and perfect skiing conditions.

1

MICROSEASONS

Traditionally the Japanese calendar had 24 seasons, which in turn were broken down into microseasons such as *higurashi naku* (the evening call of cicadas).

TOHOKU REGION

Rugged and remote, Tohoku is steeped in myth and legend. It's home to sacred mountains, dense forests, and vibrant folk traditions.

2
3
4
5
6
7
15

THE FIVE MAIN ISLANDS

The Japanese Archipelago is made up of 6,852 islands, of which only 430 are inhabited. The vast majority of the population lives on the five main islands of Honshu, Hokkaido, Kyushu, Shikoku, and Okinawa.

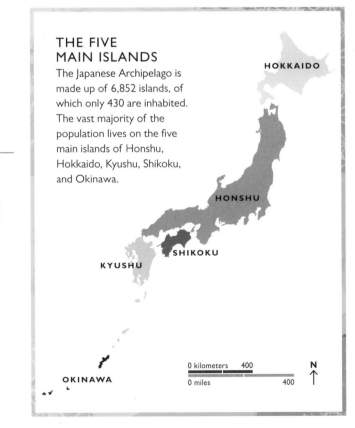

HOKKAIDO

HONSHU

SHIKOKU

KYUSHU

OKINAWA

0 kilometers 400
0 miles 400

N

KANTO REGION

Highly urbanized, Kanto encompasses both Tokyo and Yokohama and is home to around one-third of Japan's total population.

8
14
19
9
10
20
11
12
13
21

CHUBU REGION

Mountainous Chubu is a region of stark beauty, merging ancient heritage with modern industry.

0 kilometers 150
0 miles 150

N

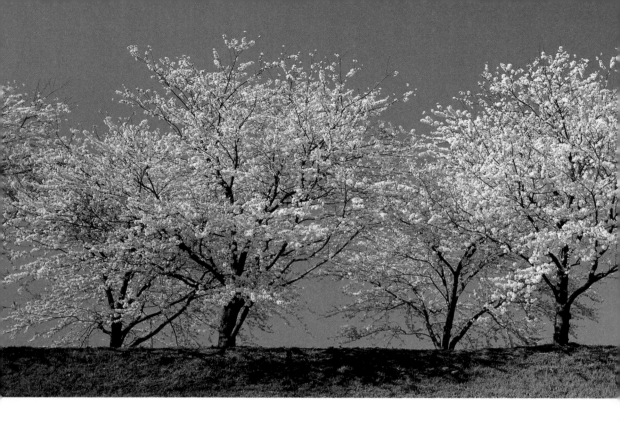

春

SPRING

The season of new beginnings

The calls of "*oni wa soto, fuku wa uchi*" (devil get out, good luck come in) to celebrate Setsubun on February 3 are the first sign Japan is ready for spring. New buds begin to shoot in parks and gardens, starting with the pinks and purples of plum blossoms in late February. And by March, a new round of sneezing and surgical mask wearing begins as the annual wave of cedar allergies hits.

FRESH FLAVORS
By the time spring is officially declared on Shunbun no Hi on March 21, the weather is mostly warm and sunny in Honshu, Kyushu and Shikoku, with cooler Hokkaido lagging a little behind and warmer Okinawa already ahead of the game. And with the new season, heavy winter food gives way to lighter flavors: mountain vegetables come to the fore, plump strawberries appear in supermarkets, and tender bamboo shoots add a freshness to spring menus.

THE ANNUAL BLOSSOMS
Nothing says spring like the cherry blossoms, and as they briefly repaint the country a palette of pinks—a movement meticulously tracked on the daily news and

in weather apps—the Japanese celebrate with *hanami* (flower viewing) parties. For most Japanese people, *hanami* is simply a way to enjoy nature and the company of family and friends, but culturally there is a deeper philosophical significance to the ritual. The viewing of the blossom's fleeting existence epitomizes the concept of *mono no aware (p.72)*, the melancholy and joy we feel with something so beautiful, yet impermanent. You can experience *hanami* anywhere in Japan—all you need to join in with the locals is a picnic sheet, a bento, and a few drinks.

SPRING FESTIVITIES

Hanami isn't the only major event in spring. If you visit in mid-March, you will witness White Day on March 14, when men give gifts to women in return for those they received on Valentine's Day; only women give gifts on February 14 in Japan.

Many Japanese people travel during the Golden Week holidays from April 29 to May 6—a period in which a collection of national holidays falls and travel prices spike—while on the third weekend of May, Tokyo's Asakusa district is home to one of the most sake-fueled and high-energy festivals on the annual calendar, the Sanja Matsuri. Honoring the founders of Sensoji temple, it features teams of pallbearers carrying 100 portable shrines through the heaving streets—bouncing, jostling, and hollering in the warmth of the late-spring sunshine.

Back down to earth, the fiscal and academic years commence on April 1, bringing the annual round of transfers in many businesses, plus entrance ceremonies at universities, high schools, junior highs, and even nurseries. The rice cycle begins, too, with seedlings being nurtured in greenhouses and then planted into paddies.

∧ *Cherry blossoms (sakura) in full bloom in Kyoto.*

夏

SUMMER

Festivals, fun and family

The musky aroma of mosquito coils, the relentless humming of cicada, parasols to cast some shade—welcome to Japanese summer. From late June, every conversation contains at least one sigh of "*Atsui!*" (hot), as the stickiness of the brief rainy season signals the change from spring to summer. By the time summer begins in earnest, it feels like the most used word in Japanese.

THE MERCURY RISES

In July and August, temperatures away from the mountains frequently top 95°F (35°C), sometimes reaching even higher in notoriously hot towns like Kumagaya in Saitama Prefecture. And when night cools, it often doesn't feel much better, with the humidity rising into the 90 percent range after dark. Thankfully, Japan also has some short-term fixes with cooling seasonal food like *kakigori*—shaved ice topped with fruit-flavored syrup and condensed milk—and *somen* and other chilled noodles. Grilled corn, juicy watermelon, and chilled edamame are other summer staples, as is savoring a few cold beers at the rooftop beer gardens that pop up in cities all around Japan for summer only.

SUMMER CELEBRATIONS

When Japan reaches peak festival season in summer, no amount of heat and humidity stops the fun. The festivals vary wildly, but there are common traits: out come the colorful cotton *yukata* gowns, the street vendors selling fried noodles and *kakigori*, and the plastic fans people waft for scant relief. Many of the festivals celebrate Obon in mid-August, when the spirits of ancestors are said to return home, prompting family get-togethers and the hanging of lanterns to guide the spirits through the darkness.

In Kyoto, the whole balmy month of July is given to the thousand-year-old Gion Matsuri, its focal point a procession of huge floats in mid-July. The Awa-Odori festival in Tokushima on Shikoku and the smaller Tokyo version in Koenji (both in August) happily have the sense to wait until nightfall before teams of dancers and musicians take to the streets for several evenings of frenetic fun. And the hundreds of fireworks displays throughout the summer have no choice but to avoid the midday glare.

BEAT THE HEAT

To escape the heat—or at least be somewhere it isn't as hot—you could follow the Japanese to popular summer holiday destinations like Hokkaido in the far north, where winter ski areas like Niseko provide a cooler summer setting for hiking and other outdoor pursuits *(p51)*; head to the breezy Japanese Alps *(p51)*; or explore the less-visited Tohoku region's farmland, rugged coastline, and mountain ranges. It might sound counterintuitive, but going to hot-spring resorts *(p208)* is popular, too. The air is often cooler there, and hanging out in traditional inns—in light *yukata* gowns and airy *tatami*-mat rooms— isn't just refreshing; it's a great way to recharge during the draining seasonal heat.

∧ *Summer sun at one of Okinawa's tropical white-sand beaches.*

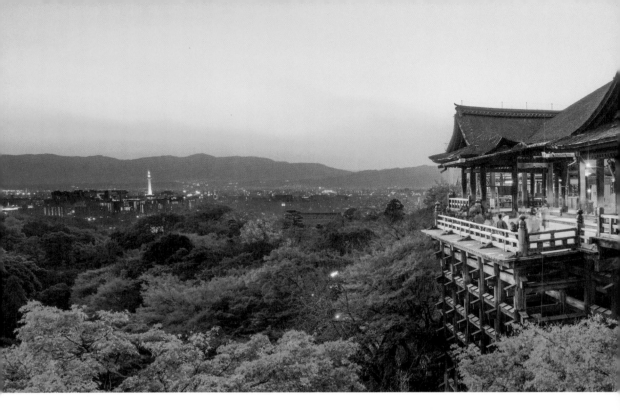

秋

FALL

Japan repainted red

As the heat begins to abate at the end of September, you can almost sense Japan heave a collective sigh of relief. At home, the electric fans get stored away and windows are left open as everyone enjoys breathing in fresh air again. There are more kids playing in the parks. And under mostly blue skies, foliage across the land transforms into reds, rusts, and yellows.

EARTHY FLAVORS

The annual wave of typhoons will occasionally put a windy damper on proceedings, but the weather in October, November, and even early December is still magical—warm by day, cool at night, and largely dry and sunny. The autumnal food is equally special. By the end of November, it begins to get cool enough to start enjoying *nabe* hotpots. Highly prized *matsutake* mushrooms reappear, too, simply grilled to bring out all their earthiness, steamed with rice as *matsutake gohan*, and used along with shrimp, chicken, and seasonal gingko nuts in *dobin-mushi*, a clear soup steamed in a small teapot and then served in teacups with a squeeze of *sudachi* citrus.

APPRECIATING NATURE

In a similar way to how the cherry blossoms are a major part of spring, in fall the *koyo* (autumnal leaves) come to the fore. While there is no exact autumn equivalent of spring's cherry-blossom viewing *hanami* events (p16), people visit parks and travel to the mountains to enjoy the seasonal colors. The bright yellow leaves along Ginkgo Avenue in Meiji-jingu Gaien Park are a highlight in Tokyo, as are the reds and yellows of Rikugien Garden. In Kyoto, the deep-red maples at Eikando Temple have people lining up for hours to see them. Away from the cities, less-crowded options include the Fuji Five Lakes near Mount Fuji and the wilds of Daisetsuzan National Park in Hokkaido, while Mount Hachimantai, which straddles Iwate and Akita prefectures in Tohoku, is a riot of autumnal colors— best enjoyed when soaking in one of the region's many natural hot-spring baths.

FALL CELEBRATIONS AND EVENTS

Beyond enjoying nature, in autumn you can take in major events like Kyoto's Jidai Matsuri in late October, which features a parade of more than 1,000 people representing figures from Japanese history, and the Grand Autumn Festival held in mid-October at Nikko's UNESCO-designated Toshogu Shrine, which includes *yabusame* horseback archery displays. More low-key, Shichi-Go-San in mid-November is a nationwide highlight, where children aged three, five, and seven dress in colorful kimono and visit shrines with their families to pray for a good future. And on Halloween, it's still warm enough at night for Shibuya in Tokyo to host the largest dress-up street party of the year. But it's not for kids—attracting as many as one million people, the atmosphere can get pretty raucous.

^ *Autumn foliage at Kiyomizu-dera Temple in Kyoto.*

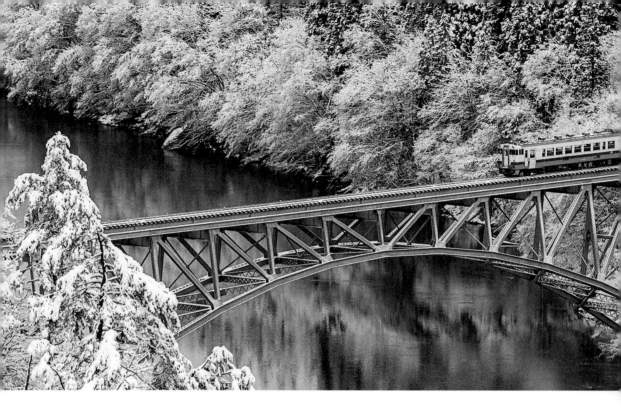

冬

WINTER

Keeping warm and looking ahead

When the last of the fall leaves are crumbling on the ground in Tokyo in late November, winter begins to creep up. You notice it little by little. Under mainly blue skies, the air dries to skin-cracking levels. In vending machines, many of the drinks switch from cold to hot, and at night, the catchy jingle of sweet potato trucks can be heard, bringing with it a charcoal-caramelized aroma that says winter is upon us. And as soon as the Halloween decorations are taken down, up go the winter illuminations, bringing a festive feel across the country.

WARMING FOOD

From December through February, the temperature in many parts of Japan significantly cools, and people turn to warming seasonal foods like stews, curries, and one-pot dishes such as *oden* to keep out the chill. The most distinctive seasonal food, however, comes toward the end of December, when *osechi-ryori* (traditional New Year foods) appear in ornate lacquered boxes on dining tables across Japan. Beautifully presented, the boxes contain divided portions of beans, meats, fish, and other small morsels that all have

meaning. You'll see black beans to symbolize health and *kobu* seaweed because it sounds close to *yorokobu*, or happiness. There'll be red and white *kamaboko* fish cakes, where the white means purity and the red is the color for good luck. In all, there'll be more than a dozen things to try. Late on New Year's Eve, people will also eat soba noodles, as the long noodles are said to signify a long life.

CHRISTMAS AND NEW YEAR

Winter experiences vary wildly in Japan, from the heavy snows of Hokkaido to the pleasant warmth enjoyed in Okinawa, but certain elements play out all over. Christmas is largely cosmetic: Santa visits nursery schools, trees go up in apartment building lobbies, and KFC does its traditional roaring trade in Christmas chicken. But, by and large, no one takes time off work, and the festivities don't last past Christmas Day.

The end of the year is similarly low key. It's a time for family and resetting for the year ahead. New Year involves a lot of year-end TV and eating—tucking into *osechi-ryori* while watching the annual Kohaku Uta singing contest and cooking your legs under the *kotatsu* heated table.

WINTER CELEBRATIONS

One thing that gets many away from the feasting is *hatsumode*: the first shrine visit of the year to pray for a good year ahead. Many people flock to auspicious shrines like Meiji Jingu in Tokyo and Ise Jingu in Mie Prefecture, while others head to the coast or mountains or to watch the *hatsuhinode*, the first sunrise of the year. And once the holidays are over, there are plenty of other events to see people through the cold months—none as big as the Sapporo Snow Festival in Hokkaido, which sees giant ice sculptures created around central Sapporo.

∧ *Snow-covered countryside in Fukushima Prefecture.*

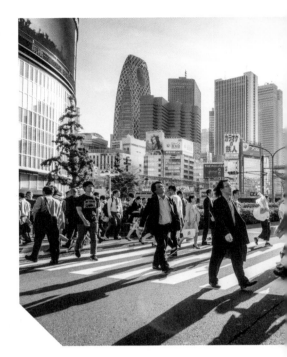

初めての出会い

FIRST ENCOUNTERS

Feel the rhythm of daily life

Arriving in Japan for the first time is a thrilling experience. It's surprisingly easy to get into the rhythm of daily life here; the food, the language, and the etiquette that guides every interaction are all part of the excitement of discovering Japan.

Let us guide you through your first experiences in Japan; as you negotiate public transportation, understand the importance of good manners, meet local people, and uncover the meaning behind the symbols you'll see all around you, your grasp on the culture will become stronger with each day and new encounter.

GETTING AROUND

Japan has the most amazingly efficient public transportation system (and as a result car ownership is about half that of the US). So you should find travelling to almost any point in the country by train or by coach fast, stress-free, and comfortable. However, for the two-thirds of all commuters who

rely on the train and subway systems to get to work, things are a little different. In Tokyo, 20 million train passengers pass through the network every day. This leads to an incredibly busy commuter rush hour— an experience to be braved or avoided, depending on your point of view. What gets everyone through the daily crush is good train manners; the key rules are to avoid loud conversations and to hold your backpack or luggage in front of you to make space for others.

Public transportation signs are usually written both in English and Japanese, so it's easy to get around. However, if you're in a small town in the countryside, finding your destination can be a whole new challenge. Not all streets have names, and the buildings within a block may be numbered in the order that they were built—intriguing but confusing. If in doubt, ask a polceman; in the city of Kyoto, as much as 90 percent of police time is spent giving directions.

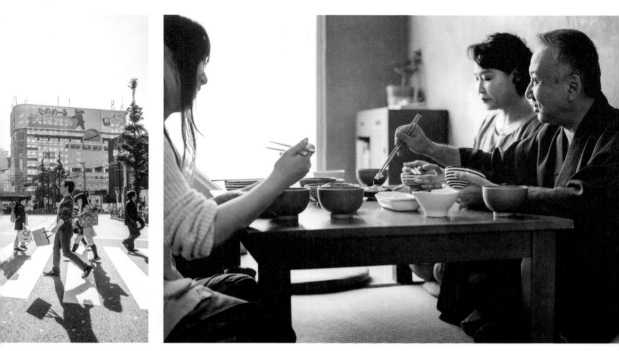

ETIQUETTE

Japan has a reputation for restraint, but anyone who has heard the piercing yell of "*Irasshaimase!*" ("Welcome!") when entering a shop or restaurant knows that the culture isn't always quite as reserved as it seems. Still, there are some unspoken rules you should know to help you feel at ease. No one expects foreigners to get everything right but engaging with the rules—which are all about valuing harmony (wa)—will generate goodwill.

Bowing: When meeting someone for the first time, it is polite to bow as a sign of respect. You can also bow when thanking someone or saying goodbye.

Shoes: Anywhere there are *tatami* mats (p.77)—and always in a person's home—you will be required to take off your shoes. It's a good idea to wear clean, matching socks.

Bathrooms: When you enter a bathroom in a house or *ryokan* (traditional inn), there will often be a pair of slippers at the door; leave your own footwear outside and switch to the these. If you bathe, whether it's at a public bath or a hot spring (p.208), it is important to shower in the wet room on the stool provided before getting into the bath, which is exclusively for relaxing.

Chopsticks: Never point your chopsticks at another person, wave them in the air, or use them to spear food. And you should never leave your chopsticks sticking into a bowl of rice, as this is reminiscent of funeral rituals.

Money: In Japan, money is rarely passed directly from hand to hand, so when paying for an item or service, place your money on the small tray provided. Tipping is not part of the culture and if you leave money for a server they'll always return it.

Shopping: If you use the changing rooms at a store, you may be offered a bag; wear this over your face to prevent your makeup from staining the new clothes.

∧ *Left to right: Shinjuku is a major transportation hub in Tokyo, with the busiest train station in the world; chopsticks are used for cooking and serving food as well as for eating.*

23

INTERACTIONS

If you have time to pick up a few useful Japanese phrases before your trip, that's great, but if not, you'll still get by just fine. You don't have to speak the language to communicate: respectful behavior and good manners will go a long way.

You'll probably find that striking up a conversation comes easily and naturally. Most Japanese people you meet will be thrilled that you are interested in their country and in getting to know them. Although they may not be confident speaking English at first, many Japanese people will have studied it at school and will love the chance to practice.

Even in a casual setting like a sporting event or an *izakaya* (Japanese tavern), people will often present you with their business card, which is standard etiquette when being introduced. Accept the card using both hands and present your own if you have it on you. It's important to make sure you treat their card with respect and

do not jam it in your pocket, but instead slip it carefully into your wallet.

SYMBOLISM

Colors are loaded with meaning in Japan. This dates back to the country's early history when they used to denote rank in society. Animals also carry fascinating symbolic significance derived from folklore and myth. Keep your eye out for these common motifs.

COLORS

Akane This is a special shade of red used for shrines. It is said to grant protection from evil and disaster, and to increase the power of the spirits.

White White is regarded as godly and pure, so sacred places are often strung with white, lightning-shaped paper (*shide*), marking the boundary between the earthly and the spiritual worlds.

Black Exuding dignity and formality, black is used for the robes of Buddhist monks.

⌄ *Left to right:* Torii gates at Shinto shrines are painted akane red; white paper shide streamers are used in Shinto rituals; unlike the vibrant colors of China and India, the robes of Buddhist monks in Japan are an austere black, or muted tones like brown and gray.

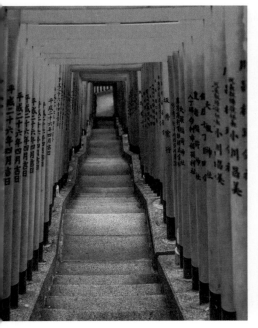

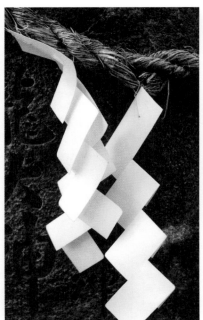

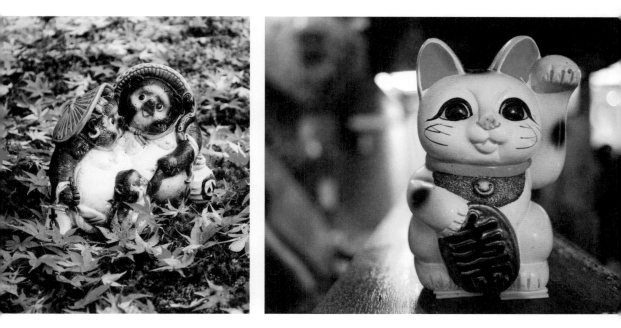

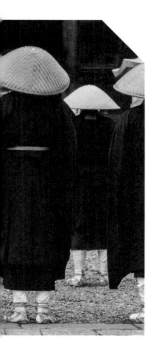

Purple In ancient times, purple dye was difficult to produce, so the color is traditionally associated with high status. In *no* theater, for example, you can recognize emperors and gods by their purple and white costumes.

Blue In the language of early Japan, there was no distinction between blue and green. It is the legacy of this oddity that the word for blue (*ao*) is still used to describe green traffic lights and leaves.

ANIMALS

Koi With their ability to swim upstream and resist the flow of water, carp are a symbol of perseverance. The colorful koi carp varieties also symbolize faithfulness and marriage.

Cranes In Japanese folklore it is believed that cranes live for 1,000 years, so these birds represent good fortune and longevity. The crane is also closely associated with wedding and New Year celebrations.

Fox Foxes are said to be messengers of the Shinto spirit Inari, so you'll often find

∧ Left to right: Tanuki statues carry sake as a symbol of virtue; lucky cats were introduced in the Edo period.

statues of them at shrines (*p.62*). Old folklore also describes them as tricksters who can transform into humans; there is a theory that the common greeting "*moshi moshi*" is used when picking up the phone because it's a tongue twister for foxes and proves you're a real human.

Tanuki A subspecies of the Asian Raccoon Dog, *tanuki* are seen as masters of disguise and cunning shape-shifters. *Tanuki* sculptures with comically inflated scrotums are, rather surprisingly, a common sight and represent good luck.

Cats The *maneki-neko* (beckoning cat) is thought to bring luck, happiness, wealth, and prosperity. These colorful felines, with their smiley faces and raised paw, will often greet you at the entrance to shops and restaurants.

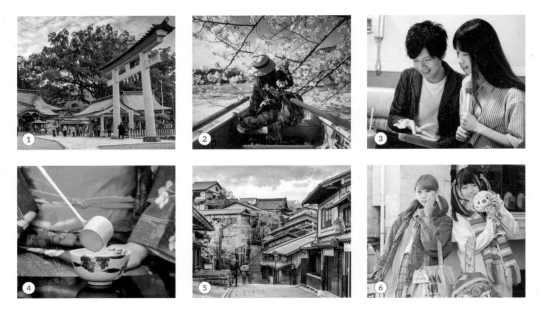

THE ESSENCE OF JAPAN

Whether planning your first trip or needing ideas for yet another visit, here are some essential highlights you won't want to miss. Blending cultural experiences with breathtaking views up and down the archipelago, these moments will draw you deeper into the heart and soul of Japanese life.

1. Cross the threshold into the world of the gods at a Shinto shrine. You'll find some are peaceful and intimate, while others are lively destinations resounding with ringing bells and the chatter of people discussing the love fortunes they've bought at the shrine stalls. (p.60)

2. Picnic under the cherry blossom trees in spring—a truly Japanese celebration of nature and the changing seasons. You can even chase the blossoms as they burst into life in stages across Japan from March in the south to early May up north. (p.14)

3. No talent required: sing your heart out at karaoke. You can order food and drink right in your private, soundproof room, so settle in for the evening and get ready to belt out your favorite songs in the ultimate sing-along. (p.158)

4. Experience a tranquil tea ceremony and fall under the spell of this traditional, elegant ritual. The ceremony is full of Zen-inspired moments of peace and meditation and beauty in the form of the ceramic bowls and wall art. (p.198)

5. Visit Kyoto, a historic icon in the heart of modern Japan. The city is home to an amazing array of incredible architecture, with more UNESCO-listed World Heritage Sites than any other city on the planet. The best way to experience Kyoto is to stay in a *ryokan* (traditional inn), where you'll sleep on a futon on *tatami* mats and dine on classic Japanese food washed down with plenty of sake. (p.42)

6. Express yourself through style in the fashion districts of the big cities. Get inspired on Sundays when the streets

become a catwalk of stylish shoppers—either showing off the latest chic trends or continuing the Japanese tradition of colorful experimentation. *(p.128)*

7. Find your inner peace in a Zen garden.
Sparse and barren at first glance, look closer to seek the meaning behind each choice of rock and stone, as understanding the scene before you is the key to unlocking true tranquility. *(p.78)*

8. Join the riotous celebrations at a summer festival.
Although each festival is different—some honoring a particular shrine or historic event—you'll find they're all full of exuberant crowds enjoying delicious street food, lively entertainment, and quality time with friends and family. *(p.17)*

9. Create a living sculpture in an ikebana class.
Everything from the choice of vase to the spaces between the twigs and flowers becomes an artistic tool to design a piece that captures the fleeting beauty of nature. *(p.74)*

10. Check out a vending machine classic: canned coffee,
an everyday staple all across Japan. Ditch the ordinary cafés and stop at the nearest vending machine—you'll never be far from one of these ubiquitous devices—to enjoy a refreshingly cold coffee in the heat of summer or a deliciously hot can in winter. *(p.104)*

11. Take a dip in a relaxing hot spring.
As one of the most active volcanic regions in the world, is it any wonder that hot springs are such an integral part of Japan's culture? Find out why they're so important to the Japanese by soaking in a *rotenburo*—an outdoor hot spring—to enjoy not just a unique cultural experience but also the stunning natural views. *(p.208)*

12. Savor Japan's award-winning whisky in a refreshing highball,
which pairs perfectly with either meat or seafood. With the help of its seasonal climates and the native wood used for casking, Japanese whisky now takes center stage across the world. *(p.200)*

歴史

HISTORY

The story of Japan

^ *Lady Murakami's* The Tale of Genji *is considered the world's first novel.*

Japanese history has been marked by periods of isolation, allowing Japan to develop a unique and insular culture that captivated the world once it opened up to the global community in the 19th century.

THE HEIAN ERA

The first records of Japan appear in the 3rd-century annals of the Chinese courts. They recount the existence of people living on the islands off the coast of Korea, ruled over by a queen named Himiko.

As contact between China, Korea, and Japan deepened, a new Japanese elite emerged, deeply steeped in the culture of the Chinese aristocracy. Named after its capital (present-day Kyoto) the Heian Era (794–1185) was a turning point in Japanese civilization, as the aristocrats of the court fused indigenous elements and themes, such as native mythology and the celebration of nature, to traditional Chinese pursuits of courtly painting, calligraphy, and poetry.

Meanwhile, cultured Heian women pioneered the first Japanese syllabary, *hiragana*, which they used to compose epoch-defining works of literature such as *The Tale of Genji* and the *Pillowbook*, works of exquisite sensitivity that immortalized the elegant world of the Heian Court.

KEY MOMENTS IN JAPANESE HISTORY

239
Himiko, queen of Yamato (early Japan), sends envoys to China.

300 BC–AD 300
New methods of farming, metalworking, and pottery reach southwestern Japan from the mainland via Korea.

794
Heian-kyo (Kyoto) becomes the capital of Japan.

^ **C 1000**
The Tale of Genji is written by court Lady Murasaki.

v **1180–1185**
The Minamoto clan defeat the Taira and establish the Kamakura Shogunate.

THE SAMURAI RULE

In 1185, the refined world of the court was shattered by the struggle of the Taira and Minamoto clans—marking the point at which a feudal warrior culture, the samurai, supplanted that of Kyoto's aristocracy. This civil war led to the establishment of Japan's first Shogunate administration, and the transferral of true power from Kyoto to Kamakura. The Shoguns were hereditary warrior-rulers, exercising power over the country on behalf of the emperors in whose name they ruled. It was at this time that Zen Buddhism, another Chinese import, became popular with the warrior elite for whom its precepts—acting with intuition, confronting death without fear—were concepts to be cultivated.

In 1467, a new civil war ended the authority of the shoguns, and a century of turmoil followed. Eventually, a trio of leaders—Nobunaga Oda, Hideyoshi Toyotomi, and Ieyasu Tokugawa—reestablished the authority of the central government. The seat of power was moved to the site of a small fishing settlement named Edo, present-day Tokyo.

EDO JAPAN

The new Tokugawa Shogunate sought to promote stability by restricting foreign shipping to the area of Nagasaki. The Portuguese, who had previously been welcome in the country, were expelled following Jesuit attempts to convert the Japanese to Catholicism. Only the Dutch, who aided in the suppression of Japan's Christian community, were allowed to continue trading.

For the following two hundred years, Japan was largely cut off from the west. With peace restored, the country boomed, and by 1700 Edo was the largest city in the world—with more than 1,000,000 inhabitants. In the newly rich cities, the wealthy merchants created their own distinct culture characterized by bawdy literature, riotous theater, and pleasure quarters known as the "floating world." This period of isolation is responsible for the creation of the distinctly Japanese culture, which remains one of the country's enduring fascinations to this day.

⌄ *The helmets of samurai armor were adorned with crests, like the camellia below.*

1467
The devastating Onin War begins. Much of Kyoto is destroyed by fire in the fighting.

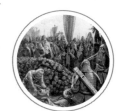

1274
An invading Mongol fleet is destroyed by a typhoon, which the Japanese dub the "kamikaze."

∧ 1603
Ieyasu Tokugawa wins the battle of Sekigahara, and establishes the Tokugawa shogunate based in Edo (Tokyo).

1689
Famous haiku poet Matsuo Basho departs on his journey to the north.

1641
All foreign commerce is confined to an island in Nagasaki Bay, and only the Dutch and Chinese are allowed access.

⌄ 1831
Hokusai's Thirty-Six Views of Mount Fuji is published.

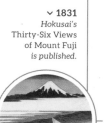

THE MEIJI ERA

In 1853, Commodore Perry of the US Navy steamed into Edo Bay to challenge Japan's refusal to enter into international relations. Weakened by unrest from within, the Shogunate had no choice but to accede to these demands. During a period of civil war that followed, reformers made use of Western military tactics and technology to force damaging concessions from the Shogunate, resulting in its total collapse.

In 1868, imperial power was restored, and Emperor Meiji relocated to the new capital of Tokyo. The Meiji regime quickly embraced the technological achievements of the West and set out to modernize the country. Seemingly overnight, all the trademarks of Western civilization exploded into life across Japan, from railroads and banks to cigarettes and top hats.

EARLY 20TH CENTURY

After a hugely transforming reign, the Meiji Emperor died in 1912. The Taisho era that followed saw party politics flourish, while suffrage was extended and new labor laws enacted. A vibrant new culture blossomed as young Japanese men and women reveled in their new economic, social, and political freedoms.

Japan seemed to be set on a course for liberalization. But then, in 1923, the devastating Great Kanto Earthquake struck. More than 100,000 people died, and much of Tokyo was destroyed. To many conservatives, this catastrophe was heaven's judgment on the excesses of the Taisho era. A rumor soon spread that Korean residents of Tokyo were taking advantage of the disaster, looting and committing arson. As mob violence against the Korean population broke out, conservatives used the chaos to reassert control. Soon the military was in complete control over Japanese society and acting increasingly assertive abroad.

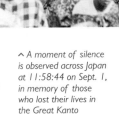

∧ A moment of silence is observed across Japan at 11:58:44 on Sept. 1, in memory of those who lost their lives in the Great Kanto Earthquake.

1856
Japanese prints are found in a packing crate in Paris, and Europe goes wild for "Japonisme."

1868
Imperial power is restored after the Shogunate era, and the capital of Edo is renamed Tokyo.

∨ 1923
The Great Kanto Earthquake devastates Tokyo and Yokohama, leaving 600,000 people homeless.

∧ 1853
Commodore Matthew Perry anchors in Edo Bay, and Japan is reintroduced to Western society.

∧ 1905
Japan emerges victorious from the Russo-Japanese war. Korea becomes a Japanese protectorate.

By the mid-1930s the country was embroiled in a war with China that estranged it from the rest of the world. Then, in December 1941, Japan made the fateful decision to launch surprise attacks against both the US and the British Empire, entering World War II. In August 1945, with millions dead across Asia and most of Japan's cities already in ruins, the US dropped atomic bombs on Hiroshima and Nagasaki. Emperor Hirohito instructed his government to sue for peace.

THE POSTWAR YEARS

Following the Japanese surrender, the Americans occupied Japan for seven years that proved transformative to Japan. The Americans brought democracy and the expectation of a level of personal freedom that would have been unthinkable even in the freewheeling Taisho Era.

In 1952 the American occupation ended, and Japan was finally free from military control for the first time in decades. A creative shockwave was unleashed, ushering in a period of intense innovation in art, film, literature, and architecture.

As the US became involved in first the Korean, and then Vietnamese wars, Japanese industrial production surged to meet demand, and soon automotive and technological exports made Japan one of the richest nations in the world. The country continued to boom until the economic bubble burst in 1992, followed by over two decades of stagnation.

21ST-CENTURY JAPAN

Despite the legacy of Japan's postbubble economic malaise, the nation remains an industrial and cultural behemoth on the world stage. The Japanese have shown great resilience in overcoming various setbacks. They have persevered and rebuilt in the aftermath of the Great Tohoku Earthquake and Fukushima nuclear disasters of 2011, and continue to be visionaries in the fields of transportation, space exploration, technology, design, and media.

As a new emperor takes the throne, the whole nation is determined to use the opportunity of the 2020 Olympic Games to step forward into the world spotlight once again.

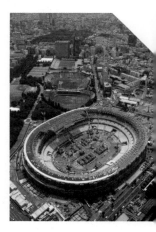

⌄ *Across the world, excitement builds for the opening of the Summer Olympics on July 24, 2020.*

^ **1941–1945**
Japan attacks Pearl Harbor and enters World War II. The war draws to a close when atomic bombs are dropped on Hiroshima.

⌄ **1964**
Tokyo becomes the first Asian country to host the Olympics.

1992
Japan's economic bubble bursts, ending decades of continuous postwar growth.

2011
A major earthquake and tsunami hit northern Honshu. As a result, a major nuclear emergency is declared at Fukushima.

^ **2019**
End of the Heisei era as Emperor Akihito retires. Crown Prince Naruhito ascends the throne and the new Reiwa era begins.

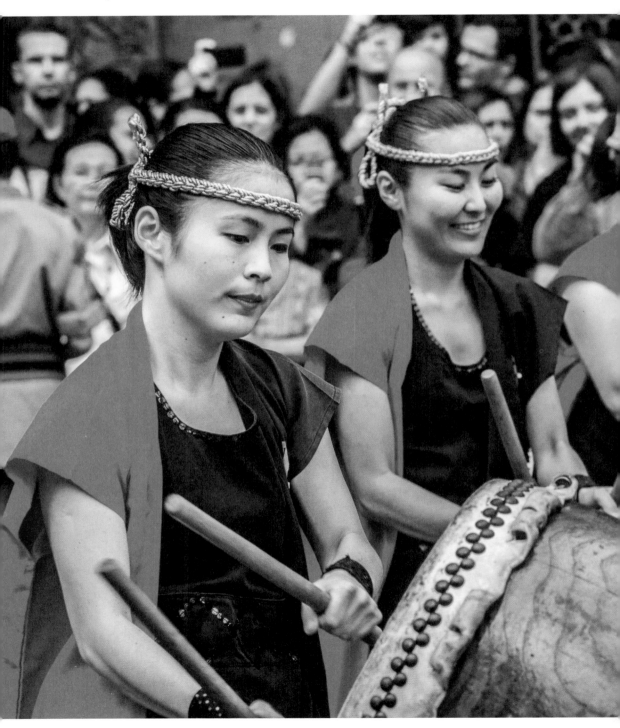

< *The Tanabata (Star Festival) has been celebrated in Sao Paulo since 1979.*

世界中の日本

JAPAN AROUND THE WORLD

Be more Japan wherever you are

Japan's cultural influence stretches far beyond its borders, impacting everything from Hollywood movies to what we eat for lunch. These days it's easy to bring Japanese culture into your life thanks to an array of international sights and festivals showcasing its creative legacy. Here are some highlights to help get you started.

FESTIVAL FUN

UK HyperJapan at London's Olympia every July is a high-octane extravaganza of the very latest in food, fashion, live music, gaming, anime, and alternative arts.

USA Brought to Hawaii in the 19th century, the Obon festival—which honors the spirits of departed ancestors—is now a summer-long event evoking the sounds and smells of Japan with street food, live music, dancing, and lanterns at sunset.

Germany Düsseldorf's annual Japan Day (held in May or June) is a hugely popular celebration of every facet of Japanese culture, from cosplay to origami.

Brazil In July of each year, the streets of the Liberdade neighborhood in Sao Paolo— home to the world's largest expatriate Japanese community—are thronged with festival goers marking Tanabata, or the Star Festival, by hanging prayers from the trees.

BEAUTIFUL BLOSSOMS

USA Join the festive fun around San Francisco's Japantown district during the Northern California Cherry Blossom Festival or head to Washington, DC's National Cherry Blossom Festival to celebrate the city's thousands of trees that were donated by Japan.

Canada Feast your eyes on the pink and white blooms of 40,000 cherry trees— gifted by Japan in the 1930s—at the joyful Vancouver Cherry Blossom Festival.

The Netherlands Head to the Bloesempark section of Amsterdamse Bos to join the families and friends picnicking under the pastel-pink trees in celebration of Amsterdam's Cherry Blossom Festival.

A TASTE OF JAPAN

UK For the chance to experience an *izakaya* (a Japanese-style tavern), head to London's Asakusa or try recreating your favorite dishes at home with ingredients from Ichiba, Europe's largest Japanese food hall, just down the road. Wash it all down with a Japanese whisky tasting at Kouzu.

USA Home to the oldest Japanese community in the US, it's no surprise that San Francisco offers some of the best Japanese food in America. The restaurants here are so authentic, they even display real *sampuru*, or "samples," the waxwork display of menu items that are commonplace in restaurants in Japan.

Germany Home to the largest Japanese community in Europe, Düsseldorf is known as "Little Tokyo on the Rhine." There are a plethora of good ramen bars in the city, but for something more unusual, try Soba-an at the heart of the Japanese neighborhood. The house-made buckwheat noodles of this unassuming spot are a balm for every homesick expat and one of the best kept secrets in the city.

The Netherlands The Netherlands was the only country in the West permitted to maintain a presence in Japan during its 200 years of isolation. These historic links are reflected in the ready availability of dishes such as *okonomiyaki* (savory pancakes), sushi, yakitori, and ramen in Amsterdam. For Michelin-starred cuisine, visit Teppanyaki Restaurant Sazanka or Yamazato Restaurant at the Hotel Okura Amsterdam.

TRANQUIL GARDENS

UK Take a break from the hustle and bustle of London with a visit to the Japanese-inspired roof garden at SOAS, University of London, or the impeccably kept Japanese Landscape at Kew Gardens.

Cowden Garden in Scotland, meanwhile, has been described as "the most important Japanese garden in the Western World" and is the first and only garden of its size and scale to be designed by a woman.

USA Laid down in 1894, San Francisco's enormous Tea Garden in Golden Gate Park includes a teahouse and dry garden and hosts an annual Summer Festival with a tea ceremony and other events. Portland's serene Japanese Garden is widely lauded for its authenticity, but the most quirky offering in the US is the secret sanctuary on the rooftop of the DoubleTree Hotel in Little Tokyo in LA. Featuring manicured greenery, cascading waterfalls, and tranquil ponds, it's a meticulous recreation of the garden created for samurai lord Kiyomasa Kato in Edo in the 16th century.

France Featuring one of the finest bonsai collections in Europe, the beautiful Parc Oriental in Maulévrier contains enchanting traditional Japanese tea-rooms, as well as meandering streams, a bridge, a pagoda, and a garden shop—perfect if you want to start your own bonsai collection. In Paris, the beautiful Ichikawa Japanese Garden provides an unexpected retreat in the heart of the city.

Monaco Designed in 1994 by Yasuo Beppu, Monaco's Japanese Garden was conceptualized as a miniature representation of Shintoist philosophy. Take a stroll through the gardens to discover a verdant oasis featuring an unusual combination of Japanese tradition with Mediterranean touches.

THE JEWEL-LIKE JARDIN JAPONAIS IS AN OASIS OF TRANQUILITY.

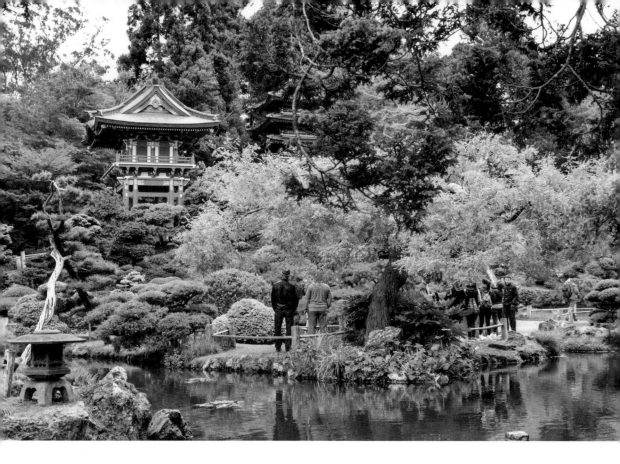

Australia Designed as a *kaiyu-shiki*, or strolling garden, the Cowra Japanese Garden in New South Wales was established to commemorate the Japanese war casualties buried in the district and was supported by the Japanese government as a sign of thanks for the respectful treatment of the graves. A cherry blossom festival is held at the garden each year, as well as Girl's Day and Boy's Day festivals, and you can also take part in tea ceremonies and workshops on Japanese crafts.

TRADITIONAL TEA

UK For a more modern take on tea culture, pay a visit to Japanese tea specialist Postcard Teas in London's smart Mayfair district—reputed to be the finest tea shop in Europe. Customers are encouraged to try the teas before buying, with samples provided in beautiful traditional Japanese ceramics (also for sale). To immerse yourself even further in the world of Japanese tea, you can join a tea ceremony group such The London Tea Club in Hackney, which offers the opportunity to meet for regular tea ceremonies.

France Hidden away in the heart of Paris, next to the Panthéon Bouddhique museum (which has a fine collection of Japanese art), you'll find a lovely small Japanese garden and tea hut. The jewel-like Jardin Japonais, with its lush groves of bamboo, miniature stream, and charming stepping stones, is an oasis of tranquility. Built by a master Japanese carpenter, the Pavillon de Thé hosts regular tea ceremonies.

⌃ *San Francisco's Tea Garden is the oldest public Japanese garden in America.*

^ *Sou Fujimoto: Futures of the Future is one of many exhibitions on Japanese art and design that have been held at Japan House London.*

INSPIRATIONAL ART

UK Between the British Museum, the V&A, and the hip White Rainbow gallery in Fitzrovia, London offers an impressively comprehensive collection of Japanese art. In the British Museum alone, you'll find around 430 artworks and archaeological and historical artifacts.

USA The Museum of Fine Arts, Boston, is reputed to hold the finest collection of Japanese art outside Japan. The early Buddhist paintings and sculpture are the envy of even Japanese museums, while their collection of *ukiyo-e* prints, swords, and *no* masks are unmatched in the West.

Greece The island of Corfu's Museum of Asian Art of holds one of the most unexpected collections of Japanese art in the world. This first-rate collection owes its existence to the Greek ambassador to Austria, Gregorios Manos, who purchased 9,500 or so Chinese, Korean, and Japanese artifacts at art auctions in Vienna and Paris in the late 19th and early 20th centuries.

CUTTING-EDGE DESIGN

UK London's chic Japan House is an elegant cultural center with a carefully curated program that highlights Japan's regional craftsmanship and refined design sensibilities, as well as showcases the country's cuisine and technology. It is one of three such spaces around the world. (The others are in Sao Paolo and LA.)

USA At New York City store Nalata Nalata, you'll not only find an amazing array of beautifully crafted Japanese objects, but also discover the stories behind them. The concept was created by husband-and-wife team Stevenson Aung and Angélique Chmielewski, who also offer thoughtfully written and beautifully photographed articles on their website.

HEAD HERE FOR A TASTE OF A JAPANESE *ONSEN* IN THE WILDS OF THE COUNTRYSIDE.

Malaysia Head to Isetan in Kuala Lumpur, a lavish Japanese emporium spread over six floors. The store's avant garde "Cube" space, has 12 experiential areas where you can delve deeper into Japanese culture, while the bookstore features a carefully curated selection of around 10,000 titles.

ECLECTIC ENTERTAINMENT

UK The Royal Holloway campus in Egham has hosted numerous *no* performances at its dedicated Handa Noh Stage. There, distinguished *no* actor and professor Naohiko Umewaka organizes workshops and demonstrations to help make this art more accessible to Western students.

USA In Columbia, Missouri, you can watch performances of traditional Japanese puppet drama (bunraku) by the Bunraku Bay Puppet Theater. All manner of traditional entertainment is on offer at Florida's Morikami Museum, which has a full calendar of classes, workshops, and shows throughout the year. Be sure to book one of the one-day *koto* (zither) courses taught by master instrumentalist Yoshiko Carlton.

Israel The embrace of Japan's *otaku* (geek) culture has spread as far as Jerusalem with the city's Harucon comic convention. Held during the Purim holiday, it offers sessions with comic book professionals, previews of films and portfolio review sessions with

⌄ *Termas Geometricas' natural hot-spring pools offer a taste of the Japanese* onsen *experience in Chile.*

top comic book and video game companies, as well as the obligatory cosplay contest.

RELAXING HOT SPRINGS

USA Inspired by Japanese *sento* (public baths), Onsen in San Francisco is the best place in the city to enjoy the restorative quality of soaking in a hot water bath. Meanwhile, on the East Coast, at Pembroke Springs in Virginia, you can relax in two large Japanese baths fed by natural spring waters, surrounded by beautiful forest.

Australia Located just 75 minutes from Melbourne in Hepburn Springs, Shizuka Ryokan offers an authentic Japanese experience. This quiet, minimalist space features traditional *tatami* mats, *yukata* robes, and *shoji* screens, as well as a Zen rock garden to contemplate postdip.

Chile Nestled in a lush forest canyon in Chile, the Termas Geometricas spa is a stunning maze of red planks that wind over a flowing stream through the verdant trees. Head here for a taste of a Japanese *onsen* in the wilds of the countryside.

SACRED SPACES

USA Established on the Big Sur coast of California in 1967, Tassajara is a Soto Zen training monastery. It offers courses during fall and winter, or you can pay a visit in the summer guest season and savor the monastery's vegetarian cooking.

France Located in Valaire, La Gendronnière is the oldest Zen Buddhist temple in France. Join other disciples in the practice of Soto Zen at this remote community, surrounded by a forest of ancient trees.

China To explore the Chinese roots of Zen Buddhism, head to Song Shan, the towering mountain that looms over Henan Province. It's home to the Shaolin Temple, China's most important Buddhist monastery.

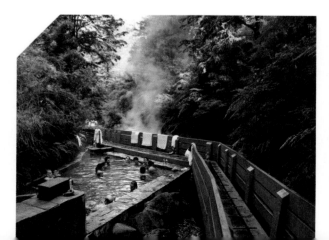

日本の見方

A VIEW OF JAPAN

Look beyond typical travel brochure images of temples, castles, and neon-drenched city centers, and you will find there is far more to Japan than initially meets the eye. From the subtropical islands of Okinawa to the rolling farmlands and heavy winter snows of Hokkaido in the far north, Japan delivers diverse scenic beauty. Mountain ranges dominate much of the land, providing the Japanese with places of pilgrimage and play: hiking trails, hot springs, and ski slopes. As an island nation, the archipelago is dotted with island chains, some windswept and rugged like the Oki Islands and Sado, others sun-soaked and balmy. The country's varied climates have created distinct local cultures, meaning that even urban Japan isn't cast from a single mold. Among the modernity, Kyoto frequently reveals glimpses of its ancient past, while regional hubs operate not just at a different pace than Tokyo, they wear their local heritage with pride.

地図の上から
ON THE MAP
Exploring Japan's landscapes

Make your journey an exploration of Japan's diversity. Experience big-city buzz in Tokyo, slower urban life in Matsuyama, and traditional island ways in Okinawa. Hike the paths trodden by pilgrims for centuries in the Japanese Alps, go diving in the Izu Islands, and discover the rural folklore of the Tono Valley in Iwate. From the ice floes off Hokkaido to the mangroves of Iriomote, there are countless ways to see Japan.

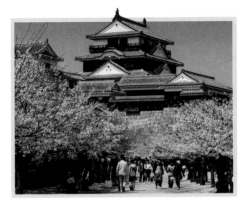

∧ URBAN CALM
Enjoy a more relaxed urban experience in regional cities like Matsuyama (p45), where local traditions linger and modern life moves at a laid-back pace.

NATURAL HAVEN
Of Japan's 34 national parks, the most remote is Ogasawara National Park, about 600 miles (1,000 km) south of Tokyo.

∧ ISLAND PARADISE
The beautiful Yaeyama Islands in Okinawa (p55) are home to lush jungle, pristine beaches, sleepy villages, and world-class dive spots.

UNSHAKEABLE SPIRIT
Reborn after the devastating 1945 atomic bomb, Hiroshima (p44) is today a buzzing metropolitan center.

SHIMOSHIMA ISLAND ●

● HIROSHIMA

● MATSUYAMA

YAEYAMA ISLANDS
●

SHIMOSHIMA ISLAND ●

FESTIVAL FUN
One of Japan's youngest cities, spirited Sapporo stands out for its American-style grid system (p43). Visit in September for the Autumn Fest food festival or in February for the annual Snow Festival.

SAPPORO

NISEKO

∧ SNOW CENTRAL
Snowboarders and skiers alike flock to Niseko (p51) for its long, cold winter season, numerous slopes, and quality powder.

HIKING HEAVEN
Mount Fuji may be more famous, but the best hiking and most striking mountain views are in the Japanese Alps (p51).

TONO

∧ RURAL IDYLL
Steeped in legend, Tono offers a taste of traditional countryside life, with people still living in rhythm with nature and observing age-old traditions (p49). Look out for the town's distinctive magariya (L-shaped houses).

JAPANESE ALPS

TOKYO

∨ CAPTIVATING CAPITAL
Home to 9 million people in its central wards, Tokyo is one of the busiest, most crowded and built-up cities in the world. It's unmissable.

CLOSE QUARTERS
Don't expect much space in Japan's biggest cities. The population density in central Tokyo is roughly 15,000 people per square kilometer.

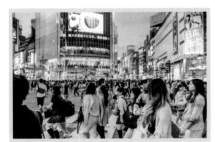

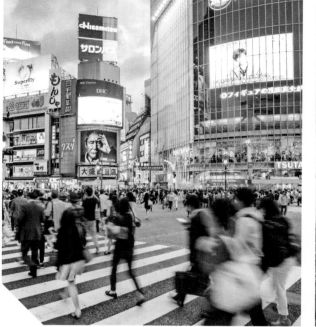

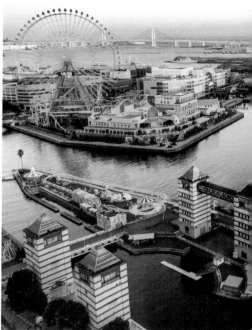

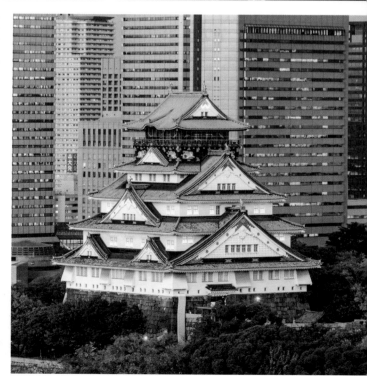

∧ Clockwise from above: Shibuya Crossing is one of Tokyo's most famous sights; Yokohama has long been a center of shipping and trade; Osaka Castle sits at the heart of the city.

KYOTO

Kyoto is only Japan's ninth most populated city, but in terms of culture and tourism it's up there with Tokyo. The city offers many ways to experience traditional Japan: relax at a tea ceremony, try *zazen* meditation, stay at a *ryokan* inn, or maybe even enjoy a night of geisha entertainment.

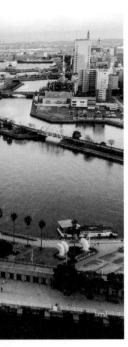

都市の景観

CITYSCAPES

Japan's dynamic metropolises

Encapsulating the country's contrasts, Japan's stimulating cities marry tradition and modernity while also carving out their own unique local character.

THE BIG FIVE

Traveling to Japan's most populous cities will fully immerse you in Japanese life, providing the perfect introduction to the country's culture.

TOKYO

The capital since 1868, Tokyo is Japan's most densely populated city, with over 9 million people living in its core 23 wards (council districts). Busy central wards like Shinjuku and Shibuya have all the neon, high-rises, and crowds you'd expect, but you can find a different side of Tokyo life in the city's classical gardens, historic temples, quiet riverbanks, and traditional neighborhoods like Shibamata, Yanaka, and Nezu.

YOKOHAMA

As part of Greater Tokyo, Yokohama in many ways feels like an extension of the capital—but the 3.5 million people living there would be quick to call out some differences. The city has a vibrant Chinatown, for one thing, and a lively bay area that splices modern entertainment complexes with Western-style architecture that dates back to the end of Japan's self-isolation in the mid-1800s.

NAGOYA

Just over 185 miles (300 km) west of Yokohama, Nagoya gets overlooked by many travelers, but with 2.2 million residents, the city is a major economic player—it's the birthplace of Toyota, among other things. Nagoyans, however, take more pride in their food than business savvy: miso, *tebasaki* (peppery deep-fried chicken wings), and *miso katsu* (breaded pork cutlets with a miso sauce) are just some of the delicious local specialities.

OSAKA

Moving west again from Nagoya, the 2.7 million people in Osaka are defiantly different—with a reputation for being more direct and outgoing than any other Japanese—and their city reflects that. Dazzling downtown Dotonbori has more neon and hustle than anywhere in Tokyo.

SAPPORO

The capital of Hokkaido in Japan's north, Sapporo is the most distinctive of the big five. Settled by the Japanese in the latter half of the 1800s, the relatively new city incorporated—unusually for Japan—a grid system that makes it a very easy, uncluttered city to get around. It also stands out for its snow. In winter, Sapporo gets a whopping 20 ft (6 m) of it annually, along with temperatures that can dip as low as 5°F (−15°C).

BEYOND THE BIG CITIES

Beyond the sprawling mass of metropolises like Tokyo and Osaka, Japan's smaller cities offer very different urban experiences. More mellow and less densely packed, they're full of local flavor and history.

HAKODATE

Located at the southern tip of Hokkaido, Hakodate's Motomachi and port districts are home to old red-brick warehouses, churches, and other Western architecture that serve as a reminder of European influences on Hokkaido's early development in the late 1800s. The city's fishing fleet, meanwhile, lands some of Japan's finest crabs, sea urchins, and other seafood, which you can eat fresh at the morning market. Don't miss the most famous Hakodate sight—the night view of the city from the observation deck atop 1,096-ft (334-m) Mount Hakodate.

KANAZAWA

On the Sea of Japan coast on Honshu, Kanazawa is often referred to as "Little Kyoto." Known for its gourmet seafood, the city is connected to Tokyo, Osaka, and Kyoto by direct train, but still doesn't get huge numbers of tourists. In the Edo era, the city rose to prominence under the Maeda clan as the center of the Kaga region, and just as Kyoto is dotted with remnants of its past, so too is Kanazawa. The preserved Higashi Chaya geisha district, Nagamachi samurai quarter, and serene Kenroku-en gardens are just a handful of its treasures.

HIROSHIMA

On the far west of Honshu, Hiroshima is one of Japan's best-known cities because of the tragic events that occurred on August 6, 1945, when the US Air Force's *Enola Gay* bomber dropped an atomic bomb into the heart of the city, killing tens of thousands of Hiroshimans in a split second. Moving memorials to the tragedy dot the center of modern-day Hiroshima, but they don't overshadow it—the city itself has a bubbly nightlife and is within easy reach of Miyajima, the island that's home to Itsukushima Shrine and its sublime "floating" *torii* gateway.

⌄ *Left to right: Hakodate's historic warehouses have today been turned into shops; walking through Kanazawa's streets is like stepping back into the past.*

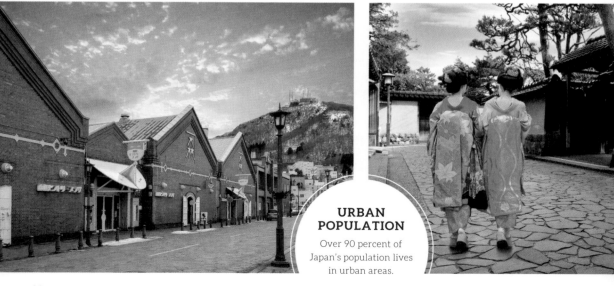

URBAN POPULATION

Over 90 percent of Japan's population lives in urban areas.

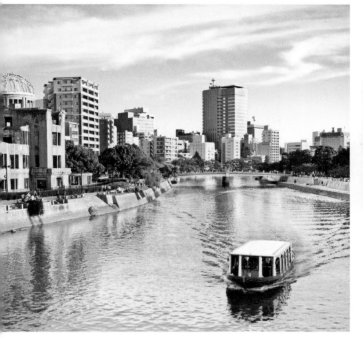

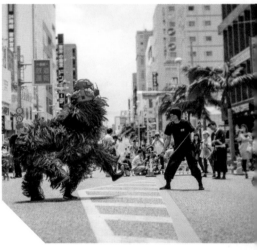

∧ *Clockwise from left: Hiroshima's modern architecture sits alongside memorials to the city's tragic past; Matsuyama's Dogo Onsen Honkan bathhouse is a Japanese icon; Naha comes alive at festival time.*

MATSUYAMA

Located on Shikoku, the smallest of Japan's four main islands, Matsuyama is a fine example of a city that balances past and present. The largest and most cosmopolitan of Shikoku's cities, it has a skyline dominated by a hilltop castle, and its streets still employ a network of rickety old trams. In its Dogo Onsen area, Matsuyama also has one of the most celebrated bathhouses in Japan, the creaking Dogo Onsen Honkan, which has been both a key location in renowned novelist Natsume Soseki's book *Botchan* and the inspiration for the bathhouse in Studio Ghibli's Oscar-winning animated movie *Spirited Away*.

NAHA

Way down in Okinawa, Naha has a very different feel than other Japanese cities. Warm to hot temperatures year-round, palm trees, and a relative lack of high-rises have seen to that, while there are also influences from the US military presence and from Ryukyu, an independent kingdom that included Okinawa until it was annexed by Japan in the 1870s. Apart from the main entertainment area, Naha has a laid-back island vibe, and it makes a great jumping-off point to explore the stunning Okinawan island chains *(p55)*.

> NAHA HAS A DIFFERENT FEEL THAN OTHER JAPANESE CITIES, WITH A LAID-BACK ISLAND VIBE.

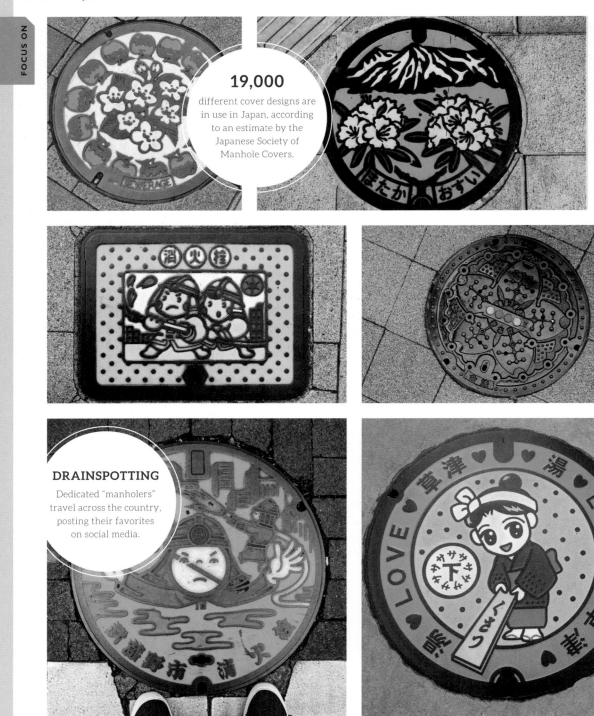

19,000
different cover designs are
in use in Japan, according
to an estimate by the
Japanese Society of
Manhole Covers.

DRAINSPOTTING

Dedicated "manholers"
travel across the country,
posting their favorites
on social media.

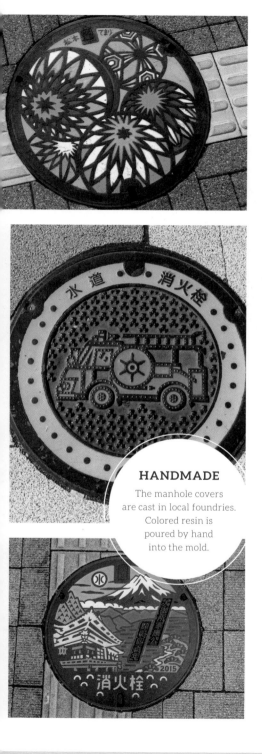

HANDMADE

The manhole covers are cast in local foundries. Colored resin is poured by hand into the mold.

マンホールの蓋

MANHOLE COVERS

Art beneath your feet

The Japanese have a talent for elevating the mundane into a thing of beauty, and there is no finer example of this than the humble manhole cover. Originally designed to make taxpayers more amenable to paying for costly drainage projects, Japan's decorated manhole covers have become a source of local pride, highlighting regional attractions, wildlife, festivals, historic events, and even folklore.

Matsumoto (Nagano Prefecture) celebrates the local craft of making *temari*—handmade balls of intricately woven silk yarn used as gifts and decorations—while Kusatsu in Gunma Prefecture depicts a woman in traditional dress carrying out *yumomi*, a centuries-old method to cool the town's hot-spring water to bathing temperature by stirring it with wooden paddles. Throughout the country you can spot an array of colorful designs that celebrate Japan's fire departments with depictions of firefighters at work.

Not surprisingly, these manhole covers are now a social media phenomenon. You can track them with apps like Manhoo!, which lists the locations of more than 3,000 different designs around the country. In February 2019, there was even a Manhole Cover Festival held in Tokyo, complete with stands selling manhole cover snacks, pens, pin badges, and trading cards: everything a drainspotter could dream of.

‹ *Japan's colorful manhole covers not only vary according to the region that they're in, but also differ depending on the utility type and the manhole manufacturer.*

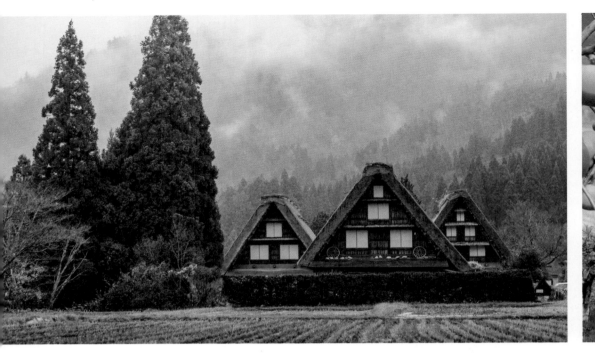

日本の農村

RURAL JAPAN

A slower way of life

Visit the Japanese countryside and you'll soon understand that things look and work differently: the colorful strings of orange persimmons you see hanging outside homes to dry, the occasional scent of a bonfire, the clusters of watery rice paddies between homesteads, and the way darkness blankets everything at night, with the sky up above speckled with vivid stars. Life here moves at a much slower pace than in urban Japan, dictated by the changing seasons and the planting of crops.

STUNNING VISTAS

Because Japan is so mountainous, only about 12 percent of the country is farmland—an insignificant figure compared to other major economies. With relatively little space for farming, Japan grows less than half its own food. Travel through Hokkaido and you'll see rolling fields and expansive flat lands, but in many other

LIFE HERE IS DICTATED BY THE CHANGING SEASONS AND THE PLANTING OF CROPS.

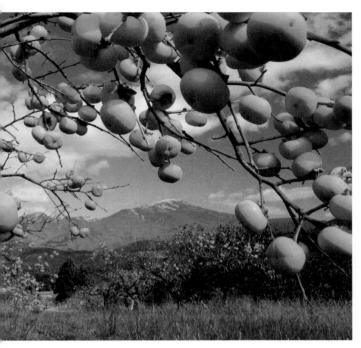

‹ Left to right: Shirakawago is famed for its unique thatched houses; persimmons are a common sight in the countryside in autumn.

GET INVOLVED

You don't have to visit rural Japan as a sightseer—you could also go on a working farm vacation to really go deep into Japan. An organization called World Wide Opportunities on Organic Farms (WWOOF) has hundreds of farm-stay hosts all over Japan who can give short- and mid-term work experiences to travelers.

parts of rural Japan farmland takes a different form in line with the natural terrain, such as the main tea production areas of Shizuoka and Kyoto, where green tea bushes grow in photogenic rows on tiered, hillside plantations—they're tricky to reach without a car, but worth the effort for the wonderful views.

It's in the village of Shirakawago in Gifu Prefecture—at the foot of holy Mount Haku—that Japan's countryside arguably looks its most idyllic. The steeply thatched *gasshozukuri* farmhouses here, enveloped by the green of rice paddies in summer and frosted with snow in winter, take their name from the way they resemble hands clasped in prayer.

OFF THE TOURIST TRAIL

Less-trodden alternatives include the Tono Valley in Iwate Prefecture, which feels almost frozen in time. Rice paddies and small farms dot the valley floor, and local folklore adds a touch of mystique, with stories like that of the *kappa*, a pond dweller with a taste for cucumbers and a sinister fondness for drowning people. The Iya Valley in Tokushima Prefecture is even more idyllic, its river gorges and wooded mountainsides home to thatched houses, vine bridges, and natural hot springs.

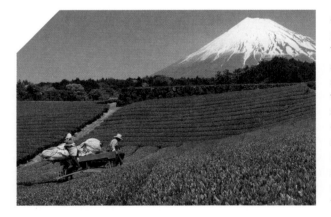

⌄ Tea fields follow the contours of the country's hilly terrain.

山

MOUNTAINS

Peaks of pilgrimage and play

More than 70 percent of Japan's landmass is mountainous, bestowing the country's peaks with a special place in Japanese culture, spirituality, and life. Spend time on their slopes and you'll have not only the chance to see some of the country's most spectacular scenery, but also the opportunity to connect with Japanese traditions both old and new.

THE THREE SACRED PEAKS

For their displays of natural power (which give them a close connection to the gods), three Japanese peaks have traditionally been deemed holier than all others. Collectively known as the Sanreizan, the trio includes Mount Fuji, the now-dormant volcano lying to the west of Tokyo (p52). Second on the list is the 8,860-ft (2,700-m) Mount Haku, on the borders of Ishikawa, Gifu, and Fukui prefectures, revered for the meltwater lakes at its base—though today it is perhaps more prized as a destination for winter sports. Finally, there is the 9,890-ft (3,015-m) Mount Tate in Toyama Prefecture, dotted with natural hot springs and sulphur vents, and said to be where the spirits of the deceased gather. For centuries, pilgrims have scaled their heights in search of spiritual enlightenment, launching a tradition of Japanese mountain climbing that continues to this day.

⌄ The Japanese Alps were named for their resemblance to the European Alps.

PIONEERING MOUNTAINEERS

Japan's tradition of mountain climbing is one of the oldest in the world, dating as far back as the 9th century.

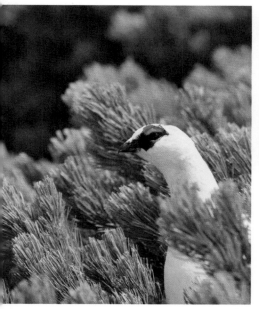

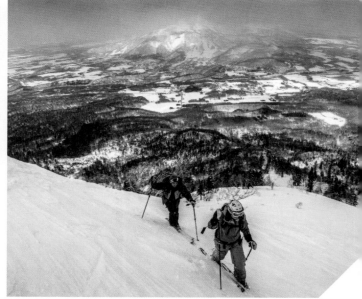

JAPAN'S ALPS

Pilgrims and monks first carved out many of Japan's top hiking routes, and there are none more popular than those in the Japanese Alps, which are divided into three sections. The northern part contains the Hida Mountains, which run just over 60 miles (100 km) through Gifu, Nagano, and Toyama prefectures and include the 9,839-ft (2,999-m) Mount Tsurugi, rated as the most dangerous climb in Japan. The Kiso Mountains in Nagano and Gifu make up the central section, and the valleys between their peaks contain some of the prettiest preserved villages in Japan—former staging posts on the old Nakasendo highway, such as Tsumago. In the southern section are the Akaishi Mountains, on the border of Nagano, Yamanashi, and Shizuoka prefectures. Home to ten of the 100 top-ranked mountains in Japan, they are a good place to spot Japanese serow (goat-antelopes), sika deer, and birds like the rock ptarmigan and spotted nutcracker.

HITTING THE SLOPES

Skiing was introduced to Japan in the early 1900s by an Austrian army major named Theodor von Lerch—he is commemorated by one of Niigata Prefecture's local mascots, the moustachioed Lerch-san. Today, Niigata is still home to great skiing and snowboarding in areas such as Yuzawa and Naeba, as is neighboring Nagano, where Hakuba hosted the 1998 Winter Olympics. But both have been eclipsed by Niseko in Hokkaido, which has become one of Asia's top winter-sports destinations thanks to its powder snow and backcountry options.

∧ *Left to right: Wildlife found in the Japanese Alps includes the rock ptarmigan; Niseko is one of Japan's premier destinations for winter sports.*

THE TOP 100

In the 1960s, the writer and mountaineer Kyuya Fukada published a book titled *100 Famous Japanese Mountains*, each peak selected by him for its grace, history, and individuality. Covering mountains across the nation, it has become something of a bible for Japanese hikers—the 100 mountains everyone wants to summit.

富士山

MOUNT FUJI

Japan's iconic peak

As Japan's tallest and most sacred mountain, with an almost symmetrical form that dominates the landscape, the 12,388-ft (3,776-m) Mount Fuji is the classic symbol of Japan and a source of inspiration for artists and poets. The woodblock artist Katsushika Hokusai famously depicted the peak in his *Thirty-Six Views of Mount Fuji* series, which includes one of the most reproduced images in history, *The Great Wave off Kanagawa*.

The first person to climb it is said to have been a monk in the 600s, and it has long been revered as one of the three holiest peaks in Japan *(p50)* thanks to its sheer size, volcanic power, and tales of deities that call it home, as well as the ascetic challenges provided by its climate and terrain *(p216)*.

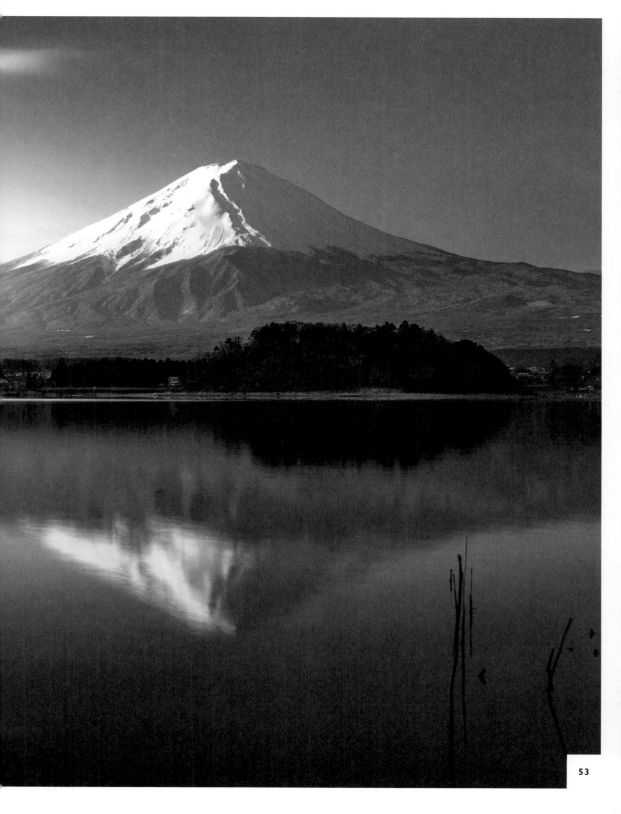

∧ *The Okinawa archipelago is made up of 160 small islands.*

日本の島々

ISLAND DIVERSITY

From windswept to subtropical

With close to 7,000 islands in total—both large and small, inhabited and deserted—Japan is undoubtedly an island nation. The area known as mainland Japan is actually comprised of five large islands—Honshu, Hokkaido, Kyushu, Shikoku, and Okinawa—while around these are small island groups like the Oki, Izu, Ogasawara, and Yaeyama islands. Take a trip to these outer reaches and you will be rewarded with a broader and deeper experience of Japan.

ISLANDS OF EXILE

Looking north to the Sea of Japan, Sado Island off the coast of Niigata and the four Oki Islands off Shimane are all rugged and windswept northern isles that were once places of exile—the monk Nichiren was a famous exile on Sado in the 1270s, and the Emperor Go-Toba died in exile on Oki in 1239. Far off many visitors' radars, they are wonderful, undervisited destinations, with fishing and agriculture as their mainstays. Sado hosts the annual Earth Celebration music festival in August, while the Oki Islands offer a taste of slow island life amid stunning nature—a patchwork of rocky shores, pretty beaches, and highlands where cows and horses graze.

TOKYO SIDE TRIPS

The easiest island chain to visit is the Izu Islands, just off the southern coast of Tokyo and administratively part of the capital. The largest of them, Oshima—

< *Sado Island was once the home of political exiles.*

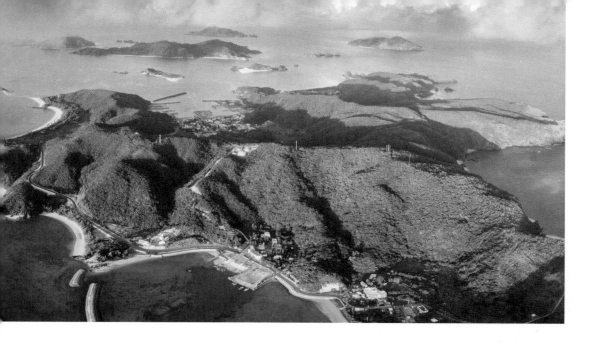

which has the volcanic Mount Mihara at its center—is only 1 hour 45 minutes by jetfoil from Tokyo Bay and is especially pretty when camellias are in bloom in early spring. In the same chain, Niijima is good for surfers, while Miyakejima—an overnight ferry away—has great hiking, diving, and hot-spring baths.

SUN-KISSED RETREATS

Technically still in Tokyo Prefecture, the 30 small Ogasawara Islands 600 miles (1,000 km) south of mainland Tokyo are well worth the 24-hour ferry trip. In 2011, they received UNESCO designation for their natural beauty and diversity, which encompasses coral reefs, indigenous wildlife, and rare flora and fauna. The islands of Okinawa are similarly stunning, with the subtropical Yaeyamas in particular standing out for their incredible diversity. Highlights in the archipelago include the preserved villages on Taketomi, where water buffalo taxi carts are still a common sight; the dense jungle and mangrove groves of Iriomote; and the pristine beaches and diving sites of Ishigaki.

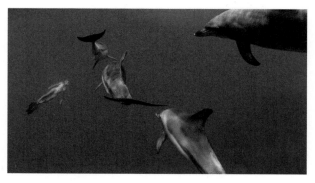

∧ Wildlife found off the Ogasawara Islands includes Indo-Pacific bottlenose dolphins.

THEMED ISLANDS

Forget themed restaurants, Japan specializes in themed islands. Naoshima (Kagawa Prefecture) and a cluster of other small islands between Shikoku and Honshu are famed for their contemporary art, while Okunoshima in Hiroshima Prefecture is overrun by friendly feral rabbits, and Aoshima in Ehime is the most famous of Japan's dozen or so "cat islands."

時代を超越した日本

TIMELESS JAPAN

A meticulous attention to detail, an appreciation for the imperfection and impermanence of life *(wabi-sabi)*, and a love of nature are all reflected in Japan's extraordinary craftsmanship and cultural traditions. The country's indigenous Shinto religion is essentially worship of nature, leading, for example, to the desire to create beautiful gardens and bonsai. The introduction of Buddhism in the 6th century played an enormous role in the development of Japanese aesthetics and the arts, from temple architecture to sculpture and lacquerware. And Buddhist philosophy, in particular the precise rituals of the tea ceremony *(p198)*, profoundly influenced flower arranging, calligraphy, ceramics, and landscape gardening. Through the centuries, Japanese artisans have refined their crafts, perfected their techniques, and passed their knowledge down for generations. Japan considers artists so vital to the nation's cultural heritage, it officially recognizes the best of them as Living National Treasures.

地図の上から

ON THE MAP

Exploring timeless Japan

Japan's cultural legacy is so entwined with everyday life, it's hard to travel without experiencing it everywhere you go. Temples and shrines are the heart and soul of every community; gardens are an integral part of Japan's artistic expression. You'll encounter Japan's decorative arts throughout the country, from galleries selling local crafts to world-renowned national collections in Tokyo.

STAY HUMBLE

Entrances to traditional garden teahouses are small, requiring guests to duck or crawl through them as an act of humility.

ᐱ GARDENS AS ART
There's no finer union of art and gardening than the Adachi Museum in Yasugi, where cleverly placed windows frame the landscapes like works of art (p78).

ORIGAMI TRIBUTE
Thousands of origami cranes decorate the Children's Peace Monument in Hiroshima's Peace Memorial Park (p90).

● YASUGI

● HIROSHIMA

KINASHI ●

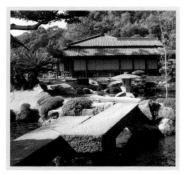

ᐱ SAMURAI SUBURB
Tucked behind the stone walls of Chiran's samurai district are seven beautifully preserved traditional homes (p76). Get a closer peek while touring their charming gardens.

BONSAI BONANZA
Kinashi has been growing bonsai for centuries and has more nurseries than anywhere else in Japan (p80).

● CHIRAN

SACRED SHRINES

Fushimi Inari Taisha, founded in Kyoto in 711, is the head shrine of some 30,000 Inari shrines in Japan. Look for the stone foxes on the grounds that serve as messengers to the gods (p60).

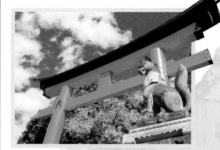

HIRAIZUMI ●

A BUDDHIST UTOPIA

Hiraizumi's Golden Hall and Pure Land Garden are part of a 12th-century complex designed to create a Buddhist paradise on earth (p65).

DIVINE MESSENGERS

The deer that roam freely in Nara Park are considered messengers to the Shinto gods.

SAITAMA ●

● TOKYO

LIVING SCULPTURE

Saitama's Omiya Bonsai Art Museum displays hundreds of miniature trees (p80).

● NAGOYA

● KYOTO

UKIYO-E MASTER

Hokusai is one of Japan's most well-known artists and is thought to have produced some 30,000 works. You can peruse a selection at the Sumida Hokusai Museum in Tokyo (p84).

SHINTO TREASURE

Nagoya's Atsuta Jingu shrine houses a sacred treasure (p63).

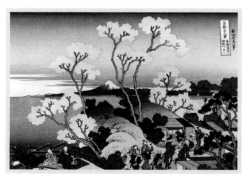

UNDER ONE ROOF

The Tokyo National Museum contains the world's largest collection of Japanese art and decorative crafts.

神道

SHINTO

Way of the gods

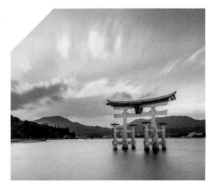

^ The torii (gate) of
Itsukushima Shrine
(Miyajima Island) is
one of Japan's three
most scenic views.

Japan's oldest
religion, Shinto
("way of the gods")
finds divinity in all
aspects of nature. It
has no founder or
sacred scriptures;
instead, its
philosophy is
centered around
living life in
harmony and
cooperation with
everything and everyone around you.

The core concept of Shinto is that
deities known as *kami* preside over all
things in nature, be they living, dead, or
inanimate. There are lesser and greater
kami, who exist in everything from rocks
and trees to phenomena like the wind and
waves and even illnesses. The *kami* reside
at sacred shrines *(jinja)*, where people go
to worship them. Each shrine is devoted
to a particular *kami*—Inari shrines such as
Fushimi Inari-Taisha in Kyoto, for example,
are dedicated to the god of prosperity
(symbolized by rice) and safety, and are
easily distinguishable by stone foxes on

the grounds that serve as the deity's
messengers. Other popular *kami* include
Hachiman, the deity of archery and
war, whose shrines include the famous
Tsurugaoka-Hachimangu in Kamakura.

PRAYER AND HARMONY

Purification ceremonies and other rituals
are performed at set times throughout the
year, but generally shrines are informal
places that people visit at their leisure
to make a prayer or offering. Shinto's
emphasis on harmony means that it is
highly tolerant of other religions, and you
may sometimes find Shinto shrines at
Buddhist temples—many Japanese people
will happily visit and perform rites at both.

Many facets of Japanese life, including
an emphasis on cleanliness and an austere
aesthetic, have their roots in Shinto practice.
Shinto's deep affinity with nature is also
reflected in the concept of *wabi-sabi (p72)*,
which sees beauty in natural imperfections.

> The honden is the
most sacred building at
a shrine; this one is at
Ueno Toshogu in Tokyo.

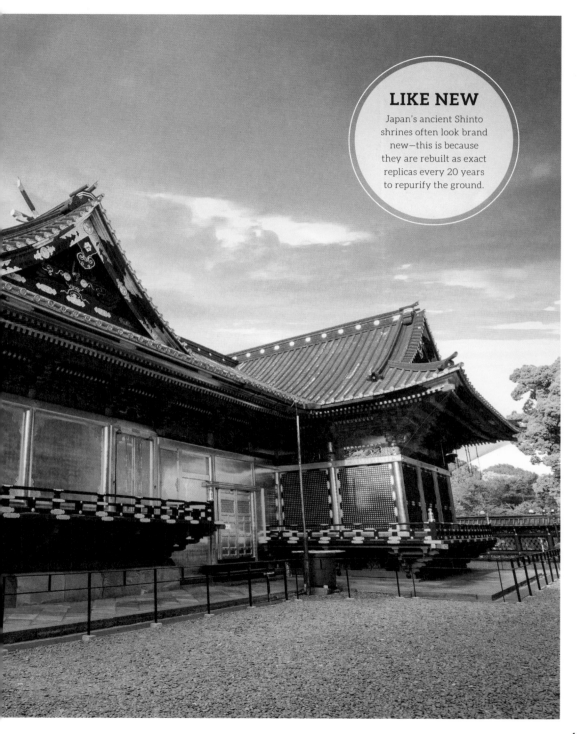

LIKE NEW

Japan's ancient Shinto shrines often look brand new—this is because they are rebuilt as exact replicas every 20 years to repurify the ground.

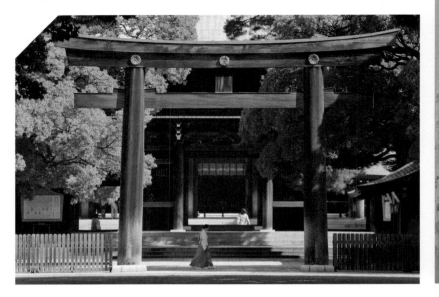

^ Left to right: The torii at Meiji Jingu is made from 1,500-year-old cypress pine from Taiwan; thousands of vermilion torii line the 2.5-mile- (4-km-) long trail to Fushimi Inari-taisha; the unique Meoto Iwa, or "wedded rocks," at Futamigaura Beach symbolize the union of marriage.

VISITING A SHRINE

Visiting one of Japan's 80,000 shrines is like stepping into an oasis of intense calm, where the atmosphere thrums with an almost tangible connection to the natural and spiritual worlds. To reach this hallowed space you must first pass through a *torii*— a vermilion gateway that symbolizes the border between the ordinary and sacred realms. Most shrines just have one *torii*, but some, such as Kyoto's Fushimi Inari-taisha, have tunnels made up of thousands of them. As you enter the complex, look out for the auspicious animal statues and *shimenawa* (decorative ropes of rice straw or hemp that hang over entrances), which protect the shrine from evil and sickness.

Before heading further inside the shrine, make your way to the stone water basin near the entrance to wash your hands (a sign of purification). From there, a stone *sando* (pathway) leads to the *haiden* (offering hall) and *honden* (sanctuary) where the shrine's *kami* resides. Only the *haiden* is open to the general public; the *honden* is usually only entered by the head priests. Alert the *kami* to your presence by ringing a bell and clapping your hands before praying. It's also traditional to toss a coin into the trough in front of the shrine —five and fifty yen (the coins with holes in them) are considered the most propitious.

JAPAN'S MOST SACRED SHRINES

Nearly every community has a Shinto shrine, but the following hold a special place in the Shinto world.

Ise Jingu Japan's most sacred Shinto shrine, in the seaside town of Ise (Mie Prefecture), is split into two compounds: the outer Geku and the more significant inner Naiku. Legend has it that a mirror representing the Sun Goddess Amaterasu, the ultimate ancestress of Japan's current imperial family, rests in the Naiku.

Izumo Taisha Second in importance to Ise Jingu is Izumo Taisha in Izumo (Shimane Prefecture). It is dedicated to the God of

ALERT THE *KAMI* TO YOUR PRESENCE BY RINGING A BELL AND CLAPPING YOUR HANDS.

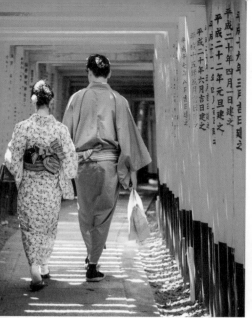

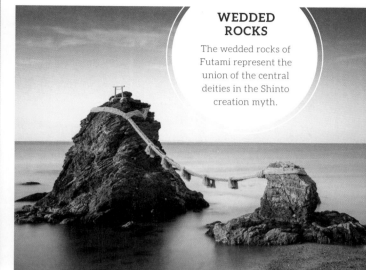

WEDDED ROCKS

The wedded rocks of Futami represent the union of the central deities in the Shinto creation myth.

Happy Marriage, Okuninushi-no-mikoto, which makes it popular with couples. It is also the location for the annual November gathering of the millions of *kami* from all over Japan, who are believed to meet to discuss the year's events.

Atsuta Jingu Established around 1,900 years ago, Atsuta Jingu in Nagoya (Aichi Prefecture) was founded to house a legendary sword that is one of Japan's Three Sacred Treasures.

Meiji Jingu Tokyo's premier Shinto shrine is a memorial to Emperor Meiji and his empress Shoken. Built in 1920, it is a grand, austere affair surrounded by 120,000 trees of 365 different species. The 40-ft- (12-m-) tall *torii* is the largest in Japan.

Itsukushima Jinja On Miyajima Island (Hiroshima Prefecture), Itsukushima Jinja is one of Japan's most recognizable shrines. Its low-slung halls, which rest on pierlike bases, and its striking vermilion *torii* rising out of the bay make it appear as if the shrine is floating on water.

Tosho-gu Breaking the austere mold of Shinto architecture is Tosho-gu in Nikko (Tochigi Prefecture), final resting place of the 17th-century shogun Ieyasu Tokugawa. Elaborately decorated with carving, gilting, and lacquering, its standout feature is the glittering Yomei-mon (Sun Blaze Gate).

‹ *The fox (kitsune) is a messenger of the kami Inari.*

THE THREE SACRED TREASURES OF JAPAN

Legend has it that the Three Sacred Treasures of Japan— the mirror Yata no Kagami (housed at Ise Jingu, Ise); the jade jewel Yasakani no Magatama (Imperial Palace, Tokyo); and the sword Kusanagi (Atsuta Jingu, Nagoya)—were brought to earth by the deity Ninigi-no-Mikoto, ancestor of the Japanese imperial line. Few know for sure if they exist because they are never put on public display.

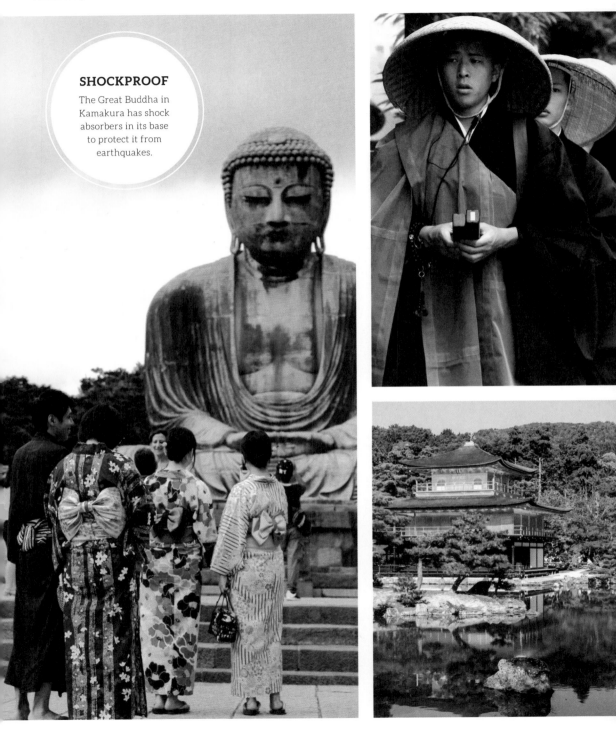

SHOCKPROOF

The Great Buddha in Kamakura has shock absorbers in its base to protect it from earthquakes.

< *Clockwise from left: The Great Buddha in Kamakura (Kanagawa Prefecture) was cast in 1252; Buddhist monks in Japan often wear black robes; Kyoto's Kinkaku-ji is one of Japan's most famous Zen temples.*

仏教

BUDDHISM

Simplicity and serenity

Based on the teachings of the Buddha, Buddhism in Japan has evolved to complement the native Shinto religion. Its belief system and morality permeate modern Japanese life, especially in the emphasis on mental control found in Zen Buddhism.

Buddhism, founded in India, arrived in Japan in the 6th century CE via China and Korea. Hundreds of different Buddhist movements, sects, and subsects—some incorporating native Shinto beliefs (p60)—subsequently developed in the country. Contrasting beliefs appealed to different groups of nobility, samurai, and commoners, who each adapted practices to their own ends. The most famous of these is Zen, which places an emphasis on *zazen* (sitting meditation) and self-help. Zen's austere aesthetic and paring of life back to its essentials has had a profound influence on Japanese arts and culture, from

philosophical concepts such as *wabi-sabi* and *mono no aware (p72)* to garden design *(p78)* to rituals such as the tea ceremony *(p198)*. Other important sects include Shingon, which incorporates Hindu elements such as hand gestures *(mudra)* and the chanting of mantras; Tendai, which places emphasis on selfless devotion; and Shugendo, an offshoot of Shingon that combines Buddhism and Shinto beliefs.

PERSONAL FAITH

At least a third of Japan's population identifies as Buddhist, and many more will visit Buddhist temples to attend festivals or ceremonies such as funerals. Temples rarely hold set services, so most worshippers visit at their convenience. Many Japanese homes will have a small Buddhist altar, and believers may also carry small charms that have been blessed by a priest for good luck *(p69)*.

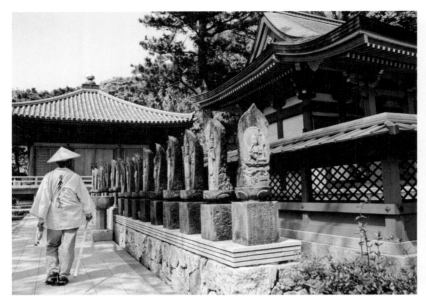

∧ Left to right: Pilgrims to Buddhist temples typically dress in white; statues of the guardian Jizo often depict him holding a staff in one hand and a jewel talisman in the other.

VISITING A TEMPLE

A visit to a Buddhist temple will transport you from the earthly world to that of the Buddha. Entrance is through the *sanmon*, an imposing main gate. Inspecting you from either side of the *sanmon*—in alcoves or on the wooden gates—will be figures of two fearsome Nio guardians, who protect the temple from evil spirits. Once you're inside the compound, the main focal point is the *hondo* (main hall), which houses the temple's principal image of Buddha and contains a table for offerings. (Some temples will enshrine other enlightened figures such as Kannon, Goddess of Mercy.) Prayers are made in silent contemplation, kneeling before the altar.

PAGODAS

Some temple complexes contain pagodas, Chinese versions of the Indian *stupas* that enshrine relics of the Buddha—although few Japanese pagodas have this reliquary function. Many are constructed with five floors, which are said to represent the five elements: earth, water, fire, wind, and sky.

JIZO STATUES

Another common feature at temple complexes is red-bibbed Jizo statues. Jizo is the guardian of children and unborn babies, and helps children who have died pass into the next world. Bereaved parents often dress the statues in red bibs and baby clothes as part of the grieving process, while others leave clothes as offerings in thanks for saving their children.

JAPAN'S MOST NOTABLE TEMPLES

Japan has no shortage of historic Buddhist temples, but the following stand out as the most monumental.

Senso-ji At the heart of Tokyo's Asakusa district, this venerable Buddhist temple was founded in the mid 7th century to enshrine a tiny gold image of the Goddess of Mercy that was caught in the net of two local

> TWO FEARSOME NIO WARRIORS PROTECT THE TEMPLE FROM EVIL SPIRITS.

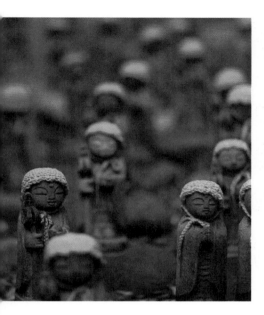

for sacred dances. Also within the grounds is a small shrine dedicated to Okuninushi, the Shinto god of love. Legend has it that if you can traverse the 33 ft (10 m) between the two stones in front of the shrine with your eyes closed, you will find true love.

Todai-ji The Great Buddha Hall at Todai-ji, in the city of Nara (Nara Prefecture), is reputedly the largest wooden building on the planet. It has been rebuilt several times through the ages, but has always housed a huge, 53-ft- (16-m-) tall bronze statue of Buddha sitting cross-legged.

Kosan-ji This technicolor temple on the island of Ikuchi-jima in Onomichi (Hiroshima Prefecture) is the creation of a local industrialist who wanted to honor his mother. Construction began in 1936 and lasted 30 years, during which time smaller-scale versions of famous Japanese temple buildings were erected on the grounds, along with an enormous statue of Kannon, the Goddess of Mercy.

fishermen. It is hugely atmospheric and perpetually thronged with visitors.

Kotoku-in The seaside town of Kamakura (Kanagawa Prefecture) is littered with temples, the most famous of which is Kotoku-in. Here you can come face to face with an 36-ft- (11-m-) tall bronze Daibutsu, a giant Buddha statue that has serenely withstood typhoons, tidal waves, and even the Great Kanto Earthquake of 1923.

Kinkaku-ji This iconic Zen Buddhist temple in Kyoto dates back to the 14th century. Today a national Special Historic Site, its centerpiece is the dazzling gold-leaf-coated pavilion that perches delicately at the edge of a lake.

Kiyomizu-dera Overlooking Kyoto, the 8th-century Kiyomizu-dera is famous for its capacious wooden terrace, built as a stage

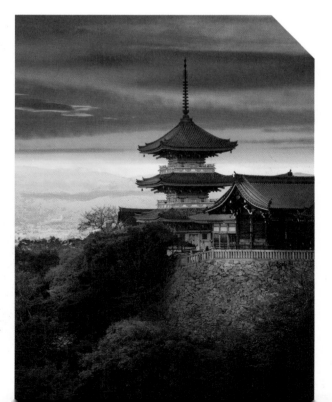

> A visit to Kiyomizu-
dera's pagoda is said to
bring about an easy
and safe childbirth.

MIXED FATE

Omikuji are classified into different rankings, ranging from *Dai-kichi* (excellent luck) to *Kyo* (bad luck).

LOCAL DESIGNS

Fox-shaped *ema* are popular at Inari shrines because of their link to the fox messenger of the *kami* Inari.

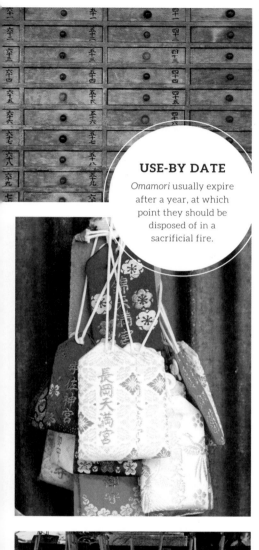

USE-BY DATE

Omamori usually expire after a year, at which point they should be disposed of in a sacrificial fire.

おみくじと願い事

FORTUNES AND CHARMS

A little bit of luck

A common sight at Shinto shrines and Buddhist temples, charms and fortunes can be purchased by anyone in need of a little extra luck from the gods. The most eye-catching talismans are the colorful *omamori*, small, silky cloth bags containing a prayer that has been blessed by a priest. Encouraging good fortune for everything from health and wealth to good test results and safe driving, they can be worn next to the body or placed somewhere relevant—but it is vital not to open the bag to read the charm or it will not work. Other popular options include *ema*, small wooden votive plaques on which a prayer or wish is written before being hung at the temple or shrine for the *kami* (deity) to see and—hopefully—make come true. They are often printed with vibrant illustrations of auspicious animals and folk gods connected with the shrine.

Those seeking more immediate influence on their fate can draw an *omikuji* (fortune-telling slip). Usually this works by pulling a random stick out of a bundle, and then selecting the printed fortune slip that corresponds to the number on the stick; alternatively, you might get your fortune from a vending machine. Beware that not all fortunes are good—if you get a bad one, it's traditional to tie the slip to a pole or pine tree at the shrine to prevent the bad luck from following you.

‹ *Clockwise from top left: An* omikuji; omamori *for sale; drawers containing* omikuji; omamori *come in brightly colored bags;* ema *plaques at Rokuharamitsu-ji, Kyoto; fox-shaped* ema

FUKUROKUJU BENZAITEN BISHAMONTEN

七福神

SEVEN LUCKY GODS

Folk deities of fortune

Like kids in the West knowing all about fairy tales, Japanese children are raised to be familiar with a quirky cast of ancient folk gods and mythical creatures. Here we meet the most popular of these, the Shichifukujin—the Seven Lucky Gods.

The Shichifukujin blend Shinto and Buddhist beliefs, and also have roots in Hindu and Taoist traditions. You will spot sculptures and paintings of the seven at temples and shrines throughout Japan, and the deities also pop up as talismans in bars, restaurants, and shops. On New Year's Eve, it's traditional to sleep with a picture of the Shichifukujin under your pillow to bring luck for the year.

THE SHICHIFUKUJIN

Traveling together in their treasure-laden ship *Takarabune*, the Shichifukujin are a motley collection of colorful personalities with unique powers and characteristics.

Fukurokuju The patron of chess players, Fukurokuju is the god of wisdom, luck, longevity, and happiness. His head is as big as his body and he carries a cane and a written scroll. He's often accompanied by a turtle, crow, or deer because these animals symbolize long life.

Benzaiten The only female of the seven, Benzaiten is a beautiful and artistic deity who is the patron of creative people such as artists, writers, and geisha. She carries a *biwa* (a traditional lutelike instrument) and has a pet white snake.

Bishamonten Bishamonten is the warrior god and patron of fighters. He's dressed in armor and carries a pagoda in one hand and a spear in the other—a reference to his role as a protector of holy sites.

DAIKOKUTEN EBISU HOTEI JUROUJIN

THE SHICHIFUKUJIN ARE A MOTLEY COLLECTION OF COLORFUL PERSONALITIES.

Daikokuten Daikokuten is the smiling, short-legged god of commerce who wears a hat and carries a bag full of swag. He is the patron of bankers, cooks, and farmers, and is sometimes depicted in female form as Daikokunyo.

Ebisu God of prosperity and wealth, Ebisu is the only one of the seven who is purely Japanese. The patron of fishermen, he is identified by his fishing rod and is often used as a mascot at fish restaurants and shops.

Hotei Hotei, who represents fortune and popularity, is the patron of children and barmen. Too fat for his clothes, the cheerful, bald man carries a bag packed with fortunes over his shoulder. He is believed to be based on a real Chinese man of the 10th century called Kaishi.

Juroujin Juroujin is also a god of longevity and is patron to the elderly. Very tall with an elongated head and straggly white beard, he is often depicted with a tortoise and a 1,500-year-old crane.

Sculptures of the Shichifukujin are a common sight at shrines and temples

∧ *On New Year's Day, residents of Shirakawa (Gifu Prefecture) dress as the Shichifukujin and dance around the village to celebrate the arrival of the deities.*

BENZAITEN

71

おみくじと願い事

AESTHETICS AND DESIGN

Concepts of taste and style

Deliberately embracing imperfection and asymmetry, Japanese aesthetics are underpinned by a set of ancient concepts that have inspired a unique approach to the creation of beautiful designs. The foundation of traditional Japanese aesthetics lies in Shinto and Buddhist beliefs, which emphasize simplicity and the ephemeral nature of life. The following principles are manifested in all aspects of Japanese design, whether it's an *ikebana* arrangement *(p74)* or the shape of a car.

WABI-SABI

Separately, *wabi* can be said to have the general meaning of rustic simplicity, while *sabi* denotes a timeless beauty, an appealing patina. Combined, the hallmarks of a *wabi-sabi* design are that its attraction derives from it being incomplete, imperfect and impermanent. So, for example, instead of being symmetrically round, a pottery bowl will be slightly wonky, its texture perhaps rough and uneven and its color natural and muted rather than bright and bold. The Japanese general public might struggle to come up with a precise explanation of the concept, but they will instinctively know whether something is *wabi-sabi* by looking for such characteristics.

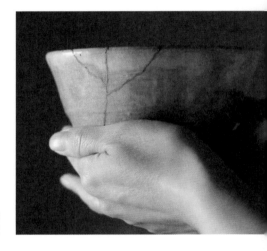

⌄ *A cracked bowl can still be* wabi-sabi.

⌄ *Influenced by the seasons,* ikebana *serves as a reminder of nature's transience.*

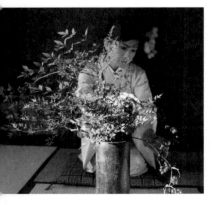

MONO NO AWARE

Underlaying *wabi-sabi* is the concept of *mono no aware*, which can be translated as "poignancy" and encapsulates an awareness of impermanence. This is the driving force behind the Japanese love of the ephemeral, such as the appreciation of cherry blossoms. It's a mixed feeling, as the joy of observing their fleeting beauty is tempered by the sadness that the blossoms will only last a short time.

‹ Wabi-sabi *can be applied to everyday life, with even a simple table setting providing a reminder that nothing is permanent.*

IKI

Translating as "chic and stylish," *iki* is a more recent concept of Japanese taste. It evolved out of the tastes of the merchant class that emerged in Japan from the 17th century onward, and thus stands in opposition to the *wabi-sabi* philosophy that was promoted by the upper classes of royalty and samurai. Today, *iki* most visibly comes into play with ordinary, everyday products that have been thoughtfully and carefully designed—such as tea towels decorated with delicate *sashiko* embroidery—but it can also be detected in the sleek electronic goods produced by design studio Nendo or even the fictional works of writer Haruki Murakami.

KINTSUGI

Fix your broken pottery *wabi-sabi*-style with *kintsugi*—a technique that embraces imperfection by using golden glue to highlight the cracks.

SHIBUI

Distinct from *wabi-sabi* is *shibui*, an adjective that conveys the concept of subtle, understated beauty and refinement. While many *wabi-sabi* objects and designs are *shibui*, not everything that could be described as *shibui* will be *wabi-sabi*. There are said to be seven possible elements to *shibui*: simplicity, implicity, modesty, naturalness, everydayness, imperfection, and silence—nothing that is gaudy or overly flashy in its design.

› *Japan's annual cherry blossoms perfectly encapsulate the joy and sadness inherent in* mono no aware.

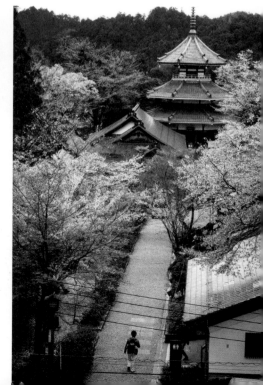

SPACE

Space is as dynamic
a component of
an arrangement
as the foliage.

3 ELEMENTS

The longest stem
represents heaven and
the shortest earth, with
the middle stem
symbolizing man.

EARLY
PIONEER

The first recorded master
of flower arranging was
15th-century Buddhist
monk Ikenobo Senkei.

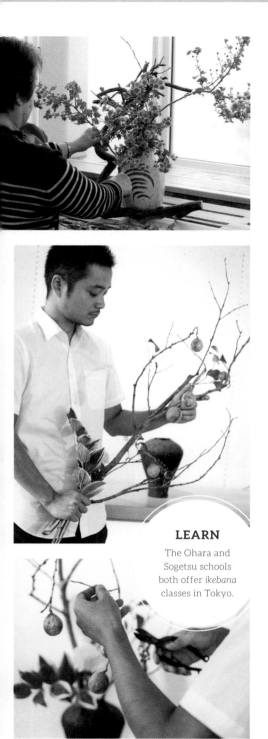

生け花

IKEBANA

Bringing flowers to life

A reminder of *mono no aware*, *ikebana* is the arrangement of flowers and other foliage into a living sculpture. The practice originated from early flower offerings at Buddhist temples, and was developed by Buddhist monks for use in the tea ceremony. In its simplest form, *ikebana* is a composition of just three elements, but styles have changed dramatically over the years. In the Edo Period, the *rikka* ("standing flowers") style, consisting of many-branched structures representing Buddhist cosmology, became vogue, followed by the simpler *shoka* style of one or more plants focusing on the plant's inner beauty.

Today, there is a mind-boggling variety of *ikebana* schools. Ikenobo is the oldest, adhering to the strict rules of *rikka* and *shoka*. The Ohara School, founded during the Meiji Period to incorporate use of Western flowers, revolutionized *ikebana* with the new *moribana* style, where flowers are "piled up" *(moru)* in flat containers to represent natural landscapes. Sogetsu was founded in 1927 in the belief that *ikebana* should be enjoyed anywhere, any time, using any material. More modern schools include Jiyuka (freestyle), without set rules and limited only by the artist's imagination.

LEARN

The Ohara and Sogetsu schools both offer *ikebana* classes in Tokyo.

‹ *Symbolism and seasonality are key considerations in the creation of an ikebana arrangement, which results in a wide array of sizes and compositions.*

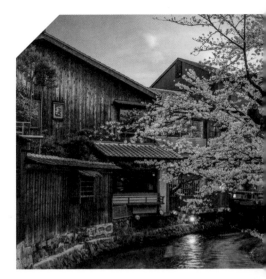

日本家屋

TRADITIONAL HOMES

Naturally practical

Filtered through the designs of temples and shrines and influenced by styles from mainland Asia, traditional Japanese architecture is defined by an emphasis on natural materials and a reverence for careful craftsmanship and calming, well-proportioned spaces.

In a land prone to earthquakes, buildings made from natural materials that are able to flex stand a better chance of withstanding a tremor than bricks and glass. Fortunately, Japan's ancient forests were a ready source of such materials, providing builders with lumber, bamboo, and plant fibers. The natural beauty of the wooden elements was showcased by leaving the grain unpainted, and master carpenters became skilled at finding ways to join the beams of a house without using nails. Although largely unadorned, houses sometimes had decorative features carved into roof lintels and window frames.

Bamboo was used for rafters, ceilings, fences, and external blinds (sudare), while the interior space was divided as necessary by shoji (movable screens) and fusuma (sliding doors). Panels of opaque washi (Japanese paper) in the shoji both allowed in light and cast calming shadows. This clever combination of design features and sustainable materials suited to the Japanese climate—with extremes of hot and cold weather and high humidity—enabled the interior to stay refreshingly cool in the summer and warm and cozy in winter.

CALMING INTERIOR

Visiting a traditional Japanese home—or, even better, staying in one of the country's many ryokan (traditional inns)—feels like stepping into a meticulously designed work of art. You enter first through the genkan, a porch area that acts as a clear point of separation between the outside world and the domestic sphere. Remove your shoes here, then step up to the wooden surface of the main entrance corridor and proceed into the house. Some larger houses may also have an entrance for visitors on the engawa—a raised wooden veranda that

∧ *Left to right: Shirakawa is famed for its traditional buildings; interiors are designed to work in harmony with the building's natural surroundings.*

VISITING A TRADITIONAL HOME IS LIKE STEPPING INTO A METICULOUS WORK OF ART.

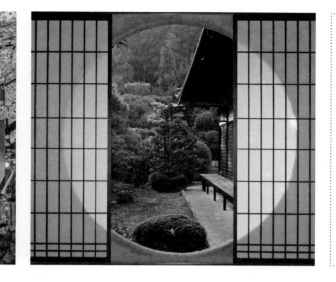

TRAVEL BACK IN TIME

A great example of a traditional upper-class home is Nomurake in Kanazawa (Ishikawa Prefecture), while Chiran (Kagoshima Prefecture) and the old travelers' rest stops of Tsumago (Nagano Prefecture) and Magome (Gifu Prefecture) feature whole streets of traditional wooden houses. In the countryside, you'll come across *minka*, the homes of farmers and artisans, often with steeply raked thatched roofs; the most famous are in Shirakawa (Gifu Prefecture) and Gokayama (Toyama Prefecture).

runs around the outside edge of the house; here, you stand on the stone step to remove your shoes. The *engawa* acts as a corridor that can either be left open as a place to sit and enjoy the surroundings in good weather or be sealed off by storm shutters.

At the heart of the house is the *irori*, a sunken hearth where charcoal is burned for heating and cooking. Reception and living rooms are heated in winter by a

kotatsu, a low wooden table with a heater underneath and a fringe of a blanket or futon under which you can tuck your legs. Also in the main reception room will be the *tokonoma*—a recessed space for displaying artistic items such as a hanging calligraphy scroll and an *ikebana* flower display. These items are often changed to reflect the seasons.

TATAMI

The distinctive and pleasant smell of a Japanese room—not unlike freshly cut grass—comes from the *tatami*. These rectangular padded straw-and-rush mats are used for flooring, providing a soft surface on which to sit and sleep (cushions and futons are used instead of chairs and beds). *Tatami* come in an aspect ratio of 2 to 1 and have different standard sizes depending on the region in which they are made: Tokyo *tatami* mats, for example, are smaller than those in Kyoto. They continue to be popular even in modern Japanese homes, where at least one room may be covered in *tatami*, and room sizes are often still quoted in terms of the number of *tatami* mats that would cover the floor.

⌄ *Seating inside the home is on cushions on the floor.*

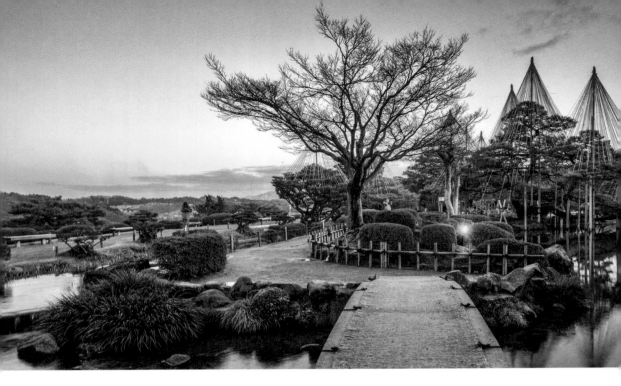

日本庭園

GARDENS

Snow, moon, and flowers

Designed to reflect the seasons, the arrangement of Japanese gardens draws inspiration from the Shinto love of nature and the Buddhist concept of paradise. Classic Japanese gardens can be roughly divided into four types, but they all share many components and principles.

HEAVEN ON EARTH

Paradise gardens are designed to evoke the Pure Land, or Buddhist paradise, with Buddha meditating on an island in the middle of a lotus pond. One of the most famous examples is Byodo-in near Kyoto, with a pond that represents the Western Ocean, where the dead are reborn.

A SPACE FOR MEDITATION

Karesansui or "dry-landscape" gardens are also commonly known as Japanese rock or Zen gardens, because they often are part of the landscaping of Buddhist Zen temples. Intended to provide a focus for meditation, carefully chosen stones are grouped amid an expanse of raked gravel. The Adachi Museum of Art in Yasugi (Shimane Prefecture) has won awards for its dry-landscape garden, but Ryoan-ji in Kyoto has perhaps the most iconic

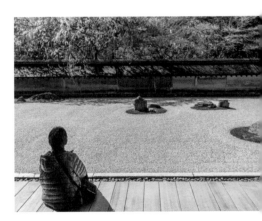

∧ Zen gardens such as Ryoan-ji in Kyoto use gravel to represent bodies of water.

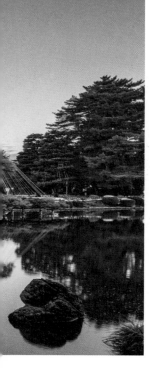

< *Kenroku-en in Kanazawa is designed to be equally stunning in every season.*

karesansui garden, featuring enigmatic rock formations that appear like miniature mountainous islands amid a sea of smooth pebbles raked into linear patterns.

CHANGING VISTAS

Kaiyu-shiki or "stroll" gardens are designed for walking, and became popular during the Edo Period (1603–1868) at the villas of the nobility. Designed to be enjoyed as you follow a path clockwise around a central pond from one carefully composed scene to another, a beautiful example is Tokyo's Rikugi-en, where the scenery is inspired by classical poetry.

TEA GARDENS

A *roji* (meaning "dewy ground") is the simple garden of a Japanese tea house. Designed to resemble a mountain trail leading from reality into the magical world of the tea ceremony, its greenery is mainly moss, ferns and evergreens, though there may also be trees such as maple or plum.

ˇ *Rikugi-en in Tokyo recreates 88 landscapes in miniature from famous poems.*

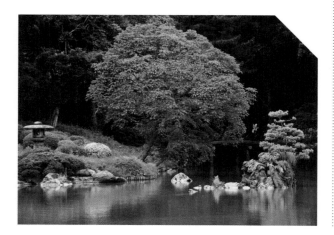

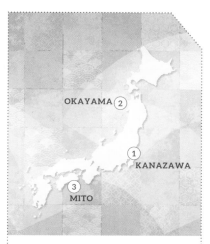

OKAYAMA ②

① KANAZAWA

③ MITO

JAPAN'S TOP GARDENS

Three gardens rank above all others in Japan, as they are said to perfectly express setsugekka. *Translating as "snow," "moon," and "flowers," this term encapsulates the beautiful aspects of nature that you can experience in each of the gardens at different points in the year.*

① *Kenroku-en* This stroll garden in Kanazawa (Ishikawa Prefecture) embodies six virtues of the ideal garden: spaciousness, serenity, venerability, scenic views, subtle design, and coolness.

② *Koraku-en* Completed in 1700, this scenic stroll garden in Okayama (Okayama Prefecture) features a path circumnavigating a central pond, which contains three islands that replicate the scenery around Lake Biwa near Kyoto.

③ *Kairaku-en* Located in Mito (Ibaraki Prefecture), this garden is famous for its 100 different types of plum trees that explode into blossom in February. It is unique in that it was designed as a public park rather than a private garden.

盆栽

BONSAI

Miniature masterpieces

Bonsai, meaning simply "plantings in a container," is the art of cultivating miniature trees in shallow pots. Originating in China, tree miniaturization was brought to Japan about 1,000 years ago, where it gained popularity as a way to capture the beauty of nature and bring it closer for personal enjoyment. Bonsai are not dwarfs by nature. Rather, any seedling tree or shrub confined to a small container, its growth controlled by trimming, pruning, and pinching, can be cultivated as a bonsai. Conifers like junipers and black pines, deciduous trees like Japanese maples, flowering trees such as the Japanese wisteria, and fruit-bearing trees like apple and plum—all can be manipulated to suggest an entire landscape. Through a practitioner's vision, patience, and skilful hands, a gnarled old pine conjures up relentless snowstorms, a slanted trunk looks like it was buffeted by strong winds, and a drooping tree appears to hang over a sheer cliff.

To see these living works of art, you can visit dedicated bonsai villages at Kinashi in Takamatsu (Kagawa Prefecture) and Omiya in Saitama (Saitama Prefecture). Saitama is also home to the Omiya Bonsai Art Museum, which houses an astonishing 1,000-year-old Ezo spruce named Todoroki (Thunder's Roar). Standing just 37 in. (94 cm) tall, its decayed trunk and carefully cultivated, brilliant-green canopy have an ethereal beauty imbued with the aesthetic of *wabi-sabi (p72)*.

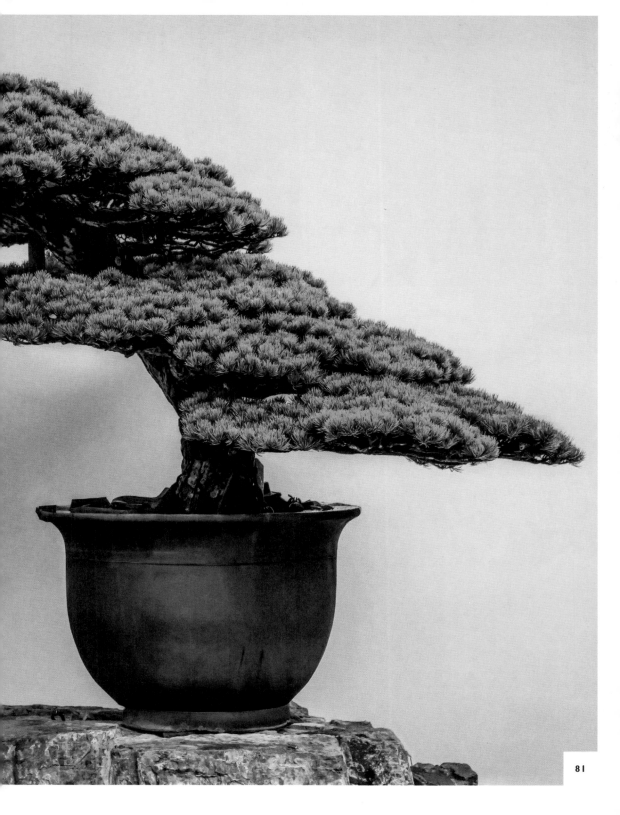

⌃ This Kano school
painting, Amusements
at Higashiyama in
Kyoto (c 1620), shows
people enjoying cherry
blossom season.

日本画

PAINTING

The evolution of artistic style

Encompassing a wide range of genres, styles, and techniques, Japanese painting has evolved as a masterful blend of native aesthetics and outside artistic influences.

EPIC ILLUSTRATIONS
Having largely taken its artistic cues from China, Japanese painting began developing its own unique style with the start of the Heian era in 794. The movement of Japan's capital from Nara to present-day Kyoto unleashed a flourishing of creativity, out of which emerged a new type of painting known as *emaki*—narrative picture scrolls depicting legends, historical tales, and romances. One of the richest styles of *emaki* was *yamato-e*, characterized by its stylized figures, floating clouds of color, and innovative aerial interior views.

MONOCHROMATIC SIMPLICITY
The 14th century saw the popularization of a more pared-back style in the form of monochromatic ink and wash paintings. Imported from China, the technique was initially used to decorate Zen Buddhist temples—its simplicity and fluid, imperfect nature chimed perfectly with the concept of *wabi-sabi (p72)*. Masters of this style include Sesshu, whose most famous work is the 49-ft- (15-m-) long *Sansui Chokan* scroll painting of the four seasons, held at the Mori Museum in Hofu (Yamaguchi

THE SHOGUNS DEMANDED
STYLISTICALLY LAVISH ART
THAT WAS BIG AND GRAND.

Prefecture) and Shubun, whose *Reading in a Bamboo Grove* is on display at the Tokyo National Museum.

KANO'S GLITTERING GRANDEUR

From the 15th to 19th centuries, the Kano school of painting was dominant. Brightly colored and stylistically lavish, often incorporating areas of gold or silver leaf, this style blossomed with the rise of the shoguns and their demand for art that was big and grand. The paintings were often on *byobu* (folding screens) and *fusuma* (sliding doors)—a beautiful example is the dreamlike *Red and White Plum Blossoms* by Ogata Korin (1658–1716), held in the collection of the MOA Museum of Art in Atami (Shizuoka Prefecture).

WESTERN INFLUENCES

In the late 19th century, traditional styles of Japanese painting were pushed aside in favor of Yoga (Western-style painting). In reaction to these imported styles came the Nihonga movement, which combined traditional painting techniques with more modern subject matter. You can see examples of these distinctive works at the Yamatane Museum of Art in Tokyo.

∧ Chogonka Emaki by Kano Sansetsu is in the yamato-e style of scroll painting.

SCROLL THROUGH ART HISTORY

The oldest surviving *yamato-e* are four 12th-century handscrolls of *The Tale of Genji (p132)*. One of the world's earliest novels, its exquisite illustrations beautifully convey the ambience of court culture of the time. Three of the scrolls are part of the collection of the Tokugawa Art Museum in Nagoya (Aichi Prefecture), and one is held by Tokyo's Gotoh Museum.

木版画

WOODBLOCK PRINTS

Pictures of the floating world

Literally meaning "pictures of the floating world", *ukiyo*-e (woodblock prints, and also paintings) take their name from the colorful scenes of 17th- to 19th-century Japan that they depict.

Developed as affordable art for the Japanese mass market, *ukiyo*-e captured the sensory pleasures of everyday life. Favorite subjects included famous geisha, kabuki actors, and sumo wrestlers, as well as renowned townscapes. Picturesque landscape views were also sought after—

∨ Hokusai's The Great Wave off Kanagawa can be viewed at Tokyo's Sumida Hokusai Museum.

not least because of the vicarious pleasure they provided in an age when few could travel to see locations themselves. Hugely popular throughout Japan, *ukiyo*-e were also a big hit abroad, influencing Western art movements such as Impressionism and Art Nouveau and artists such as Manet, Van Gogh, and Toulouse-Lautrec.

The first *ukiyo*-e prints are believed to have been produced by Hishikawa Moronobu, whose clean drawing style set the standard for artists to follow. The most

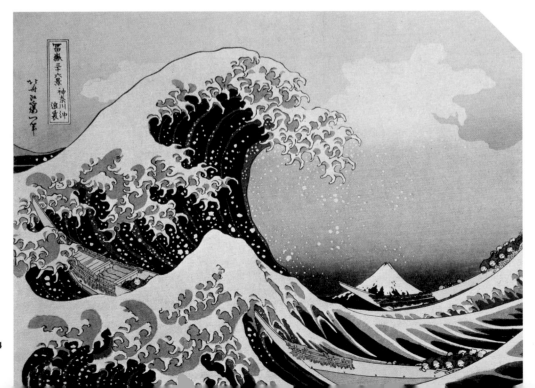

KEY UKIYO-E ARTISTS

∨ KATSUSHIKA HOKUSAI (1760–1849)

As well as his celebrated Thirty-six Views of Mount Fuji series, Hokusai is also known for drawing shunga (erotic images).

∨ UTAGAWA HIROSHIGE (1797–1858)

Hiroshige is best known for his landscape series Fifty-three Stations of the Tokaido and One Hundred Famous Views of Edo.

∧ HISHIKAWA MORONOBU (1618–94)

The earliest ukiyo-e master, this prolific artist is best known for his depiction of female beauties.

∧ UTAGAWA KUNISADA (1786–1864)

Kunisada was hugely popular during his lifetime, with a reputation that surpassed all of his contemporaries.

famous of these is Katsushika Hokusai, whose *Great Wave off Kanagawa* (part of his *Thirty-six Views of Mount Fuji* series) has become a globally recognized icon of the genre. Other influential artists include Utagawa Hiroshige, an *ukiyo-e* master who created over 8,000 works during his lifetime, and Utagawa Kunisada (also known as Utagawa Toyokuni III), famed for his actor prints and one of the most prolific and commercially successful *ukiyo-e* artists in late 19th century Japan.

UKIYO-E IMMERSION

Immerse yourself in the floating world with fabulous collections of *ukiyo-e* at the Japan Ukiyoe Museum in Matsumoto (Nagano Prefecture) and the Ota Memorial Museum of Art in Tokyo. There are museums devoted to Hokusai in Tokyo and Obuse (Nagano Prefecture), and one to Hiroshige in Ena (Gifu Prefecture).

AN INTRICATE PROCESS

Printing *ukiyo-e* is a multilayered process that involves multiple stages and a variety of craftspeople. It begins with the artist, who designs the image and breaks it down into the different colors that will be used. Next comes the woodblock carver, who transfers each separate color image to a series of woodblocks. The printer then uses each of the blocks to make the final complete image, starting with the lightest color and ending with the darkest. Each block has registration marks to help the printer line up the colors.

∧ *The graphic style of* ukiyo-e *printing is still popular today.*

DEVELOPED AS AFFORDABLE ART, *UKIYO-E* CAPTURED THE SENSORY PLEASURES OF EVERYDAY LIFE.

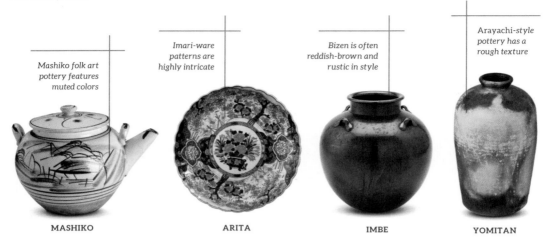

Mashiko folk art pottery features muted colors

MASHIKO

Imari-ware patterns are highly intricate

ARITA

Bizen is often reddish-brown and rustic in style

IMBE

Arayachi-style pottery has a rough texture

YOMITAN

陶芸

CERAMICS

Regional interpretations of an ancient craft

Rustic and imperfect, delicate and finely patterned: Japanese ceramics come in many beautiful forms. They are made today by skilled artisans following centuries of tradition.

Fueled by the central role of ceramics in cuisine and in the tea ceremony *(p198)*, myriad styles have developed in different areas. Each one incorporates distinct techniques and practices, which are often related to the properties of the local clay.

> LOCALS BELIEVE THE CLAY IMPROVES THE TASTE OF FOOD AND DRINK.

MASHIKO
Mashiko clay is rich in silicate and iron, which makes it not only easy to shape but also fire-resistant. With around 250

potteries and 50 ceramics shops, Mashiko (Tochigi Prefecture) is one of Japan's top pottery towns. The area is particularly known for its rustic wares made from red clay, popularized by Mashiko native Shoji Hamada, a major figure in the *mingei* folk art movement *(p118)*.

ARITA
In the 16th century, Korean potters were forcibly brought to Arita on the island of Kyushu to share their knowledge, including the technique of colored overglazing. Their legacy of thin, light, and durable porcelain—also known as Imari-ware— is notable for its delicate decoration, commonly featuring blue and white floral patterns. One of the oldest manufacturers is Arita Porcelain Lab, established in 1804 and still producing both traditional and contemporary designs.

IMBE

Bizen ceramics have been produced in Imbe (Okayama Prefecture) for over a millennium. A warm, reddish-brown color, they are typically made from an earthy, iron-rich clay. Locals believe the clay has extra-special qualities, improving the taste of food and drink and helping extend the life of flowers kept in Bizen vases.

YOMITAN

The balmy islands of Okinawa are home to the Tsuboya ceramic style, produced there since the 16th century. Tsuboya is a district in the city of Naha, where the potteries were historically located before the kilns were moved to the Yomitan peninsula in the 20th century. The simple, unglazed *arayachi* style is typically used for large storage vessels, while the more colorful glazed *joyachi* style tends to be reserved for decorative tableware.

TOBE

Manufacture of the distinctive ceramics in Tobe (Ehime Prefecture) on the island of Shukoku has changed little since they were first introduced inthe 18th century. The beautiful indigo-on-white designs are still skilfully hand-painted by local craftspeople.

BUY YOUR OWN CERAMIC TREASURE

Pottery festivals provide an excellent opportunity to find unique ceramic souvenirs. Twice a year, in spring and fall, Tobe hosts the Tobe-Yaki Ware Festival, when some 60 stalls sell the town's eye-catching indigo-and-white ceramics. Mashiko also hosts annual major pottery fairs at the end of April, early May and in early November.

ANCIENT ART FORM

Ceramics-making in Japan started during the Jomon era around 15,000 years ago, with earthenware vessels decorated with distinctive rope-like patterns.

Painted by hand, each Tobe design is unique

TOBE

Lacquerware from Wajima often uses gold decoration

∧ Left to right: The most common lacquerware colors are black and red; traditionally, wood used for marquetry is not stained or colored.

伝統工芸品

DECORATIVE CRAFTS

Art in the everyday

In Japan there is no rigid distinction between arts and crafts—both have a long, distinguished history and are equally prized. Traditional decorative crafts still thrive throughout the country, with the most skilled practitioners revered as Living National Treasures.

Across the country you can visit markets and workshops brimming with an array of beautiful decorative crafts—some even offer the opportunity to try your hand at making your own. The following are some of most popular types.

LACQUERWARE

Glossy Japanese lacquerware (*shikki*) is a joy to behold. Originating over 5,000 years ago, it is made by covering wood with layers of lacquer (derived from tree sap) and then burnishing it to a smooth, lustrous finish. The elegant lacquerware from Wajima (Ishikawa Prefecture) displays beautiful techniques such as *chinkin*, inlaid with gold, and *maki-e*, decorated with metallic powders, while the area of Tsugaru (Aomori Prefecture) in the north of Honshu specializes in a technique that uses multiple layers of different-colored lacquers to create a mottled effect. Negoro lacquerware, from Wakayama Prefecture in west Japan, features an outer red layer that slowly wears away to reveal the black lacquer beneath. Quite apart from the artistic skills involved, a high degree of technical skill is required by artisans as the lacquer is poisonous until it dries.

MARQUETRY

West of Tokyo, the hot springs resort of Hakone (Kanagawa Prefecture) is known for its intricate marquetry (*yosegi-zaiku*), where paper-thin slices of local wood are used to create elaborate geometric designs. Traditionally used for puzzle boxes and bowls, *yosegi-zaiku* is being adopted by a new generation of artisans on everything from mobile phone cases to jewelry.

METALWORK

The neighboring towns of Tsubame and Sanjo in Niigata Prefecture have been centers of metalworking for centuries. The area's speciality is Tsuiki copperware, in which a single piece of local copperplate is hand-hammered into the shape of the desired object. Gyokusendo workshop in Tsubame is particularly special, having been designated an Intangible Cultural Property by Japan's Agency of Cultural Affairs.

PAPERMAKING

Made by hand from plant fibers, *washi* (Japanese paper) encapsulates *wabi-sabi* (*p72*) in its irregular, unique, and natural appearance. Used for items such as door screens and lampshades, it comes in many different types. *Hosokawa washi*, known for its strength and durability, is made from *kozo* (mulberry) fibers, and uses petals, grasses, and wood ash to create different colors and textures. *Sekishu-banshi*, made in Shimane Prefecture and valued for its toughness, adds Oriental paperbush, *gampi* (a clove-like bush), and fermented hibiscus roots to the mix.

DOLLMAKING

In Japan, dolls *(ningyo)* have a much wider cultural appeal than just as children's toys. Everyone buys papier-mâché *daruma*, roly-poly red dolls modeled after Bodhidharma, the founder of Zen Buddhism. These good-luck talismans are often sold with blank eyes: the idea is you paint in one eye when you set a goal and the other when the goal is achieved. Far more elaborate are *hina* dolls, dressed in the flowing, ornate robes of court nobles from the Heian Period (794–1185) and made for display during the *hina-matsuri* festival on March 3.

^ *Colorful* daruma *dolls are a symbol of perseverance and luck.*

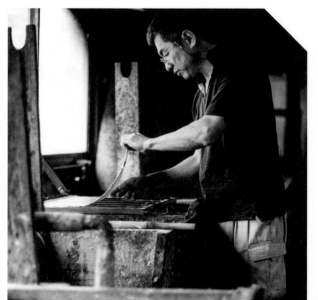

> Washi *has been made in Japan for over 1,000 years.*

89

KEY SKILL

Origami is taught in schools to help children learn geometry, spatial visualization and fine motor skills.

CLASSIC CRANES

A symbol of longevity, paper cranes are often left on hotel pillows or given away in shops.

PEACE SYMBOL

The paper cranes at the Children's Peace Monument in Hiroshima are donated from all over the world.

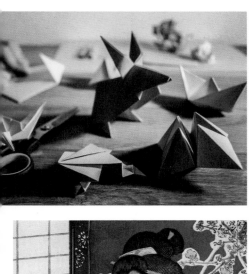

RELAX

Origami is widely recognized as a way to reduce stress.

折り紙

ORIGAMI

The art of paper folding

It starts with one simple fold, then another and another, until a single sheet of paper is crafted into an elegant design, all without the aid of scissors or glue. Originating in religious ceremonies, the practice of origami blossomed into an art during the Edo Period (1603–1868), when written instructions were published and sturdy *washi* (Japanese paper) became widely available. Interest waned at the turn of the 20th century, but was reignited by the fanciful creations of origami grandmaster Akira Yoshizawa. Today, origami is a popular hobby, and there are whole museums dedicated to the art—Nippon Origami Museum in Kaga (Ishikawa Prefecture) is the world's largest and one of the many places to take classes. Origami's techniques have also found unexpected uses in technical applications, such as rocket solar panels that can be folded for launch, unfurled in space, and then refolded for the return journey.

One of the most iconic origami designs is that of the crane. Considered auspicious in Japan, they are associated with the belief that anyone who can fold 1,000 cranes will have their wish granted. The most famous example of this story is Hiroshima's Sadako Sasaki, who folded more than 1,000 cranes in the hope of recovering from leukemia caused by the 1945 atomic bomb. She did not survive, but is memorialized at the Children's Peace Monument in Hiroshima's Peace Memorial Park, decorated with streamers of paper cranes.

‹ *The art of creating origami designs was first formally described in the book* Hiden senbazuru orikata (How to Fold a Thousand Cranes), *published in 1797.*

> *Japanese is traditionally written vertically, from top to bottom.*

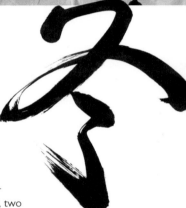

書道

CALLIGRAPHY

The way of writing

In the Western world, calligraphy *(shodo)* is associated with penmanship, but in Japan it's considered an art. The angle and pressure of the brush on paper, the gradation of the black ink, the journey of the stroke, and the position of the script all reflect the artist's pursuit of beauty and self-expression.

Japan had no form of writing system until Chinese ideograms, derived from pictographs, were introduced around the 5th century. Known as *kanji*, each Japanese ideogram has its own meaning or meanings, and they can also be combined to create new words. For example, 木 *(ki)* on its own means tree, but three together, 森 *(mori)*, mean forest. However, because the Japanese language—indigenous to Japan and unrelated to any other tongue—cannot be expressed entirely in *kanji*, two syllabic scripts were added. *Hiragana* is used for grammatical endings and some original Japanese words, while *katakana* is for all foreign words and names. Today's written Japanese is a combination of all three writing systems. Calligraphers, meanwhile, can choose from a variety of different *kanji* styles, including *kaisho* (regular block script), *gyosho* (semicursive) and *sosho* (cursive).

Japanese children study *kanji* throughout their time in school, and calligraphy is also part of the national curriculum—students are taught *shodo* from around the age of nine, and in high school there are often *shodo* clubs.

∧ *The* kanji *for "winter" in the* sosho *style of calligraphy.*

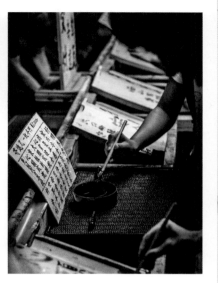

PUTTING BRUSH TO PAPER

In recent years, performance calligraphy has caught the imagination of teenage *shodo* clubs across Japan, in which participants write oversize calligraphy using big brushes in sync to music. The most famous contest is the annual Shodo Performance Koshien in Ehime Prefecture, which inspired the Japanese film *Shodo Girls: Watashitachi no Koshien* (2010).

Today, children and adults alike take private calligraphy lessons, while introductory courses for foreigners are available in Tokyo, Kyoto, and other cities. National museums and private galleries, such as the Tokyo National Museum and the Calligraphy Museum in Tokyo, stage regular exhibitions of calligraphy, and there are even ponds with *kanji* shapes, such as the one in Kyoto's Saihoji temple moss garden that is shaped like the *kanji* for "heart."

Writing a personal calligraphy for the New Year (*kakizome*) is a popular custom in Japan; traditionally the *kakizome* is burned two weeks later, and if the wind lifts the burning ashes it is said to be a sign that the skills of the writer will improve.

∧ *Traditional writing implements consist of a brush, ink, inkstone, and a water vessel.*

> *Early calligraphy styles were developed by Buddhist monks.*

革新的な日本

INNOVATIVE JAPAN

Japan is often associated with futuristic cityscapes from science fiction, and it's no wonder. Just visit Tokyo's Shibuya Crossing at nightfall and you might imagine you're on the set of another *Blade Runner* sequel. With more and more visitors coming to Japan, the country is eager to show off its forward-looking approach to technology. It's building a maglev Shinkansen bullet train between Tokyo and Osaka and a network of hydrogen stations for fuel-cell vehicles, and the government has launched a plan for a super-smart society, in which artificial intelligence, robotics, and big data will become ubiquitous, changing the lives of citizens. For travelers to Japan, however, it can be the little things that impress: a warm toilet seat; trains that run on time; an airport luggage receptacle that automatically sends your suitcases. Quirky but dependable, Japanese technology is always an eye-opening experience.

地図の上から

ON THE MAP

Exploring innovative Japan

Innovative technologies can be found everywhere in Japan, whether it's a heated table or an earthquake-proof vending machine. For an overview of science and engineering past and present, your best bets are museums in or near big cities, such as Tokyo's Miraikan and Nagoya's Toyota Commemorative Museum of Technology, while research centers like Science Square TSUKUBA will give you a taste of the future.

STIRRING SOUNDS
Renowned for its art museums, the island of Naoshima is also home to inspiring soundscape art installations (p110): Janet Cardiff and George Bures Miller's "Storm House" recreates a storm inside a traditional Japanese house.

^ ISLAND LINKS
Connecting Kobe on Honshu to Awaji Island, the Akashi Kaikyo Bridge is a wonder of engineering (p98) with a main span of nearly 1 mile (2 km).

4.2M

vending machines can be found across Japan—approximately one per every 30 people.

NAGOYA •

KOBE •

NAOSHIMA •

AWAJI •

< TITAN OF INDUSTRY
Centered on Nagoya, Japan's industrial heartland is home to the Toyota Commemorative Museum of Technology and Industry, and also the Toyota Kaikan Museum, where you can join a tour of ultra-efficient assembly plants staffed by industrial robots (p107).

OUT OF THIS WORLD

Japan's Hayabusa probe was the first to successfully retrieve samples from an asteroid in deep space.

⌄ WEATHER DEFENSES
The Metropolitan Area Outer Underground Discharge Channel is an underground flood-control facility that protects the capital (p100). Touring this spectacular structure feels like visiting an extraterrestrial cathedral.

‹ AT THE CUTTING EDGE
Science Square TSUKUBA is a showcase for innovation from the National Institute of Advanced Industrial Science and Technology, a major R&D center. Experience exhibits on robotics (p107) and other groundbreaking ideas.

TSUKUBA ●

KASUKABE ●

TOKYO ●

● **TSURU**

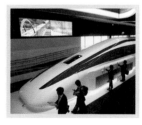

‹ INNOVATION HUB
The artificial island of Odaiba in Tokyo is home to Miraikan (the National Museum of Emerging Science and Innovation), as well as the Panasonic Center Tokyo, which displays futuristic lifestyle technologies and has a Nintendo gaming area.

› THE FUTURE OF TRAVEL
The next-generation maglev Shinkansen bullet train will travel about 300 mph (500 km/h), almost twice as fast as current models. You can watch test runs at the Yamanashi Prefectural Maglev Exhibition Center (p99).

SITTING COMFORTABLY?

Toilets in Japan can have as many as 30 control buttons for functions including bidets and seat warmers.

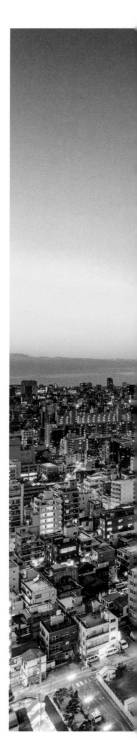

> The Tokyo Skytree
> dominates the
> capital's skyline.

エンジニアリングの驚異

ENGINEERING MARVELS

Forging cutting-edge beauty

Japanese engineers dream big. From super-fast trains to buildings that help you live longer, Japan has been at the cutting edge of engineering and design since the country began modernizing at the end of the 19th century.

A mountainous archipelago prone to earthquakes and typhoons, Japan has not only faced immense challenges when building infrastructure, but also has little in terms of natural resources. The Japanese, therefore, have had to adapt, design, manufacture, and export their way to prosperity. A dedication to high-quality craftsmanship and a willingness to invest huge sums of money in large, long-term projects have produced a modern nation with excellent infrastructure and a propensity for developing cutting-edge technology. Revolutionary technologies may be born abroad, but the Japanese will adapt them to their own needs, often with

innovative results. For example, the World Wide Web debuted in the US around 1993, but it was Japanese mobile carrier NTT DOCOMO that six years later introduced i-mode, the world's first service that allowed mobile phone users to surf the web and send emails.

DISCOVER TOKYO'S HIGHS AND LOWS

You can trace Tokyo's engineering prowess—from the subterranean depths of the Metropolitan Area Outer Underground Discharge Channel to the top of the Tokyo Skytree (*pictured*). The former is open for daily tours, while the latter offers 360-degree views of the city from its observation deck.

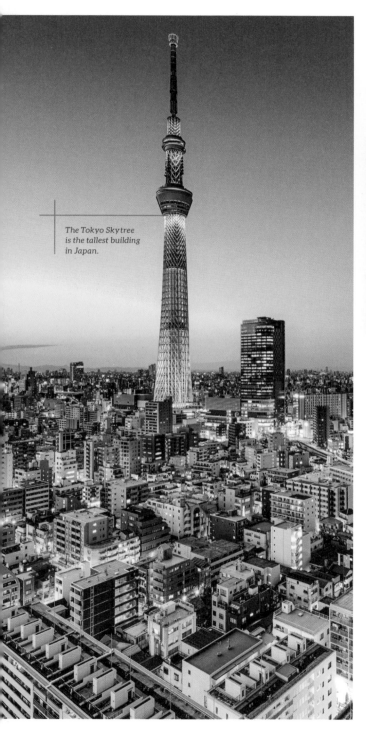

The Tokyo Skytree is the tallest building in Japan.

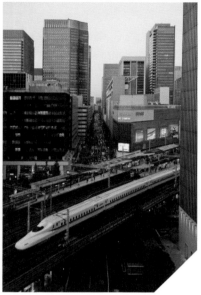

∧ Bullet trains connect Tokyo with most of Japan's major cities.

CONNECTING PEOPLE AND PLACES

One of the most visible examples of Japanese engineering prowess is the rail system. The Tokaido Shinkansen bullet train line reaches top speeds of up to 180 mph (285 km/h) and covers the 320 miles (515 km) between Tokyo and Osaka in a cool 2 hours, 22 minutes. It has a daily capacity of 360,000 passengers, and yet the average annual delay is less than 30 seconds per operational train. Despite having carried over 10 billion passengers since 1964, the Tokaido Shinkansen has had zero fatal accidents. Not one to rest on its laurels, operator JR Central is now building the Chuo Shinkansen, a maglev train that will travel at 300 mph (500 km/h), connecting Tokyo and Osaka in just over an hour.

> *The Metropolitan Area Outer Underground Discharge Channel is part of an important flood-control system.*

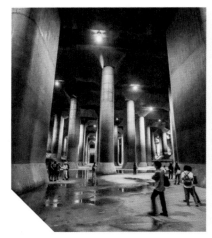

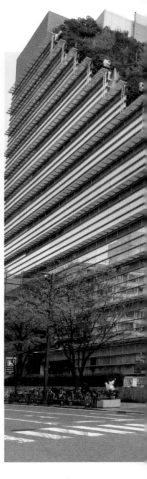

CHALLENGING ENVIRONMENTS

Underground spaces play a vital role in regulating river levels in Japan. On the outskirts of Tokyo is the Metropolitan Area Outer Underground Discharge Channel, otherwise known as G Cans. This mammoth sewer system, costing ¥230 billion and completed in 2006, is designed so that Tokyo can cope with the typhoons and severe rainy periods that are a feature of the capital's weather. The system consists of five colossal silos that are connected by a 4-mile (6.5-km) tunnel leading to a huge underground storage tank. This temple-like structure—58 ft (177 m) long, 256 ft (78 m) wide, and 82 ft (25 m) high—can pump out the equivalent of an Olympic pool in one second.

Above ground, the Tokyo Skytree— the world's tallest freestanding broadcast tower at 2,110 ft (634 m)—has taken inspiration for earthquake-proofing from Japan's centuries-old technology for building five-story pagodas. The pagoda's central column (*shimbashira*) does not physically support any stories, but instead acts as a counterweight around which the rest of the tower can vibrate; similarly, the Tokyo Skytree's core column was constructed separately from its surrounding steel frame. Oil dampers were also installed so that in the event of a quake, the shock can be absorbed. And just like actual trees, Tokyo Skytree is also supported by sturdy roots in the form of clusters of 165-ft- (50-m-) deep walled piles with steel-reinforced concrete nodes.

POPULATION PRESSURE

In Japan's population-dense cities, where land prices are astronomic, finding space to build homes is a pressing issue. This has resulted in architects designing so-called "skinny houses." One of the most famous examples is Tadao Ando's Row House, built in Osaka in 1976. At just over 10 ft (3 m) wide, this starkly simple concrete building has no windows (to enable privacy), instead allowing light in via a central open courtyard. A more recent iteration is Muji's prefab Vertical House, with a footprint of just 540 sq ft (50 sq m). The three-story home has no interior walls and doors, instead using the central staircase as a room divider.

The lack of space for building in cities also means that parks and communal green spaces are limited. One solution has been to design buildings that preserve and create as much green space as possible. A good example is the Acros Building in Fukuoka on Kyushu Island. Looking like a

∧ *The green roof of the Acros Building in Fukuoka (Fukuoka Prefecture) is part of a public park.*

ONE SOLUTION HAS BEEN TO DESIGN BUILDINGS THAT CREATE GREEN SPACE.

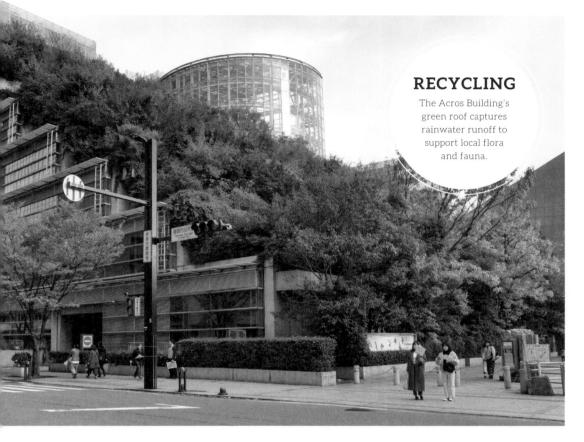

RECYCLING

The Acros Building's green roof captures rainwater runoff to support local flora and fauna.

∧ The Reversible Destiny Lofts, by Arakawa and Madeline Gins, aim to redefine life for the elderly.

contemporary Hanging Gardens of Babylon, the green roof also reduces the complex's energy consumption by keeping the temperature inside more constant.

The challenges of an aging population have also encouraged ingenious designs for Japan's built environment, such as the inventive Reversible Destiny Lofts in the Tokyo suburb of Mitaka. This rainbow-colored apartment complex is made up of stacked cubes, spheres, and tubes, with units featuring sunken kitchens, multiple levels, power outlets in the ceilings, and weirdly angled windows and walls. This is not just architectural eccentricity but a deliberate design to challenge residents, with the aim of helping to extend a person's life by constantly stimulating their senses.

ガジェット

GADGETS

Improving the everyday

Japanese gadgets for home and personal use are primarily about convenience, cleanliness, and engineering a solution to common problems, but they're often imbued with a spirit of fun. While outsiders might see items such as Thanko's full-face Pollen Blocker 2 visor-hood as "wacky," the Japanese prefer to describe them as "Galapagos" products. These unusual, homegrown technologies often struggle to thrive overseas, making them as unique to Japan as the species that evolved on the Galapagos are to that Pacific archipelago.

AMAZING APPLIANCES

Appliance manufacturers in Japan are always chasing the cutting edge while dealing with intense domestic competition.

∧ Washlet toilets are controlled by a panel next to the seat.

From the humble *kotatsu*, a low table with a heating element for relaxing in winter, to advanced induction-heating rice cookers, automatic shoe-deodorizing machines, body-scanning bathroom scales, and steam inhalers designed to mitigate allergies, Japanese homes are full of surprising products to assist with everyday life.

PUBLIC HYGIENE

Revolutionized by TOTO's Washlet series launched in 1980, Japanese toilets have functions you've never dreamed of, all in the name of cleanliness and comfort. Sometimes featuring dozens of buttons on their control panels, they can do everything from automatically opening lids to warming seats to cleansing and drying

INVENTED IN JAPAN

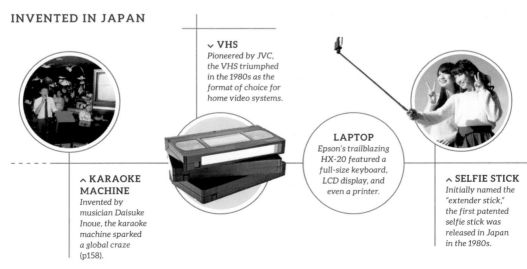

∨ VHS
Pioneered by JVC, the VHS triumphed in the 1980s as the format of choice for home video systems.

∧ KARAOKE MACHINE
Invented by musician Daisuke Inoue, the karaoke machine sparked a global craze (p158).

LAPTOP
Epson's trailblazing HX-20 featured a full-size keyboard, LCD display, and even a printer.

∧ SELFIE STICK
Initially named the "extender stick," the first patented selfie stick was released in Japan in the 1980s.

your posterior to shooting a mist over the bowl after every use, all while scrimping on water use. No visit to Japan is complete without hearing the noise of Otohime—audio functions or devices that play recordings of toilet flushes or running water to protect people's modesty while using the bathroom.

PHOTO FUN

Commemorate your time in Japan with a trip to one of the country's many *purikura*. These elaborate photo booths allow you to take pictures with friends and then embellish them with a wide variety of automatic digital edits and additions before the final sticker photos are printed; popular themes include cosmetics and fashion. As edit functions have become increasingly sophisticated, booths have expanded in size, with some as large as a compact car. Introduced in the 1990s and popularized by J-pop idol group SMAP, *purikura* are found in arcade centers throughout Japan and are particularly popular with teenage girls. Dedicated *purikura* shops sometimes also offer costumes for dress-up photos.

∧ Purikura *are a ubiquitous part of Japanese youth culture.*

CHINDOGU

The undisputed king of off-the-wall gadgets is Kenji Kawakami, creator of countless Chindogu ("strange tool") inventions. Designed to make people think and perhaps laugh, they include head-mounted toilet paper dispensers for allergy sufferers, portable crosswalks for pedestrians in a rush, and subway straps attached to toilet plungers for commuters needing something to hang onto. Kawakami describes them as a form of art.

CALCULATOR
The first handheld battery-powered electronic calculator was Canon's Pocketronic.

∧ **WALKMAN**
Sony's Walkman revolutionized the way people experienced music and sold an astonishing total of 200 million units.

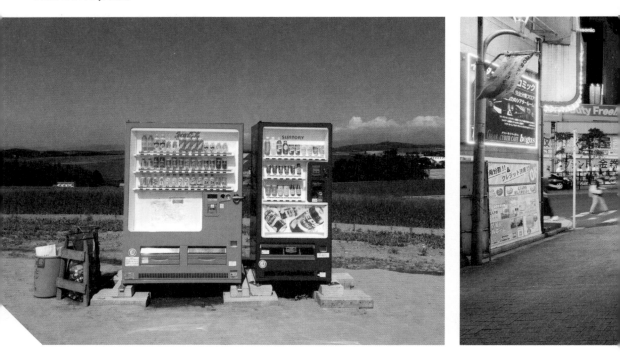

COMPLETE CONVENIENCE

From train stations to rice paddies to the slopes of Mount Fuji, vending machines can be found just about anywhere in Japan. With one of the highest vending-machine densities in the world, about one per every 30 people, they provide essential products to many Japanese. In a densely populated country with expensive, limited space for retail shops, vending machines are prized as convenient and always available.

FUTURE-FACING

Aside from their variety, vending machines in Japan deploy sophisticated technology. Developed by JR East Water Business, Acure vending machines possess a number of smart features. Found in Shinagawa Station and at other spots around Tokyo, they have touch-panel displays, are programmed to use data to estimate users' age and gender to suggest suitable drinks, and can be used to gift drinks to friends via

a smartphone app; they also accept smart card cashless payments, unlike many other machines.

To cope with power failures and other service disruptions amid Japan's frequent earthquakes, vending machines are also becoming more resilient. Some machines can operate on battery power or by a hand crank during blackouts, while others will dispense drinks free of charge during disasters. The 2011 earthquake that

^ Left to right: Vending machines can be found even in the middle of the countryside; accessible any time of day, vending machines are the epitome of convenience; drinks are one of the most common items for sale.

< Vending machines provide refreshments for hikers at the top of Mount Fuji.

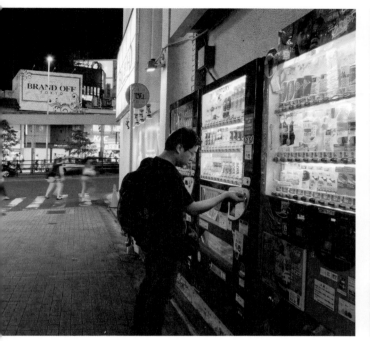

SOME MACHINES WILL DISPENSE DRINKS FREE OF CHARGE DURING DISASTERS.

devastated northern Japan affected electricity supplies and sparked a rethink of power use by vending machines. Vacuum-insulated vending machines, for instance, can go without cooling their drinks for 11 hours. Billed as the most energy-saving machines in Japan, Suntory's Eco Active Machines use half the electricity of vendors with standard heat-pump technology. Energy used by all machines was down 62 percent in 2017 compared to 2005.

EVERYTHING BUT THE KITCHEN SINK

Vending machines for coin lockers and tickets are a common sight, but other items you might come across range from batteries, umbrellas, and eyeglasses to floral bouquets, Shinto amulets, and underwear. Particularly popular are *gachapon*, which dispense capsule toys. Named for the sound of the dispensing mechanism, they spit out every trinket you can imagine, from miniature Tokyo Towers and Godzilla to fake sushi and bonnets for cats. One hit *gacha* is Koppu no Fuchiko, a female office worker in all kinds of odd poses, which has sold over 20 million units.

Nearly 60 percent of vending machines in Japan sell drinks, including beer, sake, milk, and green tea. Food is a smaller sales category, but it features some arresting items. You can buy bananas, bags of rice, *onigiri* (rice balls), *natto* (fermented soybeans), *takoyaki* (octopus balls), pizza, hotdogs and, of course, instant noodles. If that isn't unusual enough, head down to Kumamoto Prefecture, where you can buy chocolate-covered grasshoppers and other insect snacks.

1603–1868

Western clock technology is repurposed during the Edo Period to create automatons, today regarded as the forerunners of Japanese robots.

1928

Nishimura Makoto unveils the 10-ft- (3-m-) tall Gakutensoku, thought to be the first robot ever built in Japan.

1952

Osamu Tezuka's Astro Boy (known as Tetsuwan Atomu in Japanese) debuts as a comic strip in *Weekly Shonen Magazine*.

2017

Groove X's *kawaii (p124)* companion bot coos and closes its eyes when it is cradled, further advancing Japan's argument that robots can be warm and cuddly.

2014

SoftBank Robotics' Pepper has an emotion-recognition engine that can detect how humans are feeling.

2013

The 13-in- (34-cm-) tall Kirobo becomes the first humanoid robot to be sent into space.

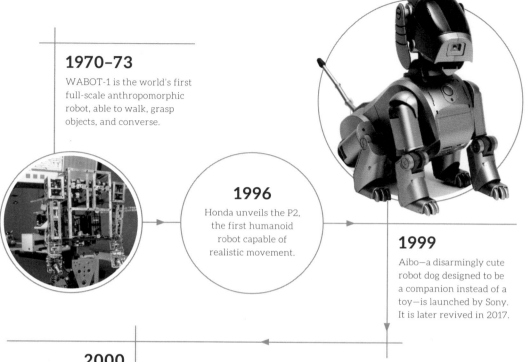

1970–73

WABOT-1 is the world's first full-scale anthropomorphic robot, able to walk, grasp objects, and converse.

1996

Honda unveils the P2, the first humanoid robot capable of realistic movement.

1999

Aibo—a disarmingly cute robot dog designed to be a companion instead of a toy—is launched by Sony. It is later revived in 2017.

2000

Honda's ASIMO is able to walk, run, communicate in multiple languages, and also serve tea.

ロボットの進化

ROBOT EVOLUTION

Development of intelligent machines

Japan loves robots. It's one of the most automated countries in the world, and leads in the development of intelligent machines for manufacturing and other applications. Advanced humanoid robots are working in Japanese shops, showrooms, and information centers, giving the world a glimpse of what's to come. This embrace of robotics has its roots in the deeply ingrained national respect for *monozukuri* (craftsmanship) as well as Japanese science fiction, in which robots are often portrayed as heroic friends to mankind—Osamu Tezuka's Astro Boy, an android imbued with superhuman powers as well as a soul, inspired generations of Japanese engineers to bring Tezuka's dream to life.

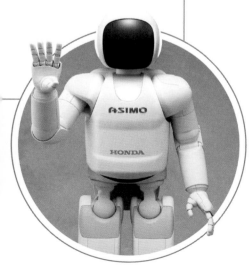

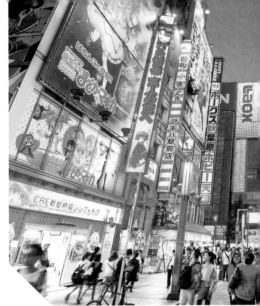

> Akihabara, Tokyo's "Electric Town," is a treasure trove for video-game lovers.

ビデオゲーム

VIDEO GAMES

Art, storytelling and technology

It's impossible to imagine the world of video games without Japan. The country has not only created countless iconic characters, but also revolutionized the way that people play. Companies like Nintendo, Sega, and Sony are household names, and their products are used by millions around the globe. Key to this success has been Japan's ability to create video games that are the perfect fusion of art, storytelling, and intuitive technology.

Although Japan began introducing arcade games in the late 1970s, the country's rise truly began in 1983, when a glut of bad

IT'S IMPOSSIBLE TO IMAGINE THE WORLD OF VIDEO GAMES WITHOUT JAPAN.

games caused the bottom to fall out of the American home console market. That same year, Nintendo's Family Computer, or Famicom, came out in Japan. Released internationally a couple of years later as the Nintendo Entertainment System (NES), it not only resurrected console gaming in America with an array of high-quality games, but also ushered in an era of domination by Japanese gaming companies.

Innovation is what Japanese gaming does best, such as the Famicom and NES's eschewal of Atari-style joysticks for dual button controllers with D-pads. Later Nintendo controllers had shoulder buttons, analog thumbsticks, and rumble feedback, all of which are now standard on modern game pads—even those from rivals.

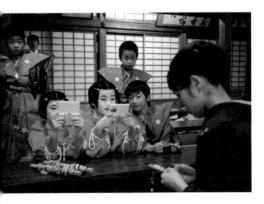

< Nintendo consoles continue to be popular around the world.

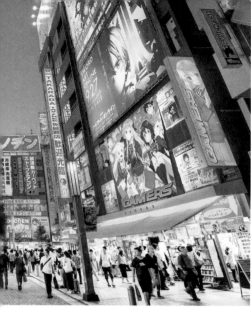

GROUNDBREAKING GAMES

> **PAC-MAN (1980)**
Originally called "Puck Man," Pac-Man was the first game character to capture the public's imagination, inspiring the top ten hit "Pac-Man Fever." The game's Ghost enemies featured incredible AI tech for their day.

< **STREET FIGHTER II: THE WORLD WARRIOR (1991)**
While not the first fighting game, Street Fighter II was a complex, pro-gaming bellwether that inspired players to master the memorable characters.

> **POKÉMON RED AND BLUE (1996)**
Released on the Game Boy, the first Pokémon became a global craze. It offered fulfilling gameplay outside the home, laying the foundation for modern smartphone games.

< **SUPER MARIO 64 (1996)**
This, along with The Legend of Zelda: Ocarina of Time, featured cutting-edge 3D graphics and gave players a newfound freedom to explore the in-game 3D world instead of confining them to a linear 2D platform.

> **FINAL FANTASY VII (1997)**
Utilizing the first PlayStation's CD-ROM format, this set the bar for role-playing games with cinematic 3D cutscenes, an epic story, and a beautiful score. It even went on to inspire a feature film.

< **WII SPORTS (2006)**
Nintendo created a worldwide phenomenon with its easy-to-use motion controllers. The Wii was not a high-powered, high-def console, proving that video game success isn't just dependent on the best graphics, but on good ideas.

GET GAMING

A video gamer's visit to Japan would not be complete without a trip to Akihabara, Tokyo's geek mecca, or Den-Den Town, Osaka's equivalent. Retro shops like Super Potato (found in both Tokyo and Osaka) are a must-stop for classic consoles and games of yore, while the latest releases can be found in big electronics stores.

While Japanese video games have pushed hardware and graphical boundaries, they are not mere technical exercises. Japan has created beloved characters like Mario and Sonic the Hedgehog, and developed games with stories that are genuinely moving, like PlayStation's *Final Fantasy VII*. The country has also popularized new ways of playing, such as music games and fitness games, and it has created distinct genres like survival horror (with games such as *Resident Evil*) and story-heavy Japanese role-playing games (like the *Kingdom Hearts* franchise).

音の風景

SOUNDSCAPES

A journey into sound

Tinkling bells such as the suzu are a common sound at shrines and temples.

SUZU

Ambient sound is everywhere, but it is such an important part of the essence of Japan that in 1996 the Ministry of the Environment created a list of the country's top 100 soundscapes (compiled from submissions by the public) in a novel move to both guard and champion the environment. Natural and man-made, whimsical and riotous, spiritual and commercial, Japan's amazing variety of soundscapes range from flowing and falling water, hissing steam, shifting ice, and local flora and fauna to temple bells, ship whistles, and ancient crafts. This appreciation of natural and historical soundscapes reflects the open-minded Japanese approach to sound in general, which has allowed innovative experimental music and aural art installations to become a significant part of the cultural landscape.

AURAL IMMERSION

Many of Japan's evocative sounds can be listened to as recordings from the comfort of your own home, but they are at their most powerful when experienced in person.

SOUND SCULPTURES

Japan excels at contemporary art, and soundscape art has long been one of the country's most inventive creations. Key artists include Ryoji Ikeda, whose performances and installations combine sound, visuals, and mathematical notations. Japan's art museums also have numerous sound installations within their collections, such as Christian Boltanski's *La forêt des murmures* and Janet Cardiff and George Bures Miller's "Storm House" at Benesse Art Site Naoshima (Kagawa Prefecture), which both feature traditional sounds recorded in Japan. Art and experimentation further cross over into the world of music, with the likes of Yellow Magic Orchestra, Ryuichi Sakamoto, and Cornelius manipulating sounds to create unique arrangements.

‹ *Weaving is one of several ancient crafts that appear on the top 100 soundscapes list.*

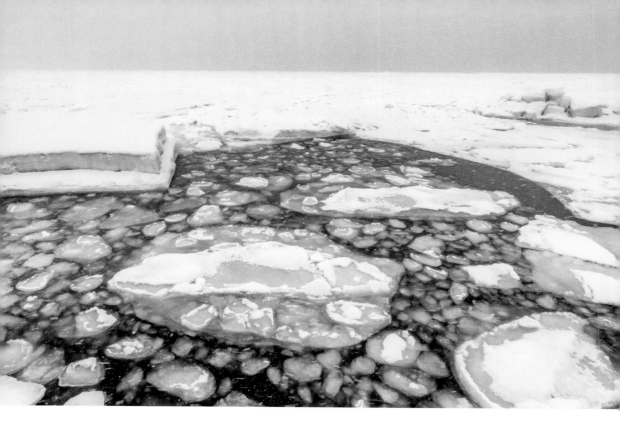

NATIONAL TREASURES

You can find a soundscape anywhere you go in Japan—you just need to pause a moment to stop and listen. The top sound on the Ministry of the Environment's list is drift ice in the Sea of Okhotsk, but more easily accessible options include the "singing" sands at Kotobikihama Beach (Kyoto Prefecture), Sapporo's Clock Tower bells, and the hubbub of red-crowned cranes in Tsurui (Hokkaido). One of Japan's most fun sounds are the nightingale floors at Nijo Castle in Kyoto—designed to act as an alarm system for the samurai, they chirp when walked upon.

YOU CAN FIND A SOUNDSCAPE ANYWHERE YOU GO IN JAPAN—JUST PAUSE TO LISTEN.

∧ Top: Drift ice in the Sea of Okhotsk is Japan's favorite sound. Above: Ryuichi Sakamoto is one of Japan's leading experimental musicians.

クリエイティブな日本
CREATIVE JAPAN

Japan is a land of contrasts: from a unique juxtaposition of tradition and innovation spring forth creative, fascinating trends that continue to unfold, influence, and inspire. Arising from the richness of spirituality, art forms, and traditional aesthetics, Japanese creativity draws deeply from the well of the past. Sometimes the evolution is clear—like the thread winding from 19th-century woodblock prints to postwar Pop Art and manga. In other cases, the legacy of Japan's traditions is more subtle, harking back to deep and intrinsic values—like the reverence for nature seen in modern architecture, or the survival of *shibui* (simplicity) in modern product design. Whatever the inspiration, it is the new heights of creativity growing from these roots that have made Japan such a key figure on the world stage of artistic expression.

地図の上から

ON THE MAP

Exploring creative Japan

Just set off down the street and you'll feel the creative spirit of Japan like a living entity all around you. It's in the breathtaking designs of the architecture, the *kawaii* (cute) mascots in posters and ads, and the displays of high fashion and chic homeware in shop windows. The whole country becomes a gallery showcasing the newest offerings of Japan's influential art and style.

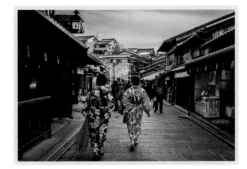

⌄ KYOTO IN A KIMONO
If you've always been fascinated by traditional Japanese clothing (p127), Kyoto is the place to be. Kimono rental is big business here and there are plenty of places to choose from to try on these elegant traditional robes.

FALL IN LOVE WITH KUMAMON!
Kumamon the black bear is the yuru-kyara *(mascot) of Kumamoto (p125). Snap a selfie with this charming celebrity at Kumamon Square.*

KYOTO ●

HIROSHIMA ●

● **KUMAMOTO**

❯ A VISION FOR A PEACEFUL FUTURE
To see the works of architect Kenzo Tange (p116), visit the Hiroshima Peace Memorial Museum. The museum is a modern twist on haniwa, tombs of Japanese rulers.

DAILY READING

The daily paper with the highest circulation in the world is Japanese—as is the second highest.

ONAGAWA

● SAPPORO

● ONAGAWA

⌄ **INSIDE AND OUT IN HOKKAIDO**
Inside the Hokkaido Museum of Modern Art you'll find stunning Japanese contemporary art. Nearby is the magnificent sculpture park Moerenumakoen (p121).

● TOKYO

● FUJI

ANIME WORLDS
The Fuji-Q Highland theme park has several areas dedicated to popular anime.

±0

Naoto Fukasawa's ±0 homewares line brings sleek contemporary design to items such as toasters, coffeemakers, clocks, and earphones.

⌃ **ANIME ATTRACTIONS**
Head to one of Tokyo's three Pokémon Centers to shop 'til you drop. Have your photo taken with the amazing displays and pick up regional merch not available anywhere else (p134).

建築トレンド

TRENDS IN ARCHITECTURE

A marriage of the traditional and modern

∧ The building-block style of the 1972 Nakagin Capsule Tower is reminiscent of organic cells, bringing Metabolism alive as a visual concept.

The connections between traditional, wooden Japanese architecture and the concrete, glass, and steel creations that cover the country today may not be immediately apparent. But look closer and you'll notice the timeless Japanese qualities of exacting precision and craftsmanship. Setting the contemporary structures apart is their innovative use of design and natural materials, be it in service of stark minimalism or soaring flights of fancy.

METABOLISM

One influential trend was Metabolism, an architectural movement that emerged in postwar Japan and sent forward-thinking architects down a new path. Championed by the likes of visionary architects Fumihiko Maki, Kenzo Tange, and Kisho Kurokawa,

the Metabolist movement saw cities as changing entities that needed to grow and develop like the human body. You can still see Kurokawa's iconic Nakagin Capsule Tower in Tokyo, and while it's one of the few remaining Metabolist structures in Japan, you can experience the movement's enduring legacy by staying in an ultramodern, ingeniously designed capsule hotel. The first of its kind was Kurokawa's Capsule Inn Osaka, which opened in 1979 and was heavily influenced by the Metabolist concept.

BACK TO NATURE

Some of the most stunning contemporary structures in Japan are those that blend natural materials with ultramodern designs, creating architecture that feels new and yet

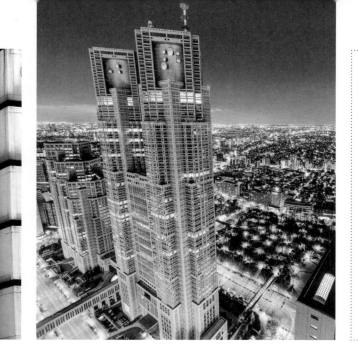

TOWERS OF THE TOKYO SKYLINE

Tokyo Tower (1958, Tachu Naito) A symbol of Japan's postwar boom, this bright broadcasting tower is a key landmark rising above the city's clustered skyscrapers

Tokyo Metropolitan Government Building (1990, Kenzo Tange) This twin-towered building complex *(left)* is an iconic sight to the Japanese.

Tokyo Skytree (2012, Nikken Sekkei) In sharp contrast to its neo-futuristic style, the tower's illuminations evoke the traditional aesthetic concepts of *iki* (style) and *miyabi* (elegance).

traditional. Many of these are found in natural settings, harking back to Japan's traditional appreciation for nature and the four seasons.

EXPLORING MODERN ARCHITECTURAL MARVELS

Jikka House This private retirement home sits on a hilltop surrounded by woodland in Shizuoka Prefecture. A cluster of five teepees clad in cedar panels, the home was designed by Issei Suma for his mother and her companion, who also wanted to use the building as a community café.

Tetsu Tea House This highlight at the Kiyoharu Shirakaba Museum in Hokuto (Yamanashi Prefecture) was designed by Terunobu Fujimori. Taking its use of traditional materials to the next level, it uses a single cypress trunk as support for the suspended treehouse, and can sway safely during storms and earthquakes. Other organic designs by Fujimori include homes whose chimneys are planted with pines and whose roofs are covered in leeks and chives.

Ribbon Chapel The award-winning Ribbon Chapel designed by the firm NAP stands in the garden of the Bella Vista Spa & Marina in Onomichi (Hiroshima Prefecture). Inspired by a flying ribbon, it has two spiral stairways that intertwine and support each other—a visual metaphor for the act of marriage.

˅ *The striking design of the Ribbon Chapel links the elements of earth and air.*

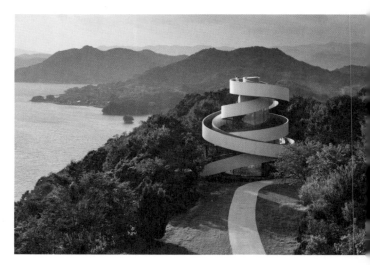

> The Japanese concept of shibui *(simple and modest beauty)* has carried over from traditional folk crafts to modern design.

モダン スタイル

MODERN STYLE

The elegance of simplicity

The design of household objects and furniture tends to focus on function and practicality in an increasingly fast-paced world. And yet, in Japan, traditional aesthetic concepts like the subtle beauty of *shibui* and the refinement of *iki (p73)* still have a profound impact on contemporary designers. Preserving these styles has allowed Japanese products to strike a fine balance between the artistic and the everyday, meaning the beautiful qualities of Japanese design survive and stand out even in an era of global mass production.

FOLK CRAFT REVIVAL

The production methods and attentive care behind Japan's traditional crafts could easily have been lost in the transformative industrial years of the early 20th century. But the old styles of ceramics, textiles, and other everyday crafts survived in the form of *mingei* (folk crafts). This is truly the people's art—so much so that the creators of *mingei* are usually anonymous.

It was primarily due to the efforts of art critic and philosopher Soetsu Yanagi (1889–1961) in the 1920s that this strand of traditional design was protected. Yanagi valued artistic concepts celebrating the simplicity and utilitarian aspect of everyday objects—particularly inexpensive, functional, and rustic crafts. He gathered together key examples to establish the Japan Folk Crafts Museum in Tokyo in

EVERYDAY ART

To turn a corner of your home into a modern, stylish gallery that's still a useable household space, seek out some pieces by Nendo. This award-winning design studio was established by Oki Sato in 2002, and creates everything from furniture and household products to graphic designs.

< *The Butterfly Stool is so called because of its fluid, curvaceous shape, reminiscent of a butterfly in flight.*

THE EPITOME OF MODERN DESIGN

Founded in 1980, MUJI has become the face of contemporary Japanese design. Natural colors and textures evoking traditional aesthetics are a key ingredient in the company's beautifully designed yet functional and accessible products. Short for *Mujirushi Ryohin* ("no-brand quality goods") its products—which include furniture, clothing and stationery—are known for their chic, simplified design and lack of logos. Since 2001 MUJI's art director has been the designer Kenya Hara, who has taken the company's ethos into new business areas including hotels and prefabricated homes.

1936, which remains one of the best places to see classic examples of *mingei*.

INFLUENCE FROM ABROAD

While Japan's traditions were carefully preserved by some designers, other artists were also exploring further afield for inspiration. Soetsu Yanagi's son Sori (1915–2011) was a notable designer in his own right. His most famous creation, the Butterfly Stool, combined the Japanese art of origami with plywood molding techniques developed by American designers Charles and Ray Eames. Sori Yanagi's elegant modern designs were also influenced by Le Corbusier and Charlotte Perriand, in whose office he worked during the 1940s.

> *Like the creators of mingei, the designers of MUJI products are often anonymous, to maintain the generic branding.*

119

現代アート

CONTEMPORARY ART

Redefining art in postwar Japan

Modern art in Japan was born from the ashes of World War II. Free from military rule, artists began to re-create the concept of art in the same way that Japan itself was going through a reconstruction on a national scale. The new generation of creators embraced performance art, explored figurative movements like Surrealism, and eschewed traditional galleries for the street, the stage, and the screen. From these bold origins full of avant-garde experimentation, Japan has become an inspiring artistic force.

POP ART REVOLUTION

Japan's version of Pop Art evolved from the nation's experimental art scene of the 1950s. In a society that had experienced both cultural censorship and great devastation, Pop Artists of this postwar, avant-garde era were a great force for change and freedom, adding a sense of cultural playfulness to the new wave of artistic expression.

Japanese Pop Art is now iconic. Takashi Murakami's rainbow-colored paintings, sculptures, and designs have been taken up by fashion firms including Louis Vuitton and Issey Miyake, making his Pop Art style a truly global phenomenon.

PIONEERING PHOTOGRAPHY

Artists in Japan embraced photography almost from its inception, but during World War II only pro-government

ⅴ The Hakone Open Air Museum (Kanagawa Prefecture).

^ *Takashi Murakami*
Multicolour Flowers,
2012.

OUTDOOR ART
The natural world and the four
seasons have always been an
inspiration for the country's artists.
Here are three of the best sights to
experience the quintessentially
Japanese blend of art and nature.

① *The Hakone Open-Air Museum*
In the hot-spring resort of Hakone
(Kanagawa Prefecture), this park
became the blueprint for similar
sights across Japan when it opened
in 1969. Across the gardens are
scattered hundreds of bold and
larger-than-life works from both
local and international artists.

② *Moerenumakoen*
This park occupies a former
landfill site outside of Sapporo
(Hokkaido Prefecture). Explore
how the artists have merged man-
made installations with the natural
elements to create ingenious and
dramatic works of art.

③ *Enoura Observatory*
This sight in Kanagawa Prefecture
is the passion project of renowned
photographer Hiroshi Sugimoto.
Looking out over Sagami Bay from
the observatory feels like stepping
into one of his extraordinary
seascape photographs.

photojournalism was allowed. Some iconic
photographers, such as Ken Domon, were
still active during this era, but it was in the
postwar years that many artists took to
photography again. Grasping their
newfound artistic freedoms, they
experimented with the medium and
focused on new subjects, changing the
purpose and course of photography
and gaining international reputations.

In the late 1960s, the small press
photography magazine *Provoke* helped
launch the career of Daido Moriyama.
Moriyama pushed the boundaries of
street photography by capturing the
beauty of the mundane, creating a
subversive narrative to the street scenes,
and inviting viewers right into the action.

草間 彌生

YAYOI KUSAMA

Polka-dot pioneer

Best known for her polka-dot–plastered paintings and larger-than-life installations, Yayoi Kusama came to the fore as a key Pop Artist of the 1960s. From her early days seeking creative freedom in postwar Japan, her outlandish performance art and innovative paintings propelled her to international fame.

Kusama's brightly colored polka-dot installations explore ideas of scale and infinity, and many are also inspired by her experiences with anxiety and depression. Her use of repeating patterns references her obsessive-compulsive disorder and hallucinations in which she sees lasting after-images on the surfaces around her.

You can find Kusama's works in galleries around the world—most notably the dedicated Yayoi Kusama Museum in Tokyo—but the best way to experience her works is to visit the Benesse Art Site Naoshima on the island of Naoshima (Kagawa Prefecture). Here works such as Kusama's instantly recognizable *Yellow Pumpkin* sculpture fill the island and create a bold and imaginative world where art reigns supreme.

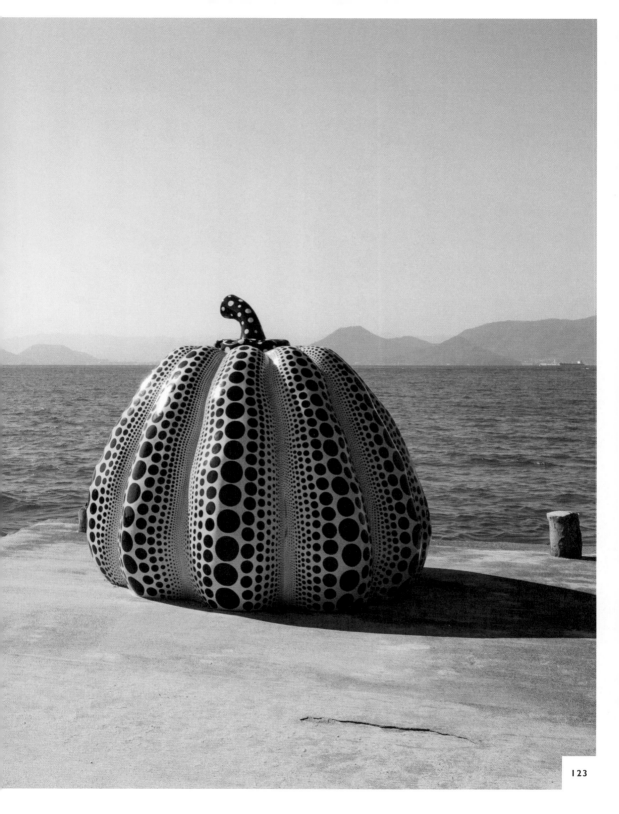

> Left to right: Hello Kitty has become a global media franchise; the Sanrio Company is worth about $62 billion; Piipo is the face of the Tokyo police force; over 1,000 mascots enter the annual Yuru-Kyara Grand Prix.

カワイイ

KAWAII

The power of cute

The impact of the candy-colored, picture-book aesthetic of *kawaii* on Japan's design industry is profound. The *kawaii* style has been applied to all kinds of products and images, resulting in striking fashions and a universe of cute characters and mascots adorning practically everything from handbags to *shinkansen* trains.

THE BIRTH OF *KAWAII*

As the popularity of manga *(p134)* grew in the 1950s and 60s, young Japanese people began to embrace the exaggerated, cute style of the characters. The taste for these images fed through to consumer culture and resulted in the birth of the global queen of *kawaii*—Hello Kitty. The little white cat was designed by Yuko Shimizu in 1974 to join the cast of characters decorating the fashion and lifestyle products of the Sanrio company, which

now includes fan-favorite characters such as Little Twin Stars, a brother and sister duo, and Gudetama, an egg yolk. Sanrio's designs and marketing are so amazingly successful that even a social media campaign using fictional high school boys to promote the company's products ended up with its own line of merchandise, as well a stage play, a manga, and an anime.

KAWAII STYLE

Embrace all things *kawaii* with a trip to Tokyo's Harajuku district, where you can pick out a small souvenir of the country's cuteness culture, or bring more *kawaii* into your life with a full wardrobe update. The street style that made Harajuku famous is still there *(p130)*, but has also spawned something more commercial. Boutiques and shops to zone in on include sanrio vivitix for Sanrio characters, and Kiddyland,

ピーポくん110

杉並区立小学校ＰＴＡ連合
杉並区立中学校ＰＴＡ
杉　並　区　教　育　委
杉並警察署・高井戸警察署・荻

中央青少年育成委員会

NHK's Domo is one of Japan's most famous yuru-kyara.

DOMO

a multistory toy shop stocking cute character goods. Another highlight is 6% DokiDoki: a bubblegum-pink emporium of vividly colored fashions and accessories. This rainbow-bright boutique is the brainchild of artist and art director Sebastian Masuda, whose projects have included the installation of tall translucent sculptures of Hello Kitty stuffed with personal objects in cities around the world, part of an art project called *Time After Time Capsule*.

MASCOTS

Japan's love for *kawaii* has been embraced by businesses and institutions, who create their own mascots similar to those of sports teams. These mascots are known as *yuru-kyara*—meaning "loose" or "relaxed" characters—and you'll see them all over the country. Some are corporate characters promoting everything from the national broadcaster NHK to Tokyo's police force, and others are created by local authorities to drive tourism.

The public can vote for their favorite mascots in the annual Yuru-kyara Grand Prix. While the event is lighthearted and fun, it's also serious business for the companies who enter their *yuru-kyara*—the winners often get a huge boost in revenue from all the publicity.

JAPAN'S LOVE FOR *KAWAII* HAS BEEN EMBRACED BY BUSINESSES AND INSTITUTIONS.

KIMONO ART

Museums with great kimono exhibits include the Itchiku Kubota Art Museum in Kawaguchiko (Yamanashi Prefecture) and the Kioi Art Gallery and Ome Kimono Museum, both in Tokyo.

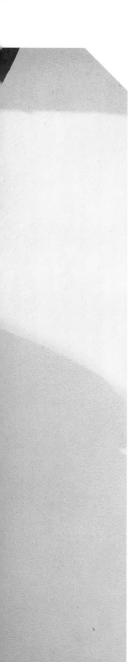

< *Clockwise from top left: Tokyo Fashion Week is a showcase for Japanese style; the fabric used for women's kimonos is often hand-painted; Harajuku girls are famed for their flamboyant style.*

ファッション

FASHION

Traditional elegance to the avant-garde

Dominated for centuries by the kimono, Japanese fashion underwent a seismic shift with the introduction of Western-style clothes *(yofuku)* in the 20th century. Both taking inspiration from and rebelling against traditional garments, designers and fashionistas have evolved an excitingly eclectic array of modern Japanese styles.

A COMPLEX SIMPLICITY

The traditional form of dress in Japan, the kimono (literally, "garment to wear") can be dated back to the 700s. It was used to denote status, with quality materials like silk reserved for the elite and cotton and hemp used for the masses. The more of your body that was covered, the higher rank you were seen to be. Workers would wear simpler outfits, but they would still be based on wrapping and folding, a technique of dressing inspired by the Chinese and expertly mastered by the Japanese.

The intricate process of dressing in a kimono involves layering, traditional folding, and careful placement of accessories. Essentially, the garment is wrapped tightly around the body—with the left side folded over the right side (right over left is how the deceased would be dressed)—and tied in place with the *obi* (sash); accessories are then draped, tied, and folded over it. Often the services of a kimono dresser are required, especially for women's kimonos.

Today, few people wear a kimono as an everyday garment, but you can still glimpse them on the streets of Kyoto and traditional villages such as Takayama (Gifu Prefecture) or *onsen* towns *(p211)*. Kimonos are also worn to celebrate rites of passage such as *shichigosan* (the lucky ages of three, five, and seven), *seijin-no-hi* (coming of age at 20), and marriage, as well as for festivals and tea ceremonies, and during cherry-blossom viewing *(p14)*.

127

DECONSTRUCTED ELEGANCE

Taking cues from a history of intricate design, new makers started to emerge in the late 20th century with a unique approach to garment construction. Building on centuries of masterful manipulation of materials, a restless and inventive youth used the traditional techniques of draping, folding, pleating, and accessorizing to create an alternative fashion with the power to shock and innovate. Staging some of the most startling and game-changing catwalk shows in couture history—such as Comme des Garçons Spring collection in 1982—Japanese designers have literally transformed the shape of couture fashion.

VISIONARY DESIGNERS

Blurring the line between clothing and art, the following designers are some of the most influential figures in the world of Japanese fashion.

Issey Miyake Miyake's Pleats Please label turned pleating into a religion. Wearable and sophisticated, his garments provide a timeless, refined look for women and men of any age.

Rei Kawakubo Kawakubo's designs for her Comme des Garçons label are cut from the rebellious and creative spirit of Japanese youth culture. Her clothes are angular, torn, organic, and flowing—quite unlike anything else. Those who can pull them off look otherworldly.

Junya Watanabe Kawakubo's protégé (and pattern maker), Watanabe followed in his mentor's footsteps as a fashion innovator. He uses synthetic fabric and technology to create futuristic wearable art.

Yohji Yamamoto A master tailor and fabric manipulator, Yamamoto studied law before becoming one of the world's best-known designers. His origami-like structured outfits firmly placed Japanese avant-garde on the world stage.

⌄ *Left to right: Junya Watanabe's designs have been described as "techno couture"; Rei Kawakubo's Comme des Garçons creations have inspired designers around the world.*

STYLE ICONS

As Tokyo and Osaka became hotspots for fashionistas the world over, street fashion in turn began to influence designers. Today's style icons have huge followings on social media, with popular figures including cool grandma Emiko Mori, joyous in colorful crocheted outfits; Coco Pink Princess, a mix-and-match youngster who will happily clash high-end labels and secondhand finds; and Mr. Bon and Mrs. Pon, a couple in their sixties who color-coordinate their stylish androgynous outfits. Twin sister music duo Amiaya are also major trendsetters, and you can't go to Japan without seeing Rola, a model and personality who became the muse of Gucci, splashed on a billboard somewhere.

∧ Trendsetting style icons Amiaya with their bold, coordinated looks.

> JAPANESE DESIGNERS HAVE LITERALLY TRANSFORMED THE SHAPE OF COUTURE FASHION.

BUY A PIECE OF WEARABLE ART

If you're shopping for high-end fashion in Japan, there's no better place to start than the wide boulevards of Tokyo's Ginza district, which plays host to some of the world's most elaborate and luxurious retail monoliths. Omotesando, stretching down to upscale Aoyama, is another definite hotspot, as are upmarket department stores such as Takashimaya in Nihonbashi and Isetan in Shinjuku. The hip Daikanyama neighborhood also has lots of refined independent fashion shops. In Kyoto, the best stores to head to are Bal and Isetan, while Chiso offers couture kimonos.

Voluminous petticoats are a key part of Lolita fashion.

FASHION PILGRIMAGE

One Sunday a month, devotees gather for the Harajuku Fashion Walk to celebrate the area's fashion culture.

∧ *Left: A large quiff is an essential aspect of the Rockabilly style. Right: The Lolita look ranges from the cute Sweet variation (top) to the darker Gothic.*

CONFOUNDING EXPECTATIONS

Offbeat, challenging, and endlessly fascinating, Japanese alternative fashion has influenced major designers all over the world and inspired countless Western songs and videos. If Japan is the street style capital of the world, then Tokyo's Harajuku and Shibuya districts are the mecca for anyone wanting to discover the more unusual side of the country's fashion tastes. Although most people will be wearing the global brands and ordinary clothes you'll find anywhere else in the world, these districts are still your best chance to see the creative legacy of Japan's experimental fashion, and the streets can become a pavement catwalk of eye-catching styles that function as the ultimate form of artistic expression.

KEY STYLES

Japan's alternative street styles come in all shapes and forms. The following are some of the most popular that have burst onto the scene over the last few decades.

Rockabilly This exaggerated version of 1950s American fashion is particularly popular with 50- to 60-year-old men, who meet in Tokyo's Yoyogi Park on Sundays.

Dolly Kei Taking inspiration from European fairy tales, girls (and guys) dress themselves up in a style that is reminiscent of antique European dolls.

Fairy Kei This over-the-top feminine style is a multilayered confection of vivid pastel colors with a touch of the 1980s.

Lolita Victorian and Edwardian children's clothes are the basis for this fashion, which is so popular it has spawned numerous subgroups, including goth and steampunk.

Left: The Ganguro look was inspired by LA surfer style. Below: Tokyo's youth gather in Harajuku on weekends to show off their latest outfits.

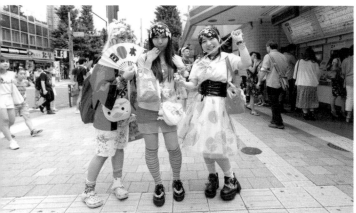

JOIN THE ALTERNATIVE REVOLUTION

Tokyo's Harajuku is the spiritual home of street fashion in Japan, and Yoyogi Park comes alive on Sundays with gatherings of style tribes en masse. Osaka's street scene is fiercely independent from Tokyo—it's louder and much more outrageous (think glitter and bold prints)—and Shinsaibashi is its center. Okayama (Okayama Prefecture) is famous for great-quality engineered denim, while Kyoto is notable for modern, inventive takes on traditional clothing. Sapporo's Tanukikoji shopping street is a catwalk for locals showing off local vintage-themed street styles.

Gyaru/Ganguro Translating as "girl" or "gal," this subculture is a celebration of all things feminine, involving high boots, loud clothes, thick makeup, heavily tanned skin, dyed blonde hair, and outrageous nails.

Harajuku Girls Part punk, part *kawaii* (p124), this look evolved post World War II and has been popular ever since. "Harajuku Girls" is also used as a broad term for Tokyo youth that congregate in the Harajuku area.

Kogal This rebellious take on school uniform features shortened skirts and loose socks. It is commonly adopted by high school girls, who hang around Shibuya's 109 building.

Mori This whimsical and stylish subculture is personified by the fashion label Earth, Music, Ecology. The look is elfin floaty chic, featuring long dresses and long hair, accompanied by longing, wistful looks.

Left: Kogal fashion is based on Japanese school uniform. Above: Mori style involves lots of floaty layers.

文学

LITERATURE

Poetry and popular novels

Japan's profound literary legacy has captured the imagination of writers and readers around the world. The haiku challenges us to draw meaning from every word of its short form, while the novel itself was born in Japan and is now one of the most important mediums of Japan's long history of storytelling.

HAIKU

Japan's most famous poetic form—the haiku—was originally the opening verse of a much longer poem. The traditional haiku was a short three-line stanza of 17 syllables, and was meant to work as a complete scene. It required great skill to condense an event or feeling to such a short form, so the haiku became popular as a stand-alone poem.

Japan's best-known haiku poet is Matsuo Basho (1644–94). Despite his fame, Basho preferred a simple life and spent most of his time traveling around

< Basho traveled alone, seeking the peace and contentment he couldn't find in the city.

Japan, writing about everyday experiences. Basho combined literary sensibilities with a down-to-earth approach, and his haiku are famous for distilling a feeling or moment to its very essence.

Though the three lines and 5-7-5 syllabic structure are the best-known features of haiku, there are other important elements: the *kigo* is a word indicating a season, while the *kireji* (cutting word) adds emotional effect or interrupts the stream of thought. Plenty of modern poets ignore these formal constraints, though, preferring a style called *jiyuuritsu* (free form)—and even the old masters ignored the rules sometimes.

A BASHO HAIKU

Basho wrote his most famous haiku in the late 17th century:

> *furui ke ya*
> *kawazu tobikomu*
> *mizu no oto*

There have been many translations of this poem, such as this one by Lafcadio Hearn from 1898:

> *Old pond*
> *frogs jumped in*
> *sound of water*

The popularity of this simple yet elegant poem has endured because of the clear image it paints, the sense of immediacy, and the unpretentious playfulness.

∧ Top row from left:
illustration of Lady Murasaki; painting of a scene from the Heike Monogatari; *portrait of Soseki Natsume. Bottom row from left: Ryunosuke Akutagawa; a selection of Haruki Murakami Novels; Banana Yoshimoto*

THE BEST OF JAPANESE LITERATURE

From its early roots in oral storytelling to the popular novels and manga of today *(p134)*, Japan has produced a constant stream of incredible tales and thoughtful works across the centuries. Fall in love with Japanese literature by taking a journey through some of its most famous works.

1. Genji Monogatari, Murasaki Shikibu (c 1020): Written in the eleventh century, *The Tale of Genji* may be the world's first novel. It reflects the refined life Murasaki Shikibu would have experienced as a lady-in-waiting of the imperial court.

2. Heike Monogatari (c 1330): This military epic recounts the defeat of the Heike clan in the Genpei War (1180–1185). It explores themes of impermanence, honor, and justice, and is important both as a classic work of literature and a historical source.

3. I Am a Cat, Soseki Natsume (1905): Narrated by a cynical housecat, *I Am a Cat* turned a satirical eye on the way Japanese and Western cultures were mixing in the Meiji era *(p31)*. It was Soseki's first major work, setting him on the path to becoming one of Japan's most influential writers.

4. In a Grove, Ryunosuke Akutagawa (1922): This is one of the best-known short stories by Akutagawa, whose name was given to a prestigious Japanese short-story prize. It blends Japanese themes with the more Western styles of modernist literature.

5. Norwegian Wood, Haruki Murakami (1987): The modern master of the Japanese "I" novel—a style of first-person confessional literature—Murakami became a literary sensation both in Japan and abroad after the release of this lyrical, elegiac yet critical look at the youth movement of the 1960s.

6. Kitchen, Banana Yoshimoto (1988): A hit both in Japan and abroad, *Kitchen*'s simple style is reminiscent of traditional Japanese poetry. Yoshimoto uses everyday domestic scenes to reflect on big issues such as grief, societal expectations, and the loneliness of modern Tokyo life.

∧ *Left to right: The Choju-giga scrolls are viewed as Japan's first manga; Astro Boy was the first anime to be aired overseas and has since inspired several films.*

漫画とアニメ

MANGA AND ANIME

A global phenomenon

Since the end of World War II Japan has developed enormous industries in comics and animation. Loved for their imaginative characters and complex plots, these exciting media are a modern incarnation of Japan's deeply held tradition of storytelling.

THE EVOLUTION OF MANGA

Manga and anime are the Japanese words for comics and animation, respectively. Some argue that manga has deep roots in the country's earlier art forms, harking back to illustrated scrolls and the *ukiyo*-e of the Edo era (*p84*). However, the clearest

forerunners of manga were Japan's first colorful comic strips, developed in the years before World War II.

The postwar years saw the rise of story comics, printed in monochrome on rough paper—which remains the standard today. The comics are released first in thick manga anthology magazines, before being compiled as *tankobon* (book volumes) to unite the whole story in one collection.

Whether you're a die-hard fan or eager to learn, the Kyoto International Manga Museum is a must-see stop providing a fascinating tour of manga history. The real highlight, though, is the museum's library, and gazing up at the thousands of colorful *tankobon* on these towering bookshelves brings home the passion behind the much-loved world of manga.

MANGA HAS DEEP ROOTS IN JAPAN'S EARLIER ART FORMS SUCH AS WOODBLOCK PRINTS.

^ *Most magazines have a specific target audience, but the right stories and characters cross every boundary and attract fans from all demographics.*

FROM MANGA TO ANIME

The birth of modern anime came in 1963, when popular manga artist Osamu Tezuka created a cartoon version of his hit comic series *Mighty Atom* (*Astro Boy* in English). The show introduced an enduring aesthetic style, cemented the link between manga and anime, and also helped shape the standards of TV anime. The advertising company that purchased *Mighty Atom*'s weekly time slot wasn't prepared to pay high sums for a cartoon, partly due to the availability of American imports. Tezuka offered his series at far less than its production cost, relying on advertising deals, merchandise, and foreign sales to make up the shortfall—which is still common practice in the industry.

> *Weekly Shonen Jump series have become so popular overseas that the magazine is translated into multiple languages.*

CARTOON HEROES

Around the world, manga and anime have become an accessible gateway to Japanese culture. They draw in readers with wildly imaginative characters and amazing stories that unfold over the weeks and years that a series goes on. Astro Boy was an early star of both anime and manga because of Tezuka's deceptively deep and often dark stories, but he was soon joined by many other characters that found a dedicated following. Sazae-san is a housewife created by artist Machiko Hasegawa for a newspaper strip in 1946; the character debuted in her own TV anime in 1969, which is now the world's longest-running cartoon. Originally a revolutionary series full of forward-thinking feminist ideas, it is now a nostalgic and beloved show that focuses on family life in postwar Japan.

These days, the manga magazine *Weekly Shonen Jump* has become famous for publishing comics that turn into long-running and popular anime full of brilliant characters. It's the origin of hit series like *Dragon Ball*, *Naruto,* and *Death Note*, as well as the ongoing manga *Haikyuu!!*—which follows the story of a high school volleyball team—and *My Hero Academia*, a Japanese twist on American superhero comics.

DIVE INTO MANGA

Many manga run for dozens of volumes, but if that seems too much of an investment for your first foray into Japanese comics, pick up any volume of *Hetalia*. There's no plot to this lighthearted comedy series about world history, so you can start anywhere. Each character is a personification of a different country, which offers interesting insight into the Japanese writer's view of foreign people and cultures.

ANIME TODAY

While manga are commonly used as the source material for anime, the reverse is also true—and both formats can spawn adaptations in many other media, from films and games to novelizations and music albums *(p138)*.

TV anime are primarily targeted at children, so the most well-known shows in Japan are often those for younger audiences. These long-running series are mainstream staples of television, and it's not uncommon to see the smiling faces of the main characters in advertisements, and on packaging and toys.

Anime for older audiences, on the other hand, is a lot more niche. Many of these series are broadcast after midnight and watched only by small audiences of enthusiastic fans, who follow their favorite shows passionately and attend conventions to buy merchandise and cosplay as their favorite characters *(p163)*. There can be large ads for these series in the *otaku* (geek) districts of big cities *(p164)*, but they're not mainstream entertainment. And yet, despite their lower profile in Japan, these are the series that have captured the most attention abroad.

ENDURING CREATIVITY

Some look to the future of the manga and anime industries with a degree of uncertainty. Manga sales peaked in 1995, when they accounted for 40 percent of all publications sold, but by 2017 sales had fallen by over two-thirds. One likely reason

‹ Children's favorite Doraemon *is one of Japan's biggest anime franchises.*

< The Pokémon *craze of the late 1990s introduced anime to a new generation of fans around the world.*

FIRST-TIME ANIME

If you're looking to explore the world of Japanese TV anime, there's no better place to start than *Fullmetal Alchemist: Brotherhood*— an iconic adventure series set in a steampunk-esque world where alchemy is a known science. The story starts when the young Elric brothers have their lives turned upside down by an alchemical ritual gone wrong, and grows to epic proportions as the series goes on. A huge cast of memorable charters and a perfect balance of action and comedy have helped make this series a classic.

ANIME FOR OLDER AUDIENCES
ARE FAIRLY NICHE, BUT GET
THE MOST ATTENTION ABROAD.

is the rise of smartphones, which offer other means of portable entertainment. Both manga and anime have also been threatened by digital piracy, with many Western fans accessing series online to save waiting months for official translations.

And yet, despite the decline in sales and the threat of piracy, manga and anime are sure to survive the hurdles of the digital age. Streaming services like Crunchyroll now translate and air new instalments shortly after the original Japanese release, while Netflix is making anime accessible to more viewers. Back in Japan, the creative spirit of anime and manga is as strong as ever, with new series drawing in fans at home and abroad as old favorites are revitalized in new forms.

TANKOBON

Manga usually begin life as serials in long anthology magazines. The chapters are then collected and published as *tankobon* (book volumes).

MERCH MANIA

Stores like Animate sell official merchandise for legions of eager fans to add to their collections.

ANIME

Popular manga, such as *Naruto*, are then adapted into anime, reaching new audiences both in Japan and abroad.

HOLLYWOOD BECKONS

Live-action Hollywood versions bring in new audiences. Look out for upcoming films of *Attack on Titan* and *My Hero Academia*.

ON STAGE

Despite the complicated special effects, no series is too daunting for a live-action stage version.

THEME PARK THRILLS

Super-popular series inspire attractions at theme parks such as Universal Studios Japan™ or Fuji-Q Highland.

ANIME MOVIES

As the series builds momentum it spawns multiple animated films, both long and short.

GAMES GALORE

Video game tie-ins are released for various consoles, with mobile gaming more popular than ever.

THEMED CAFÉS

Serving up exclusive merchandise and themed menus, cafés are a fun way to enjoy a series with friends and fellow fans.

LIGHTS, CAMERA, ACTION!

Live-action versions bring a series to the mainstream media, appealing to viewers way beyond the original fanbase.

進化する漫画

THE EVOLUTION OF A MANGA SERIES

Creating new experiences

A popular manga can take on a life far beyond the pages of its original comic magazine. Die-hard fans always want to know more about their favorite characters and the worlds they live in, so hit series can end up inspiring adaptations in all manner of forms. Some may explore the background of a side character, some delve deeper into the fictional world of the story, and others create opportunities for fans to experience the series in a new way. From black-and-white drawings that capture the imagination to Hollywood blockbusters that bring a series to life for a global audience, we chart the journey of popular series as they evolve through new adaptations and win the hearts of new fans.

面白い日本

ENTERTAINING JAPAN

From traditional theatre, geisha, and sports to modern pastimes such as arcade gaming and karaoke, Japanese entertainment offers up a world of delights for escaping the everyday. Even the attractions that seem most traditional, such as kabuki theatre and martial arts, have a firm place in modern society—their historical origins not tying them down in old-fashioned, outdated ways, but allowing them to survive and inspire over the centuries. More modern forms of entertainment such as movies have taken full advantage of the technological innovations of the past century, evolving over the years to remain both influential and enjoyable. In 1954 Godzilla was just a man in a suit, but the spark lit by this postwar classic has grown into an explosion of Japanese films that have inspired moviemakers around the world for decades. The world of entertainment has also created some passionate subcultures—like the J-Pop fanbase and *otaku* (geeks)—whose enthusiasm has spread around the world and inspired a fascination and love for Japan in a whole new generation.

地図の上から

ON THE MAP

Exploring entertaining Japan

It's often some form of entertainment or sports that inspires an interest in Japan in the first place. Some are introduced to Japan through karate lessons as a child, or through a love of J-Pop, or an obsession with *otaku* (geek) culture. However you were introduced, diving into the fun-filled opportunities for entertainment is the perfect first step to exploring Japan, as the experience is often shared with locals and can be a great way to meet people.

‹ A VISION OF TRADITION
Kyoto is the center of the geisha world (p150). See a variety of elegant performing arts at the Miyako Odori festival, where geisha and their apprentices gather to dance and play instruments.

EMBRACE THE GEEK SIDE
Let your inner otaku run free in Osaka's Nipponbashi district. Ditch your regular shopping list for anime goods and cool gadgets.

SUMO
Head to the city of Fukuoka for the Grand Sumo Tournament (p174) held each November.

KYOTO

OSAKA

KANSAI

KOTOHIRA

FUKUOKA

FLAMBOYANT DRAMA
The Shikoku region is one of the best places to see kabuki theatre (p148). There are many theatres here, including the oldest in Japan: the Konpira Grand Theatre in the town of Kotohira.

˄ "KANSAI HAI!"
Sports are big in the Kansai region, so book your tickets early. Osaka hosts sumo in March, while baseball lovers should join the passionate fans at a Hanshin Tigers game (p172).

630 LB

At 630 lb (285 kg) the heaviest sumo wrestler ever was Yasokichi Konishiki. The average weight is 363 lb (165 kg).

⌃ BRINGING FILMS TO LIFE

Movie buffs will have plenty to enjoy in Tokyo. The National Film Archive holds viewings of a restored 1917 animated film, and the Studio Ghibli Museum has original shorts available to view only on site.

TOKYO ●

KAMAKURA ●

❯ OTAKU PARADISE

Head to Akihabara and Ikebukuro for arcades and themed cafes (p.160).

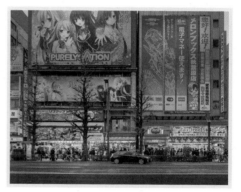

⌄ SAMURAI SPORTS

Be amazed by displays of horseback archery (p177) at the Tsurugaoka Hachimangu Reitaisai Festival, held every September in Kamakura.

BASEBALL FEVER

apan's high school baseball tournament (Summer Koshien) is a popular annual sporting event.

143

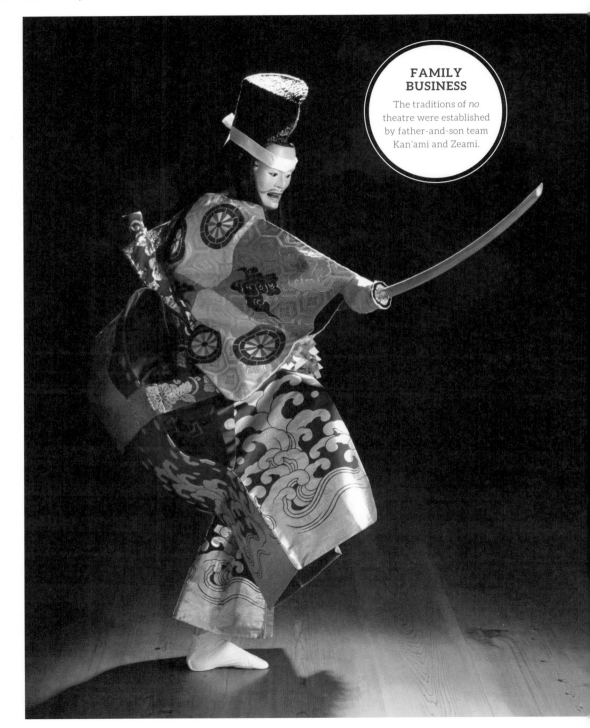

FAMILY BUSINESS

The traditions of *no* theatre were established by father-and-son team Kan'ami and Zeami.

<During a no performance, only one or two masked characters appear on the bare stage at a time.

日本の舞台

JAPANESE THEATRE

A balance of tradition and avant-garde

Japan's plays and musicals may seem difficult to appreciate for non-Japanese speakers, but the language barrier shouldn't put you off. The exaggerated visuals and exciting atmosphere of traditional theatre are still an unmissable experience, and contemporary adaptations of Western plays are a fascinating twist on old favorites.

THE THEATRE OF NO

Japanese theatre has its roots in sacred Shinto dances, which were performed on a bare wooden stage with a painted backdrop of a pine tree and a canopy of a shrinelike roof. *No* (or *noh*) plays were developed in the 14th century and are defined by their mythical subject matter, slow-moving choreography, and masked performers. Musicians playing drums and flutes sit at the rear of the stage, across which leading performers move with studied grace and deliberation, wearing extravagant silk costumes and carved wood and painted masks.

THE PLAYS AND KYŌGEN

The 240 or so *no* plays that make up the current repertoire are performed at public theatres in Tokyo, Nagoya, and Osaka, as well as the theatres of famous *no* schools such as Kanze in Tokyo. The plays are divided into five general genres, and at a typical performance, which can last several hours, you'll get to see a selection from each. They're interspersed with comic interludes called *kyogen*—amusing monologues designed to provide some light relief and counterpoint to the serious *no* dramas. Performers of both styles are male, but *kyogen* actors don't wear masks and use far less formal speech.

KABUKI

Kabuki is the most flamboyant of classical Japanese performing arts, and seeing a performance is an unforgettable experience (p149). Famous for being performed by an all-male cast, kabuki is believed to have been created in the 17th century by Izumo-no-Okuni. Her unique style of performing sacred songs and dances inspired the creation of several all-female troupes. Women performers were banned in 1629 for being too erotic, but kabuki's popular support ensured its survival. Cross-dressing male actors, called *onnagata*, took up the female roles, and the emphasis moved from song and dance to drama.

NO MASK

145

BUNRAKU

Japanese puppet dramas began in the 17th century in Osaka, which remains the home of the National Bunraku Theatre. The performing art developed out of the storytelling tradition of minstrels reciting popular tales of famous heroes and legends, accompanied by musicians playing traditional instruments like the *biwa* and *shamisen (p152)*.

The large puppets used for bunraku are incredibly lifelike, about one-third to half the size of a human. They take three people to operate: the main puppeteer who manipulates the face, head, and right arm; and assistants for the left arm and legs. All are dressed in black and are in full view of the audience. Thanks to their skill in working the puppets—a process that takes years to learn—they usually fade into the background as the audience focuses on the realistically moving figures and the emotions conjured by the narrator and the musicians.

EXPERIENCE BUNRAKU

To enjoy a bunraku performance, there's no better venue than the National Bunraku Theatre in Osaka, which provides audio guides in English as well as translated programs. There are only a few shows every year, so keep your eyes open for performance information. A good introduction to bunraku is through special performances for beginners. These combine a demonstration of the art of bunraku along with actual plays, and are conducted in multiple languages—perfect for foreign theatre lovers.

INTERPRETING THE WESTERN STORIES

Some modern playwrights and performers in Japan have turned to Western theatre for inspiration, adapting existing stories with a twist in the storytelling or the performance style. The director Yukio Ninagawa (1935–2016) was a leading figure in this branch of the modern

⌄ *Left to right: Bunraku puppeteers are known as Ningyotsukai or Ningyozukai; the puppeteers must carefully coordinate their movements.*

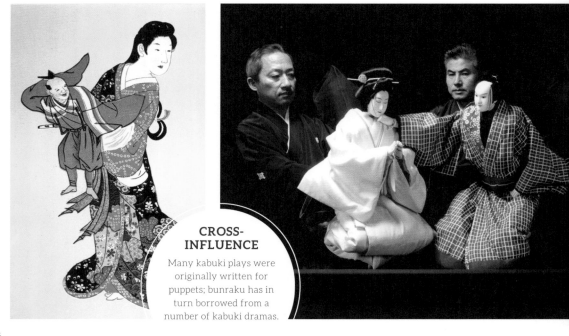

CROSS-INFLUENCE

Many kabuki plays were originally written for puppets; bunraku has in turn borrowed from a number of kabuki dramas.

< Left: A performance of Shakespeare's Cymbeline, directed by Yukio Ninagawa. Above: Takarazuka's production of The Rose of Versailles.

Japanese theatre scene, best known for his localized interpretations of Greek tragedies and Shakespeare. His version of *Macbeth* featured Buddhist chanting and witches in kabuki costumes.

The railway tycoon Ichizu Kobayashi was a lover of Western opera, and founded an all-female group in 1914 called the Takarazuka Review Company. It has flourished to become one of Japan's most beloved theatrical troupes, and performs Western-style musical dramas and shows based on Western novels such as *Gone With the Wind* and *War and Peace*. Millions of fans flock to the troupe's Tokyo stage to attend the shows, which are performed by one of six troupes—Flower, Moon, Snow, Star, Cosmos, and Senka, the last made up of the company's most senior members. Each troupe has a star pair of actors—the male impersonator, the *otoko yaku*, and the *musume yaku*, the female lead.

2.5D MUSICALS

One of the latest trends in Japanese theatre is the creation of shows based on popular manga, anime and video games. A unique fusion of a two-dimensional comic book work and a three-dimensional onstage world, the format is known as a 2.5D musical. Using elaborate sets, costumes, music, and special effects such as freeze frames, the shows vividly bring the source material to life. One of the most popular productions is *The Prince of Tennis*, based on the manga series by Takeshi Konomi, about a teen tennis prodigy. There have been more than 20 variants of the show, selling millions of tickets.

STAGING

Kabuki theatres feature a *hanamichi* (flower path), a walkway that extends into the audience, used by performers for dramatic entrances and exits.

ACTING STYLE

Grand poses and exaggerated movements are the order of the day. To emphasize a beautiful scene, all the actors may freeze in a tableau.

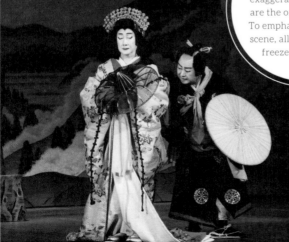

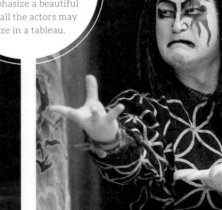

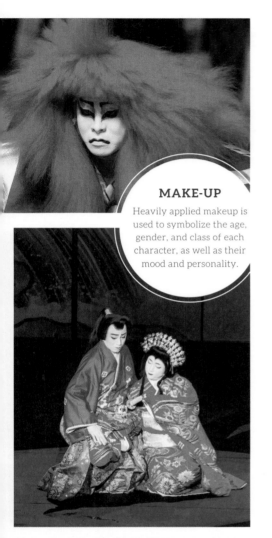

MAKE-UP

Heavily applied makeup is used to symbolize the age, gender, and class of each character, as well as their mood and personality.

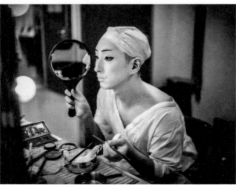

歌舞伎の経験

THE KABUKI EXPERIENCE

Watching a live performance

With its dramatic storylines, fabulous costumes, bold makeup, striking stage effects, and elaborate sets, it's easy to see how kabuki caught the public imagination to become the preeminent form of traditional entertainment. There are many historical kabuki stages dotted around Japan, such as the beautifully preserved Uchiko-za in Uchiko (Ehime Prefecture) dating from 1916, and the Kanamaru-za, or Konpira Grand Theatre, in Kotohira (Kagawa Prefecture), which is said to be Japan's oldest original kabuki theatre. However, one of the best places to watch a performance is Tokyo's celebrated Kabuki-za, which offers almost daily kabuki shows. The flamboyant façade of the theatre—decorated with red lanterns and draped purple banners—meshes perfectly with the exaggerated acting style found within. If you're daunted by the language barrier, you can get an individual ticket for a single act, so you can enjoy the over-the-top experience without worrying about following the full story. There's also an English synopsis in the program for a general outline, and the "G-Mark Guide," which offers the whole script in translation. While it's rude to talk during a performance, there are times when your fellow audience members suddenly and loudly shout out a popular actor's stage name. This practice, called *kakegoe*, is an expected part of the kabuki experience.

‹ *Kabuki is flamboyant and colorful, with a large stage and cast. The major actors are stars, often from famous acting dynasties.*

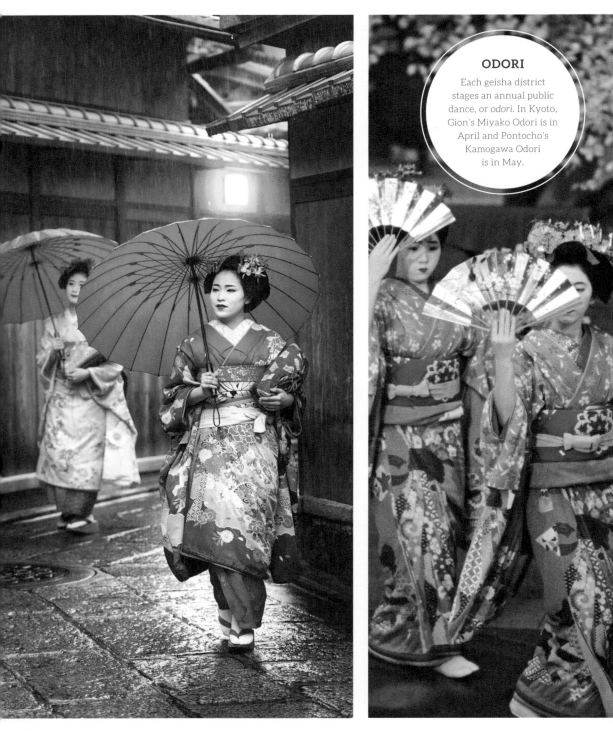

ODORI

Each geisha district stages an annual public dance, or *odori*. In Kyoto, Gion's Miyako Odori is in April and Pontocho's Kamogawa Odori is in May.

< *Left to right: In Kyoto, apprentice geisha are known as* maiko; *dancing is one of the essential skills that a geisha must master.*

芸者の世界

A GEISHA'S WORLD

An echo of the past

Contrary to misconception, a geisha is not a courtesan but rather a highly skilled entertainer, with a work schedule full of lunches and dinners, as well as continual training in music, dance, and conversation. Her clients are the business and political elite, whom she entertains at teahouses or high-class traditional restaurants. For that reason, most Japanese people have never had contact with a geisha.

BECOMING A GEISHA

Although there were an estimated 80,000 geisha in the 1920s, there are now only around 1,000. Apprenticeship begins at the age of 15, and involves living in an *okiya* (geisha boarding house) and undergoing five years of rigorous training in the traditional arts of dance, music *(p152)*, tea ceremony *(p198)*, ikebana *(p74)*, and literature *(p132)*. Being an apprentice can also mean putting up with such demands as weekly visits to a hairstylist (and no hair washing in between), little contact with families and friends, and no cell phones. Only after a woman graduates to geisha status is she allowed more freedom, perhaps even her own apartment—though often this lifestyle is unsustainable, as she may have to retire when she gets married.

GEISHA DISTRICTS

There has always been regional variety in geisha culture, but a common thread is the *hanamachi* (geisha districts), where geisha live, work, and study. The most famous *hanamachi* are in Kyoto, of which Gion is the largest and most prestigious. Official geisha appointments are extremely hard to come by, but you can catch a glimpse of Gion's geisha and apprentices on their way to clients. In today's high-tech Japan, they look like an apparition, sprung from a woodblock print *(p84)*: their faces a powdery white and lips a startling crimson, with elaborately coiffed hair decorated with dangling ornaments and silk flowers.

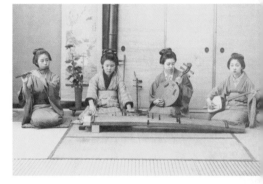

^ *Geisha are trained to play a range of musical instruments.*

IN TODAY'S HIGH-TECH JAPAN, THEY LOOK LIKE AN APPARITION FROM A WOODBLOCK PRINT.

> *Traditional instruments include the* shamisen *(lute),* fuye *(flute), and various drums.*

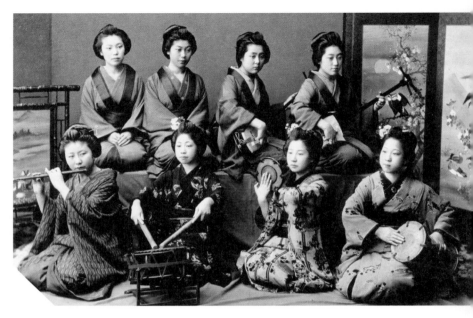

日本の音楽

JAPANESE MUSIC

From spiritual roots to modern idols

Referential to Western styles and yet uniquely Japanese, Japan's music will entertain, delight, and inspire you. There are familiarities and curiosities, offering a fascinating journey of discovery, whether you want to dip your toes or dive in headlong. There's something for everyone, with styles ranging from deeply traditional and spiritual to experimental and avant-garde to buoyant, playful, quirky pop.

THE SOUND OF TRADITION

Early Japanese music can be traced back to *gagaku*, a type of classical music played at the Imperial court to accompany dramatic performances. The music was often sparse and driven by the action onstage. *Shomyo*, the chanting and singing of the monks, was also a major part of Japan's musical lineage. A key element of both styles was the *hyoshigi*, a simple-looking instrument made of two wooden boards. The spiritual, tonal sound made by hitting them together is part of the fabric of Japanese traditional music, and is also a feature of *no* theatre (p145). Meanwhile, lacking direct contact with the court and the high arts, ordinary

THE SPIRITUAL, TONAL SOUND OF *HYOSHIGI* IS PART OF THE FABRIC OF TRADITIONAL MUSIC.

^ (Left to right) Izumi Yukimura, Chiemi Eri, and Hibari Misora were three of Japan's top pop singers in the postwar era.

THE EPITOME OF ENKA

For an introduction to *enka*, you should listen to Misora Hibari's "Kawa no Nagare no Yo ni" ("Like The Flow of the River"). Frequently voted the best Japanese song of all time, this emotional ballad is considered the finest example of late *enka* and is as popular today as it was upon release in 1989.

^ Saburo Kitajima is one of Japan's most popular enka singers.

people developed their own form of traditional folk music, and *joruri*—a style of music and storytelling—became popular with all classes.

One other important style, *enka*, came into fashion before the advent of contemporary music. Originating in the early 20th century as political messages set to music, the style was made up of slow, sentimental songs and would later become the basis for Japanese popular music. *Enka* singers would often use extensive vocal wavering and vibrato, predicting the vocal flourishes of modern R&B music.

THE BIRTH OF A NEW ERA

In the 20th century, Japan made the leap from a long period of traditional music to soaking up a range of outside influences. Hawaii, Japan's American neighbor, introduced some Hawaiian and 1950s Americana elements to late *enka*, which became a full-blown obsession with early Western rock and roll that endures to this day. "Ue Wo Muite Aruko" by Kyu Sakamoto, released in 1961, is probably

the true birth of the new wave of Japanese music. Sung by an Elvis-inspired crooner, this spiritual link between *enka* and J-Pop remains the only Japanese song to ever top the American charts. In the West, the song was renamed "Sukiyaki"—not because it has anything to do with the slow-cooked meat dish known as *sukiyaki*, but because it was easier to say.

THE AGE OF J-POP

J-Pop is a mega-force of contemporary music that kicked off in the 1990s. The name was originally coined to denote every type of pop music apart from *enka*, but is now most closely linked to bubbly chart toppers that have an irresistible rhythm and simple—almost clichéd—lyrics, and are often accompanied by choreographed dance moves. Strong melodic songwriting and catchy, hummable tunes have made sure that J-Pop is here to stay, despite the influence of smoother, R&B–style K-Pop (Korean pop)—another music-industry behemoth that has swept the globe.

FEEL THE MUSIC

The thrill of a live concert is always exciting, and Japan takes it to the next level with *wotagei*. Performed by *wota* (J-Pop idol fans), this high-energy dance involves waving

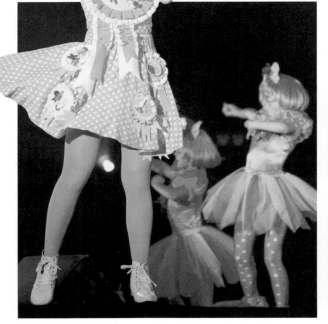

glow sticks and chanting, and is truly a sight to behold when a whole crowd joins in. To see the *wota* in action, download some J-Pop and look up a band or two to see live in concert in Japan. Hugely popular bands include SMAP, Arashi, and Glay, whose "best of" album sold 4.8 million copies and who hold a live concert audience record at 200,000 people. But the genre isn't just about bands. Singer Hikaru Utada is one of the best-known J-Pop artists outside Japan, while Kyari Pamyu Pamyu is also a hugely popular icon, adored by hordes of Japanese teenagers for her catchy tunes, sugary-sweet lyrics, and hyper-cute Harajuku-inspired style *(p130)*.

If simple pop music isn't your thing, you can explore an endless supply of unique Japanese twists to different music genres, like the hugely popular Babymetal. This seemingly impossible blend of super-cute and death metal takes the form of an all-girl trio decked out in gothic Lolita and *dolly-kei* chic *(p130)*, with incredible talent

‹ *Left to right: Singer Kyary Pamyu Pamyu is the queen of the cute aesthetic; Glay is one of Japan's biggest rock bands.*

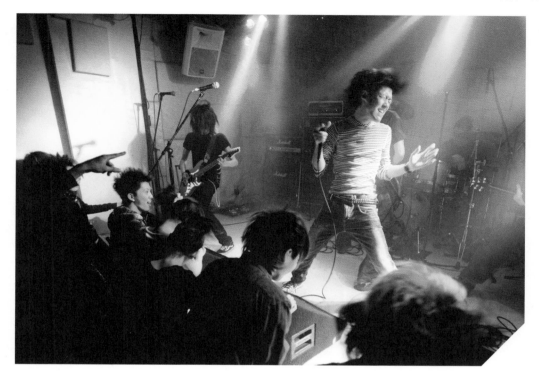

∧ *Mosaic is one of many live houses that can be found in Tokyo.*

and quality songs that ensure the fashion statement doesn't overpower the music. The band has dominated the live arena with the help of their highly talented backing group, the Kami Band.

ENTER THE LIVE HOUSE SCENE

There's more to enjoy than just the world of the pop idols, with a contemporary music palette that offers incredible breadth and diversity. Outside the mainstream, experimental music, electronica, and melodic pop have grown to share sound space with hip-hop, dub, and rave. To fully immerse yourself in these new sounds,

your best option is to head to a live house. These Japanese institutions serve up jazz, electronica, heavy rock, thrash metal, folk, and punk in large doses, often combining the different styles. There are people on stage who shouldn't give up their day job, and some who you can't believe are playing in a venue this tiny. A true live house is usually small and dark, and customers come to appreciate the music—it's a serious business, and many spectators don't even drink. The best-known bands often have no actual success outside of the sphere of the performance, making it truly a moment in time, a microcosm of creativity and appreciation that takes place nightly across Japan. Shows usually kick off in the early evening with a lineup of four or five bands, and will be finished in time for you to catch the last train home or hit the local bars or late-night eateries.

BABYMETAL IS A SEEMINGLY IMPOSSIBLE BLEND OF SUPER-CUTE AND DEATH METAL.

155

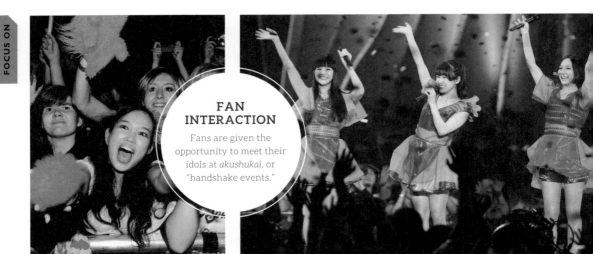

FAN INTERACTION

Fans are given the opportunity to meet their idols at *akushukai*, or "handshake events."

IMAGE

Most bands have a young, cute, and innocent image, which is reflected in their outfits and strict codes of behavior.

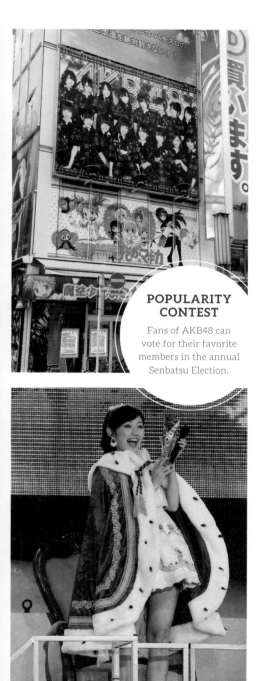

POPULARITY CONTEST

Fans of AKB48 can vote for their favorite members in the annual Senbatsu Election.

究極のポップアイドル

THE ULTIMATE POP IDOLS

Girl bands with clout

Since the 2000s, female pop idol bands have become big business in Japan. While some boy bands also have large followings, it's nothing compared to the culture around the female *aidoru* (idols), who earn themselves legions of fans that worship them—as the name suggests—like idols. The Japanese even refer to this era as "*Idol sengoku jida*": the Age of the Wars of the Idols. It sounds like an epic era in history, and for all the money it has generated and the dramas it has created, it might as well be.

Arguably the reigning monarchs are the girls of AKB48. Formed in Tokyo's *otaku* (geek) paradise of Akihabara *(p160)* in 2005, the band are the ultimate in prefabricated pop. The group was put together by mega-producer Yasushi Akimoto, who wanted to create a girl band with their own performance space (in Akihabara), to enable them to do daily shows and meet-and-greets for the obsessive fans. In order to keep up with this demanding schedule, the group has over a hundred members in their teens and early twenties, split into separate teams with a general theme and color to each group. The band is the highest-selling act in Japan and has occupied the first four places on the yearly singles chart since 2011. It has also spawned numerous spin-offs, with more "48 groups" around Japan and in several other Asian countries.

< *Clockwise from top left: Pop idol fans; the band Perfume; a poster for AKB48 in Akihabara; AKB48 member Mayu Watanabe; AKB48 in concert.*

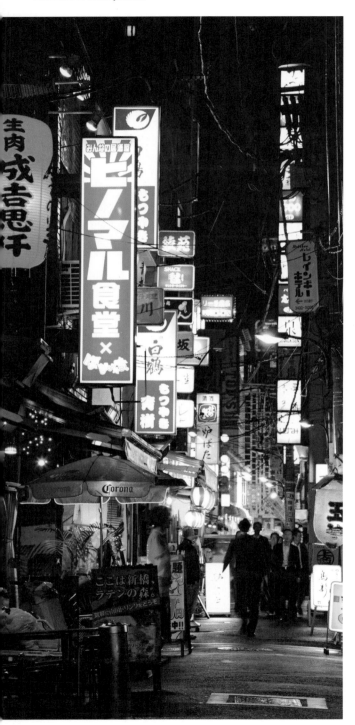

‹ Shimbashi is a popular nightlife district in Tokyo.

ナイトライフ

NIGHTLIFE

From dusk till dawn

When the sun sets, Japan's streets transform under the bright glow of neon lights. From frenetic clubs to chilled-out live music events, the country has all the usual nightlife options that you might expect. For a quintessentially Japanese night out, however, your best port of call is an *izakaya* or a karaoke bar.

IZAKAYA

A cross between a bar and a restaurant, *izakaya* are the Japanese equivalent of pubs. Evolving out of standing bars in sake shops, they offered small plates of food to go with the drinks and became popular places for after-work socializing. You can usually find *izakaya* near train stations or in entertainment districts, and the atmosphere is lively with lots of chatter. They make the perfect venue for a long, relaxed evening—grab a table, order some sake *(p202)*, and steadily work your way through the appetizing array of tapas-style dishes.

KARAOKE CULTURE

Karaoke has its roots in *utagoe kissa*—singing cafés that were popular in the 1950s to 1970s—and since then has become a global phenomenon. Standing

∧ Trips to karaoke bars are a convivial way to relax after work.

∧ Izakaya *are great for socializing and unpretentious food.*

up in front of your friends to sing along to a recorded backing track might seem like a nightmare to some, but for a hard-working Japanese population it's a way to let off steam. It's even common as a team-bonding exercise, and acts as a great leveler—proficiency level is not taken into account, and quite often the worst vocal will get the best response. At the majority of Japanese venues you book a private room, so you don't have to worry about singing in front of strangers. You can also order in food and drink, and while many Japanese people won't need to get drunk to let their karaoke inhibitions go, it adds to the bonding experience—combining the casual feel of after-work drinks with the entertainment value of a sing-along.

TRY IT OUT

In any urban area of Japan, you're likely to have many choices when it comes to picking a karaoke place for your evening entertainment. Big Echo and Joysound are the most foreigner-friendly in terms of the technology and instructions, but the assistants at any venue will be happy to give you a walkthrough of the handheld console that's used to input the songs. English words almost always accompany the Japanese lyrics on screen, and Joysound even has a list of the best non-Japanese Karaoke songs for the 2010s.

ESSENTIAL TERMS

Juhachiban: The song you excel at singing—if you don't have one already, karaoke will help you find it.

Karamovie: The music video that plays along with the songs at karaoke—often a retro-looking creation by the karaoke companies, as the real videos are too expensive.

Hitokara: Singing karaoke alone; not as common as going as a group, but sometimes you just need to practice your *juhachiban!*

日本のオタク

OTAKU JAPAN

A celebration of geekery

Japan's small but passionate *otaku* (geek) subculture has been gaining momentum around the world since the 1990s, when anime (cartoons) started to become more famous and accessible overseas *(p134)*. For the new generations of people growing up on a steady diet of Japanese video games, anime, and manga (comics), it's a dream to make a pilgrimage to Japan, where shops, restaurants, and attractions created just for *otaku* customers have become the fabric of whole districts.

DEFINING *OTAKU*

When the term *"otaku"* was coined by essayist Akio Nakamori in 1983, it was used in a disparaging way to define all those people who were obsessed with something that was otherwise considered fairly geeky and immature: be it manga, dolls, or video games. This negative view endured for many decades, and while geek culture has become more acceptable in the 21st century, many Japanese people still have mixed feelings on this subject—and *otaku* often prefer to keep their hobbies to themselves. Foreign fans, on the other hand, have wholeheartedly adopted the term, and the title of *otaku* is a badge of honor that they proudly use to declare themselves a die-hard fanatic of their particular passion.

ꜜ *Left to right:
Arcades such as Club
Sega and Taito Station
can be found across
Japan; Tokyo's
Akihabara district is
a hot spot for arcades
and all things* otaku.

< *The Gundam Café in Tokyo's Akihabra district celebrates one of Japan's long-running and hugely popular* mecha *(giant robot) franchises.*

ARCADE CULTURE

Arcades, known as game centers in Japan, used to be a worldwide staple. Now the scene seems to exist solely on the set of 1980s films, replaced by home consoles, PC software, and portable devices. Except, that is, in Japan, where arcades continue to thrive, thanks to the owners' commitment to creating a unique experience that can't be duplicated anywhere else.

The venues differ in size, but their basic layout is about the same. The first floor is crammed with fun games and crane machines, which are more likely to attract casual passersby, young couples, and families. The upper floors feature perennial favorites like shooting, fighting, and music games—and this is where you can go to play alongside the hardcore gamers of *otaku*-level expertise. The last floor is usually devoted to *purikura* photo-sticker booths *(p103)*, which are a must on any outing with friends.

The key to the arcades' continued success is innovation, and the latest trend is represented by virtual reality (VR). Most VR game centers are concentrated in Tokyo and require visitors to have at least some Japanese language ability—or you can just wing it and enjoy the experience.

ESCAPE REALITY IN A THEMED CAFÉ

The first maid café was a temporary pop-up in 1998, but a permanent site opened in Tokyo's Akihabara district in 2001. Themed cafés in *otaku*-centric areas have since become a standard, as they're the perfect place for customers who enjoy escaping into their favorite hobbies. Some places are devoted to a particular franchise, while others—such as the Animate Cafés (with 25 branches around Japan)—change their theme every month or so, focusing on a different anime every time. Both groups offer a themed menu and sell time-limited merchandise.

A MAID CAFÉ SERVER

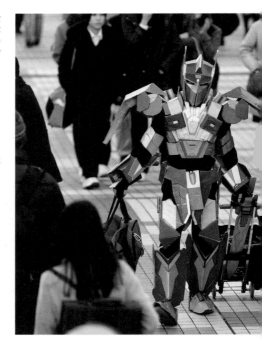

> Many fans bring suitcases to Comiket to hold all the merchandise they buy at the event.

THE CONVENTION CALENDAR

Otaku of all kinds have exciting events and conventions to look forward to throughout the year, where they can hear news about their hobbies, buy new products, and meet up with friends. Embrace your geeky hobbies by joining the crowds of eager *otaku* at one of these events—it can be a great place to meet like-minded fans, especially since some of these events draw over 100,000 attendees.

At BitSummit (June) and Tokyo Game Show (September), you can try out the latest innovations in gaming and hear all about new installments of your favorite video game franchises. Jump Festa (December) focuses instead on the manga content of best-selling *Shonen Jump* magazine (p135). Among more niche events, the Dolls Party (May) and I Doll (events throughout the year) attract thousands of fans of Dollfie and Pullip, two popular doll brands.

THE *DOJIN* MARKET

Collecting official merchandise is important for many *otaku*, but there's also a huge demand for fan-made products based on popular manga and anime. These *dojin* (independent) goods may take the form of novels or video games, but the biggest sellers are comics. The creators are often avid fans of a series who make *dojin* comics as a hobby, though some are aspiring manga authors or artists. As the products use copyrighted stories and characters, *dojin* goods are technically illegal. Surprisingly, though, the official publishers tend to look the other way; for the manga industry, in particular, it's a win-win situation as the *dojin* community is a hotbed for talent and helps fuel fans' interest in new series.

< New virtual reality equipment and games are often on display at Tokyo Game Show.

Otaku districts (p164) often have chain stores (such as Mandarake and K-Books) dedicated exclusively to *dojin* goods. You can also explore the world of the *dojin* community at Comiket (usually August and September), a hugely popular independent comics event held twice a year in Tokyo.

DRESS TO IMPRESS

Dressing up as your favorite fictional character isn't a uniquely Japanese concept, and has been part of geek fandoms since the mid-20th century. But this hobby has been inextricably tied up with the *otaku* community since fans began donning costumes for the first Comiket events in the 1970s. The word "*cosplay*" (a portmanteau of "costume" and "play") was coined in 1983 by writer Nobuyuki Takahashi, and is now a common word used by geek and *otaku* communities around the world. You may find a few shops selling costumes, wigs, and other accessories in Japan, but hardcore cosplayers make their own costumes, whether it's a simple school uniform or a full-on suit of armor.

Many *otaku*-centric conventions such as Comiket have a *cosplay* area where people can meet and take photos, and every month there are a few dedicated *cosplay* events around the country. Surprisingly, the two most important annual *cosplay* gatherings aren't held in the *otaku* districts of Tokyo. One is Osaka's Nipponbashi Street Festa (March), featuring a 1,000-strong parade of colorful cosplayers. The other is the World Cosplay Summit held at the end of July in Nagoya (Aichi Prefecture), uniting passionate *otaku* from around the world for a vibrant celebration of *cosplay* culture.

∧ *Japanese anime, manga and video games are common inspirations for cosplay, but you'll also likely see Western creations such as Disney characters and Marvel superheroes.*

OTAKU HAVE EXCITING EVENTS TO LOOK FORWARD TO THROUGHOUT THE YEAR.

オタク街

OTAKU DISTRICTS

Shopping in geek central

Tokyo is Japan's indisputable geek haven. From giant billboard video game ads to public awareness campaigns featuring popular manga characters, you just can't escape *otaku* imagery. Even the jingles that play at train stations are sometimes from popular anime. With few exceptions, all the Tokyo subcenters—such as Shinjuku, Shibuya, and Harajuku— have their fair share of *otaku* attractions, from themed cafés to arcades. But serious *otaku* should take a couple of days to explore the fabulously geeky Akihabara *(shown here)* and Ikebukuro. Akihabara, also known as Akiba, has shops for all kinds of *otaku*, whether you're a fan of *mecha* models or J-Pop idols. Ikebukuro, meanwhile, is full of fun for casual shoppers, but also teems with geeky wonderlands aimed especially at anime and manga fangirls. The elegant Swallowtail Café, for example, is the female answer to the male-oriented maid cafés of Akiba.

Wherever you are in Japan, keep an eye out for the blue "Animate" sign. Each location of this nationwide chain feels like a mini *otaku* treasure trove of all the latest anime goods.

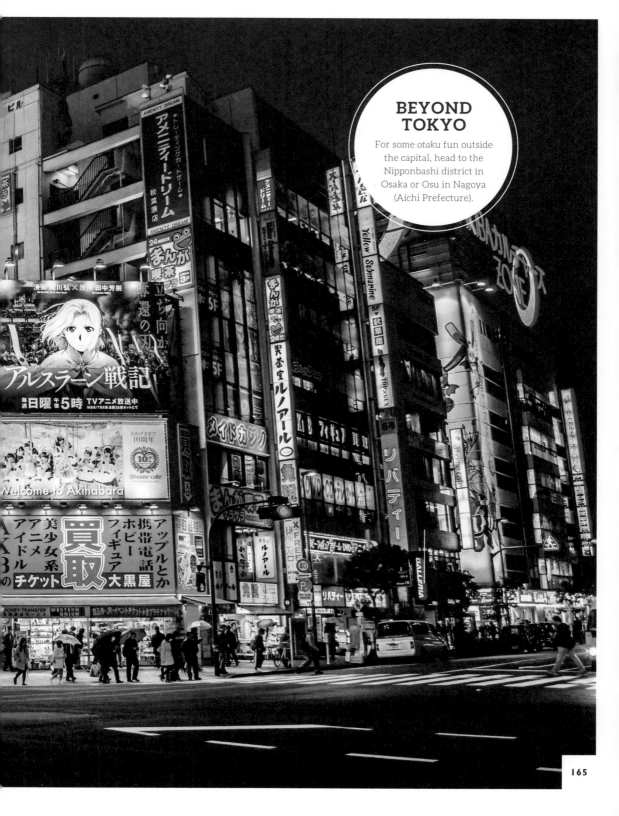

BEYOND TOKYO

For some *otaku* fun outside the capital, head to the Nipponbashi district in Osaka or Osu in Nagoya (Aichi Prefecture).

> Left to right: Japan began regular TV broadcasting in 1953, after its initial tests in the 1930s were halted by the onset of World War II; many period dramas are based on novels or comics, or, like the 2010 version of 13 Assassins, remakes of older films.

日本の映像作品

JAPAN ON SCREEN

Nation-defining genres

In the latter half of the 20th century, Japan's prolific and influential media industries rose to international fame through the development of new techniques, modern genres, and moving stories.

THE TRUTH ABOUT GAME SHOWS

Japanese TV is often thought of as bright and wacky, dominated by sci-fi anime (p134) and inexplicable game shows. However, the country's most enduring TV hits are its lively variety shows and serious period dramas.

The appearance of *Matthew's Best Hit TV* in the 2003 film *Lost in Translation* cemented the overseas image of the Japanese game show as a bizarre blend of high-energy interviewing, slapstick comedy, and gaudy transitions. These game shows do exist—and they're popular—but

they're usually just segments on longer variety shows. These shows have been a Japanese TV staple since the 1950s, and some of them have been around for decades. Some of the genre's roots lie in Japan's theatrical traditions: the exaggerated characters mirror elements of kabuki, while the comedic games and sketches of the *owarai* (comedians) have strong links to *rakugo* (on-stage storytelling). Alongside these comedians, segments might include travel stories, musical performances, interviews, challenges or competitions, and even investigative pieces. The hosts' reactions

SOME OF THE ROOTS OF JAPAN'S VARIETY SHOWS LIE IN ITS THEATRICAL TRADITIONS.

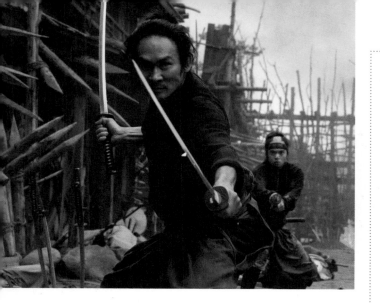

are often shown in a small box in the corner of the screen throughout.

HISTORICAL DRAMAS

On both the big and small screens of Japan, historical dramas—known as *jidaigeki*—are always big business. Many fall under the umbrella of *chanbara*, "samurai cinema," which tends to focus on samurai trying to live by their moral code in a changing, often hostile world. But though this is the most famous sub-genre of *jidaigeki*, there are plenty of others, including romance, politics, and comedy.

You can get a glimpse of what it would be like to work on a *jidaigeki* film set by visiting Toei Kyoto Studio Park in Kyoto, where you can try on costumes and traditional kimono, watch performances, and visit period-themed attractions like a house set up with ninja traps.

THE ISOLATION ERA

Jidaigeki are most often set around the Edo period *(p30)*. At this time Japan was mostly cut off from the outside world, so setting dramas in this era gives filmmakers a clearly defined social structure in which to set conflicts. The unique role of the

ADAPTATIONS

You may not think that you've watched much Japanese TV, but you've almost certainly seen something based on it. Here are just a few you may have heard of:

Home movie bloopers: A segment from variety show *Kato-chan Ken-chan Gokigen TV* became the basis of famous series such as *America's Funniest Home Videos* and *You've Been Framed*, where viewers send in funny home videos.

Ninja Warrior: With adaptations found around the world, this thrilling physical challenge show started life as the obstacle course series *Sasuke* in Japan.

Hole in the Wall: Inspired by the *nokabe* ("brain wall") segment from variety show *The Tunnels' Thanks to Everyone*, this unexpected classic is similar to human Tetris.

Iron Chef: All the adaptations of this much-loved cooking contest are based on the Japanese original.

samurai in this period means *chanbara* films have plenty of opportunities for dramatic sword-fight scenes, while the wandering *ronin* (masterless samurai) has the same independent, roguish feeling as the outlaw in Hollywood Westerns.

∧ Above: From left to right—Shoichi Hirose, Haruo Nakajima, and Masaki Shinohara were the actors behind the legendary monsters King Ghidorah, Godzilla, and Rodan. Left: Nakajima on set.

MAKING MOVIE HISTORY

Japan's film industry is not only one of the world's largest and longest-established, but also one of its most influential. Domestic films get well over half the box office share in Japan, and its directors are regularly nominated for international awards. Beyond the proliferation of historical dramas it shares with television, there are three styles in which Japan is undoubtedly a global leader: *tokusatsu* (special effects), horror, and animation. Here are a few standout examples to whet your appetite.

TOKUSATSU

Although the name comes from a portmanteau of special effects (*tokushu satsuei*), *tokusatsu* movies have a more handcrafted aesthetic than the CGI-heavy films we're used to today. To understand the vision of *tokusatsu*, just

think back to the original *Godzilla* (1954). Inspired by the special effects of the 1933 *King Kong*, the creators of *Godzilla* became the first to truly define the *tokusatsu* style of live-action adventure films, setting the visual template for many films to come.

Just a few years later, *Super Giant* was released, introducing Japan's first big screen superhero. This early classic became the foundation for the "masked hero" sub-genre of *tokustatsu*, which soon spilled over onto TV screens and continues to play a major part in the realm of children's televisions. The *Super Sentai* series has been running in various forms since 1975, and was even adapted into the 1990s smash hit *Power Rangers* in the West.

HORROR

After the release of the cult-classic *Ring* in 1998, a new term was invented: J-horror.

∧ The Godzilla franchise now comprises over 30 films.

It brought international attention to Japan's unique approach to horror films, which focus on building suspense and psychological tension—whether in stories about the supernatural (such as in *Dark Water*, 2002) or those that come with a heavy helping of gore (as in *Audition*, 1999).

Japan has long enjoyed a good horror story, with ghosts and malevolent spirits often cropping up in folklore, and the *kaidan* (ghost story) genre becoming hugely popular during the Edo period. Many J-horror films take these sources as inspiration, but they often deal with modern themes, as well; *Ring* (1998) deals with the fear and urban legends that grow out of new technology.

ANIMATION

Japanese anime (short for animation) may be more famous in its TV form (p134), but big-screen animated features are one of the country's most influential cultural exports. Its wide appeal has given rise to a long line of family classics to rival those of the Walt Disney Animation Studios, so if you haven't had a chance to try them yet, don't hesitate to add some Studio Ghibli to your movie library. Cofounders Hayao Miyazaki and Isao Takahata have produced unmissable films such as *Spirited Away* and *Howl's Moving Castle*, and their creations often balance a child's-eye-view of the world with a nuanced, elegiac tone that appeals to adults.

But while animation in the West has historically been aimed at children, Japanese anime isn't bound by a single target audience, and can cover the same range of styles, budgets, and genres as any other type of film. This means Japanese animated movies can be so much more than just family favorites; they are often groundbreaking contributions to world cinema, reaching beyond the medium of animation and influencing moviemakers on a global scale.

THE WIDE APPEAL OF ANIME HAS GIVEN RISE TO A LONG LINE OF FAMILY CLASSICS.

The dystopian cyberpunk flick *Akira* (1988) was one of the first anime movies to cross over to the West, changing the way that moviegoers and filmmakers perceived animation in the West. Since then, a steady stream of incredible features has followed: the psychological thrillers of Satoshi Kon, dreamy visuals and bittersweet stories by Makoto Shinkai, and the distinct aesthetic of Mamoru Hosoda. His film *Mirai* was nominated for Best Animated Feature at the 2019 Oscars, the first non-Ghibli anime to be recognized in this way.

⌄ Your Name. *(2016) by Makoto Shinkai is the fourth-highest-grossing film in Japanese history.*

UGETSU

(1953) From their use of long takes to their narrative ambiguity, the films of Kenji Mizoguchi clearly inspired French New Wave directors.

SEVEN SAMURAI

(1954) This film by Akira Kurosawa had a huge impact on the work of George Lucas.

LADY SNOWBLOOD

(1973) A bloody revenge story with a female lead: the influence on Quentin Tarantino's *Kill Bill* is clear.

ISLE OF DOGS

(2018) This stop-motion feature by Wes Anderson is crammed with references to Japanese culture and cinema, particularly the films of Akira Kurosawa.

BATTLE ROYALE

(2000) *The Hunger Games* has obvious parallels, and Tarantino has called it one of his favorite films.

PAPRIKA

(2006) From blurry lines between dreams and reality to similar wardrobe choices—there are clear links between this animated film and the 2010 hit *Inception*.

TAMPOPO

(1985) A love letter to Westerners and to food, *Tampopo* is director Juzo Itami's take on American film styles.

AKIRA

(1988) You can draw a clear line from *Akira's* wildly influential action scenes and gritty aesthetic to many later sci-fi films.

PRINCESS MONONOKE

(1997) Studio Ghibli's first breakthrough in the West paved the way for more animated films to come.

RING

(1998) Eschewing gore in favor of psychological terror, *Ring* defined the J-Horror genre. It was remade as *The Ring* by Gore Verbinski, and influenced scores more restrained horror films.

日本の映画

JAPANESE CINEMA

A conversation with the West

From adaptations to homages, here are just a few of the most important moments in the conversation between Japanese and Western films. Japanese cinema has always mixed foreign technologies and styles with its own culture and sensibilities, creating something truly unique in the process—but the flow of influence goes both ways. In some cases, Japanese films have been directly remade for Western audiences, with everything from J-horror film *Ring* to the heartwarming story of Hachiko the dog getting this treatment. But often the influence is subtler, with film styles pioneered in Japan inspiring foreign directors, or key themes and plotlines being reused for a different audience in a new era or nation.

> *Soccer was introduced to Japan in the 1870s, by a Canadian officer of the Royal Navy.*

スポーツ

SPORTS

A way of life and leisure

Growing up in Japan, sports often play a key role in everyday life, as extracurricular clubs and showing team spirit are crucial elements of the school experience. Many children join one of their school sports clubs in elementary or middle school and carry on right through college—and sometimes beyond, becoming members of local community teams as an adult.

A key reason behind this widespread participation is the intrinsically Japanese concept of *wa*: the importance of the group dynamic. While *wa* is an undercurrent running below the surface of Japanese life, sports is where the concept comes alive, exemplifying the crucial values of harmony, communication, and cooperation. With this kind of upbringing, sports becomes not just a fun leisure activity, but an essential part of Japanese culture.

However, it's not all about deep-rooted tradition and philosophy. Another reason behind the importance of sports is also just the pure love of the game—whatever that may be.

For many, baseball is close to an obsession, dominating the back pages of newspapers. Yet centuries-old sumo still draws big crowds, too, and Japan lands many of its Olympic medals in martial arts.

While baseball and soccer are the most-watched sports on TV, Japan has diverse sporting interests, with everything from table tennis to rugby catching the public's attention at some point during the year.

< The baseball season is 8 months long, going from April to October.

TAKE ME OUT TO THE BALL GAME

Because of their many stints as Central League and Japan Series champions, the Yomiuri Giants have both the most avid fans and die-hard haters—who are happy to declare themselves the *anchi Jaiantsu* (anti-Giants), so going to see one of their games is sure to be a lively experience. But if you're going to adopt a team, you'll make far more friends opting for one of the other 11 choices—maybe the Hiroshima Carp or the Hanshin Tigers from Osaka, both of which have a passionate fanbase.

BASEBALL

In 1867, an American professor named Horace Wilson at what is now the University of Tokyo is said to have first shown the Japanese how to play baseball. The love affair that began that day is still burning bright, and Japan is now giving back to the nation that introduced it to its favorite sport. Nowadays the names of Japanese baseball players roll off the tongue in the US.

⌄ The Japan Open is an annual, international table tennis tournament held in Japan.

THE JAPANESE LEAGUE

In the Nippon Professional Baseball league (NPB), 12 teams are split between the Pacific and Central leagues, where they play through a hundred-plus-game regular season in hopes of reaching the playoffs and competing for the coveted Japan Series. Going to a game, whether you understand it or not, is a fun experience, with choreographed cheering and clapping producing a rousing atmosphere on even the muggiest of summer nights.

BUDO—THE MARTIAL WAY

The legacy of feudal Japan (p29) is starkly apparent in the clattering of *kendo* practice swords and the poise of *kyudo* archers. Though no longer for war, the concept of *budo* (the martial way) is nevertheless preserved and respected through the practice of modern martial arts. The *budo* philosophy values not just the skills each sport entails, but the mental discipline they breed and the grounding calm they offer in an increasingly hectic society.

THE ORIGINS OF SUMO

While sumo epitomizes many of the hallmarks of *budo*, it actually predates the origins of the martial way of feudal Japan. Nobody knows exactly when sumo began, but there is one word always given to the country's most recognizable sport: ancient. It's likely 1,500 years old at least—an estimate based on wall paintings and unearthed figurines of wrestlers—and is thought to have begun as part of harvest rituals, a way to entertain the gods (p60) and gain their support for a good crop.

What is known for sure is that in the Nara period (710–794) sumo bouts were first performed in the Imperial court as entertainment, and by the Edo era (p29) wrestlers were fighting for public crowds, to raise money for the construction of temples and shrines. This spread sumo's popularity from beyond the sphere of the upper classes and throughout

∧ *Currently only men can be sumo wrestlers in Japan, but in other countries such as Brazil there are female* rikishi.

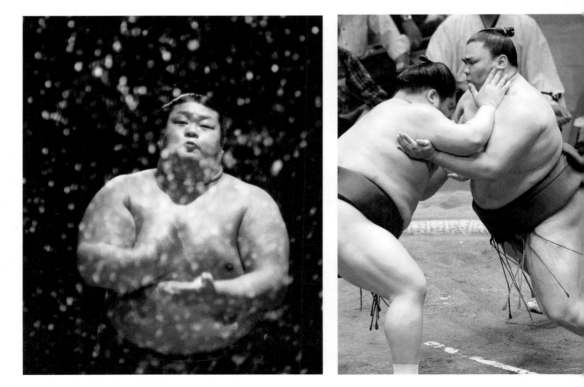

the masses, paving the way for sumo to be declared the national sport in 1909.

Although sumo is considered very Japanese, it's grown a big international following, and many wrestlers themselves come from overseas. The most successful sumo wrestler of all time, in fact, is Mongolian-born Sho Hakuho.

ATTENDING A TOURNAMENT
Every year Japan hosts six 15-day grand sumo tournaments—three in Tokyo's 11,000-seat Kokugikan arena and the rest in the Prefectures of Nagoya, Osaka, and Fukuoka. They are an incredible display of pomp and power, with prebout posturing that sees the *rikishi* (professional wrestlers) tossing salt to purify the ring, stamping their feet hard into the ground, and then, when the referee gives the nod, crashing into each other with a thud and crack that

SUMO TOURNAMENTS ARE ARE AN INCREDIBLE DISPLAY OF POMP AND POWER.

sends gasps around the arena. At times, a bout ends in seconds, with one *rikishi* being thrown to the ground or tumbling out of the *dohyo* (ring) after an initial flurry of slaps and pushes. On other occasions, they spend long minutes holding on and jostling, trying to get leverage for a throw.

Either way, it's not hard to see that sumo is a brutal sport, and wrestlers accumulate a string of injuries during a career. It's a hard life, too: many *rikishi* live together in training stables, sharing sleeping quarters, performing chores for their seniors, and being put through grueling daily training sessions.

⌄ *Left to right: A rikishi purifies the ring by throwing salt; rikishi competing in the Grand Sumo Summer Tournament; as well as refereeing the bouts, gyoji (referees) often work in the stables where the rikishi live.*

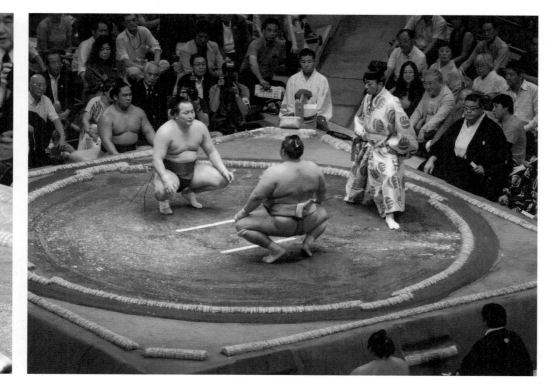

OLD SCHOOL

Modern martial arts (*bujutsu*) have evolved from the military traditions of samurai. *Ninjutsu* are the skills descended from ninja.

WAY OF THE SWORD

In *kendo*, piercing and intimidating shouts are important tools of combat to use alongside the sword.

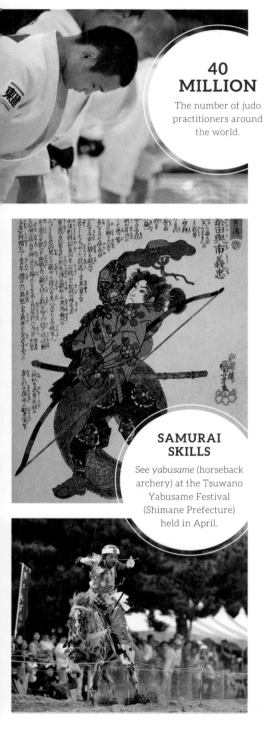

40 MILLION

The number of judo practitioners around the world.

SAMURAI SKILLS

See *yabusame* (horseback archery) at the Tsuwano Yabusame Festival (Shimane Prefecture) held in April.

武術

MARTIAL ARTS

Military science turned modern sport

Born from warfare, Japan's martial arts are a bridge between the country's past and its present. Instead of going down the path of war, the current practitioners of *bujutsu* (martial arts) are on a quest for self-improvement, seeking fitness, discipline, and a balance of mental flexibility and resilience to face life's challenges.

Japan's two most famous martial arts styles are karate and judo, but there are plenty of others you should make time to see on a trip to Japan. For *bujutsu* with a long history and obvious samurai connection, look no further than *kyudo* (archery), which can be traced back to the Yayoi period (300 BC–300 CE). It's a discipline that requires mental poise and extreme calm to be able to use a Japanese longbow to hit 14-inch (36-cm) diameter targets from 90 feet (28 m) away. Put that on horseback and you have *yabusame,* which sees riders in full traditional gear firing at targets while their horses hit a gallop. And in *kendo* (the way of the sword) there's yet another samurai skill being preserved in modern Japan. Using wooden swords, the aim of the contest is to land two hits on the designated (and well-protected) strike zones on the opponent's body. Like other *bujutsu*, the ultimate aim of training for most practitioners goes deeper than proficiency— it's all about the philosophy of *budo (p174)*: learning respect and self-control, and striving for personal development.

‹ *Martial arts is a unique and thrilling way to access Japanese history, with the Nippon Budokan Tokyo arena offering lots of chances to see tournaments.*

日本を食べる

EDIBLE JAPAN

Wherever you travel in Japan, you'll soon discover the unique joys of *washoku* (Japanese food)—the ways that seasonal produce and regional characteristics shape menus, and the manner in which chefs are able to elevate even the simplest fare to art. From high-end sushi to cheap ramen, Japanese food is a mouthwatering menu of flavors, textures, and styles. For a special night out, there's refined *kaiseki-ryori*, tempura, or *teppanyaki*, while for a quick bite there are all sorts of noodles and street stalls. And those with a sweet tooth can take their pick from traditional *wagashi* sweets, cream-filled crepes, and convenience stores full of sweet breads, chocolates, and candies. There's an equally varied choice when it comes to the liquid options— the refreshing green teas, flavorful sakes, award-winning whiskies, and so much more. It's a miracle the Japanese manage to stay so trim.

地図の上から

ON THE MAP

Exploring edible Japan

Eating well is easy in Japan, whether it's
street food in Osaka or Michelin-starred
dining in Tokyo. Regional specialties
abound, so the key is to try something of
everything—Hokkaido in particular is
famed for its top-quality produce, while
Okinawa is renowned for its pork dishes.
Complement the food with a glass of
local whisky or sake, and if it all gets too
much, take some time out with the serene
ritual of the tea ceremony. With vending
machines and convenience stores to satisfy
your every whim, you'll never go hungry
whatever the time of day or night.

SUSHI INSPIRATION

The use of salmon in
sushi was suggested
to Japan in the 1980s
by a Norwegian
delegation.

˄ TIMELESS TEA
*The tiered tea fields
of Uji in the south of
Kyoto Prefecture
produce some of the
finest green teas
in Japan (p196). At
Fukujuen Ujicha Kobo,
in the center of Uji,
you can try and buy
many varieties, as well
as take part in a tea
appreciation workshop.*

OSAKA ●

OKINAWA

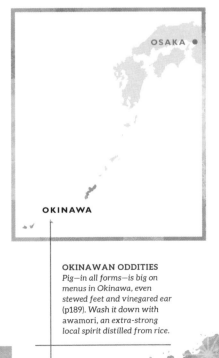

**˃ EAT UNTIL
YOU DROP**
*Osaka's unofficial motto is
kui daore—eat until you
drop. Osakans love food
and the city is famed for
its wonderful foodie
offerings (p188). Join the
locals in sampling cheap
and delicious street foods
such as takoyaki (battered
octopus balls).*

OSAKA KYOTO

OKINAWAN ODDITIES
*Pig—in all forms—is big on
menus in Okinawa, even
stewed feet and vinegared ear
(p189). Wash it down with
awamori, an extra-strong
local spirit distilled from rice.*

WHISKY WONDERLAND
The Yoichi Distillery, run by Nikka, is one of Japan's main distilleries.

HOKKAIDO

YOICHI

⌄ THE NATION'S BREADBASKET
The northernmost of Japan's four main islands is the country's largest producer of rice, wheat, potato, beans, sugar beets, vegetables, and dairy products. For the Japanese, if produce comes from Hokkaido, it must be good (p188).

LOST IN TRANSLATION
The Japanese word for the English term "sake" is *nihonshu*. The Japanese *sake* (or *o-sake*) refers to alcohol in general.

MORIOKA

OODLES OF NOODLES
Morioka is famed for its wanko soba *noodle-eating challenge (p188).*

NIIGATA

‹ SAKE CENTRAL
The breweries in Niigata make the best sake in Japan (p202). The pure runoff water from the region's snowmelt is a key component in the brewing process and also nurtures the numerous rice paddies where local sake rice is grown.

TOKYO

GOOD MANNERS
It is polite to say *itadakimasu* before a meal and *gochisosama* afterward to show appreciation to all those involved in creating it.

‹ CULINARY CAPITAL
Tokyo is one of the best places to eat in the world, with the most Michelin-starred restaurants of any city. Treat yourself to an elaborate dinner or grab a set-lunch bargain.

> Nigiri *sushi is thin slices of fish on top of rice.*

寿司と刺身

SUSHI AND SASHIMI

Ubiquitous classics

Ask someone outside Japan to name one Japanese food and the chances are high they'll say sushi. The lightly vinegared rice topped with seafood has become the unofficial national dish. Sashimi—sliced fillets of raw fish served without rice—is perhaps less well known internationally, but is no less of a Japanese culinary classic.

WASABI

Indispensable to both sushi and sashimi, wasabi not only provides a warming accent but also functions to suppress certain microbes in raw fish that could potentially cause food poisoning.

FRAGRANCE FREE

Sushi is subtle, so scents matter. High-end restaurants ask customers not to wear any perfumes that might taint the air.

SUSHI

What the world calls sushi nowadays developed in Tokyo in the 1800s. Initially a dish of raw fish on a bed of vinegared rice, it evolved into bite-sized format as a quick-to-eat street food. Sushi in its current form spans multiple culinary levels, from three-Michelin-star restaurants such as Sukibayashi Jiro in Ginza, Tokyo, to low-cost *kaitenzushi* (conveyor-belt sushi). Go high-end for a special occasion and you can expect to enjoy a tasting menu of seasonal seafood prepared directly in front of you—typically starting with lighter flavors such as flounder and then progressing to heavier tastes like sea urchin and eel.

Go low-end—the way most people would enjoy sushi with family or friends—and you can still eat well, plucking anything

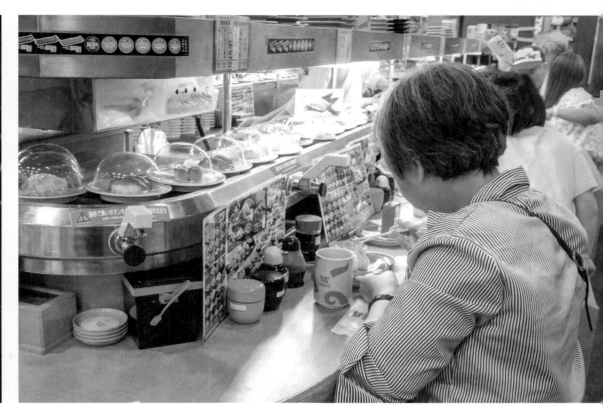

you fancy from the conveyor belt and even ordering very un-sushi sides like fried chicken, cheese fries, and creamy parfait. Even cheaper are supermarkets, where you can get a good-quality sushi bento (carryout)—ideal for a picnic.

SASHIMI

More often seen than sushi on *izakaya* (pub) menus or as part of dinner at home, not to mention a staple in the early courses in refined *kaiseki-ryori (p191)*, is sashimi. Sashimi is more popular, although it has nowhere near the same kind of profile outside Japan that sushi enjoys.

Maybe that's because it's such a simple dish—just skilfully sliced fresh seafood served with a little soy sauce and wasabi or grated ginger. Sashimi's simplicity goes

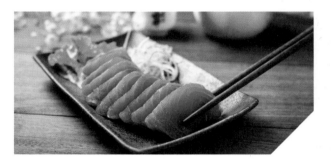

perfectly with a nice sake *(p202)* as a starter to a meal, when the palate is still clean enough to appreciate the delicate flavors of the seafood prepared this way. Tuna, salmon, sea bream, squid, bonito, yellowtail, and octopus are among the typical options you'll see on menus.

⌃ *Top to bottom: At kaitenzushi you are charged per plate; sashimi must be eaten with chopsticks, but for sushi it is also acceptable to use your hands.*

183

麺

NOODLES

A national institution

SOBA

UDON

SOMEN

Eaten at home, at no-frills stands, in restaurants, for lunch or dinner, hot or cold, spiced or subtle, noodles *(men)* in Japan come often and in numerous guises.

Of all the many noodle varieties in Japan, it's ramen that sits at the head of the table. It was first imported from China in the 19th century, when Japan reopened itself to the world after centuries of near-isolation, and today there are more than 50,000 ramen restaurants across the country. There are numerous types of ramen styles, which vary depending on the combinations of chicken, pork, fish, and vegetables used in their broths. Tonkotsu (or Hakata) ramen, for example, gets its distinctive milky look from its pork bone base, while the thickness of Sapporo ramen comes from the addition of miso (fermented soybean paste) to the broth. *Shoyu ramen*—the most common of all—has a clear brown broth because the chicken and vegetable base has soy *(shoyu)* added to it.

Other variations include soba, a brownish noodle made mainly with buckwheat flour and with a similar thickness and length to spaghetti. Typically it's served chilled with a dipping sauce or in a hot broth. Udon is a thick, whiteish wheat-flour noodle with a neutral flavor, which at its simplest comes in a warming broth of *dashi* (fish/seaweed stock) and soy sauce—though it can also be stir-fried *(yaki udon)*, served in a thick curry sauce, or cooked up in many other ways. *Somen*, a very thin wheat noodle, is never better than in the oppressive heat and humidity of summer, when it is chilled and served with an equally cool soy sauce and *dashi* dipping sauce.

SLURP UP

Whatever the noodle, the soundtrack is the same: slurping. In some cultures slurping might be considered offputting to other diners, but not in Japan. The act of slurping is part of the fun, a way to

WHATEVER THE NOODLE, THE SOUNDTRACK IS THE SAME: SLURPING.

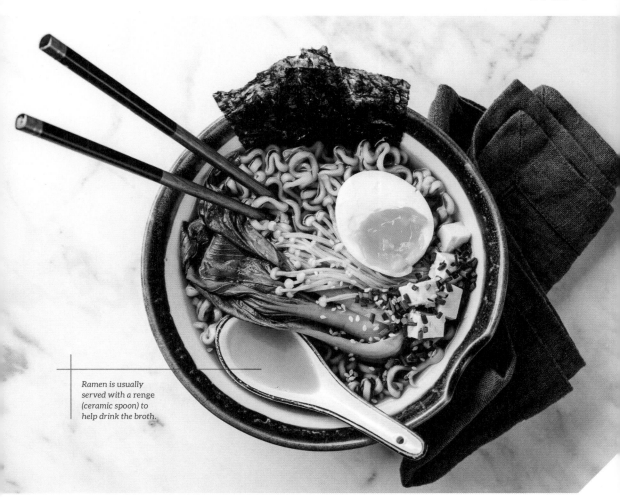

Ramen is usually served with a renge (ceramic spoon) to help drink the broth.

immerse yourself in the fleeting enjoyment of a bowl of noodles. It will also augment your tasting experience, as the process of aeration when slurping is said to enhance flavor, while the brisk inhalation supposedly sends delicate aromas deeper into the nasal passage.

However, don't feel bad if you just can't get used to slurping. A phrase coined in 2016 suggests not everyone likes it. *Nu-hara* (noodle harassment) describes the feeling of being annoyed by the sound of others slurping noodles.

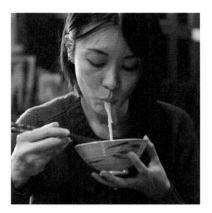

∧ Shoyu ramen *broth is based on soy sauce.*

< *Slurping is considered a sign of enjoyment when eating noodles.*

185

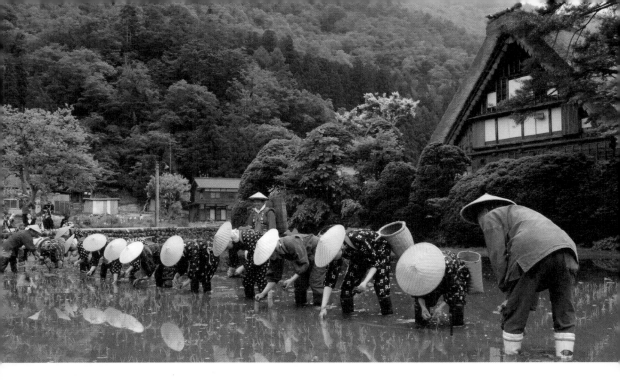

∧ Rice has been cultivated in Japan for over 3,000 years.

ご飯

RICE

An essential staple

The rice harvest usually takes place in fall.

It's integral to sushi and millions of daily bento (carryout boxes), is served in bowls as part of the traditional breakfast and *teishoku* set meals, and is also processed into *mochi* rice cakes and *senbei* rice crackers, as well as sake. Rice is the Japanese staple.

KEY CROP

Rice farming is a major industry in Japan, with the country's rice paddies producing 7.5 million tons of rice annually, including food varieties like Koshihikari and sake strains such as Yamada-Nishiki. Much of it is grown in rural areas like Hokkaido, Niigata, and the Tohoku region, but small-scale farms are scattered all over the country. The production cycle begins in the spring, when farmers cultivate seedlings in greenhouses and then plow and irrigate the paddies *(tanbo)* before transplanting the seedlings into the *tanbo*'s thick, wet mud. By autumn, the rice stalks will have golden ears hanging ready for harvest.

< *Left: Bento boxes often feature rice with fun decorations. Below: In a meal with several dishes, rice is usually served in a separate bowl.*

POPULAR DISHES

Rice consumption in Japan has dropped as more Western foods have entered the Japanese diet, but it still appears in myriad forms beyond sushi, bento, and plain bowls. For the ever-popular *donburi*, it's served in a bowl and then topped with all sorts of things: *tendon* (topped with tempura), *gyudon* (with a beef and fried onion mix), and *oyakodon* (chicken, onion, and loosely scrambled eggs) are just some of the options that you might come across. *Chahan* (fried rice), though Chinese, is another very popular rice dish, as is rice served with Japanese, Indian, and Thai curries. *Onigiri* rice balls are a savory snack found in every supermarket and convenience store (p192), while nourishing but light-on-the-stomach rice porridge (*okayu*) is the perfect comfort food if you're feeling under the weather—every rice cooker in Japan features a setting for making it.

Given how widespread rice is, it perhaps shouldn't come as a surprise that the Japanese word for rice, *gohan*, is used to mean both "cooked rice" and "meal." It also appears as a suffix in breakfast *(asagohan)*, lunch *(hirugohan)*, and dinner *(bangohan)*.

2.5

bowls of rice per person are eaten each day in Japan on average.

MIND YOUR MANNERS

The dos and don'ts of eating rice are easy to follow. First, don't leave your chopsticks standing in the bowl—this is what happens in funeral rites; use the chopstick rest instead. When eating from a rice bowl, hold the bowl with one hand and bring it toward your mouth when taking a mouthful with your chopsticks. That way, any food that drops should land back in the bowl. It is also polite to finish every last grain to show your appreciation for the food and farmers.

地域の食べ物

REGIONAL FOOD

Experiencing local flavor

Going local means eating local, and in Japan every city and region has its own specialties to try. Here are some of the highlights.

Hokkaido The chill of Hokkaido's deep winters is staved off with some of Japan's heartiest regional dishes, from the springy noodles and miso-heavy soup of Sapporo ramen to the *jingisukan* mutton barbecue and the warming *supu kare* (soup curry).

Tohoku Morioka in Iwate Prefecture is noodle country. Its *sandaimen* (three great noodles) include *reimen*, an extra-chewy noodle served in a chilled sour-spicy soup, and *jajamen*, a chunky wheat noodle that's mixed with a meaty miso paste. But the most distinctive of all is

> Street foods such as takoyaki *are served at stalls known as* yatai.

< Toppings for Sapporo ramen vary, but the soup is usually miso-based.

wanko soba, single-mouthful bowls of soba noodles. Consuming this dish has become an all-you-can-eat challenge, where diners see how many bowls they can devour—the record is a stomach-churning 632.

Tokyo Tokyo's *monjayaki* is the epitome of *B-kyu gurume*—simple, soulful, low-cost food. A bubbling, gooey batter mixed with diced cabbage and other ingredients, it is best tried at one of the many *monjayaki* restaurants that can be found in the captial's Tsukishima neighborhood.

Kyoto Kyoto does exceptional vegetarian food. In addition to tofu dishes such as *yudofu* (simmered tofu), there's *shojin-ryori*, a multidish form of Buddhist cuisine heavy on tofu variations and seasonal vegetables.

Osaka A classic Osaka street food, *takoyaki* are chunks of octopus cooked into dough balls and then served with a thick brown sauce, *aonori* (seaweed flakes), mayonnaise, and bonito flakes.

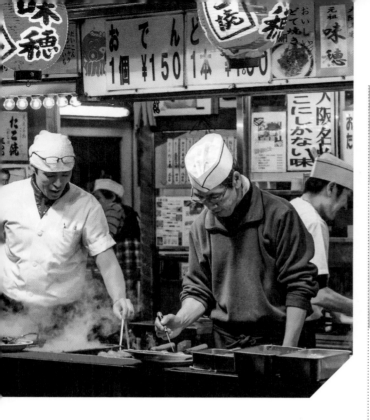

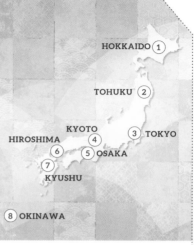

TAKE A BITE
A gastronomic tour of Japan.

(1) *Hokkaido* Warm your body and soul with hearty comfort food.

(2) *Tohoku* Get your noodle fix and try the *wanko soba* challenge.

(3) *Tokyo* Enjoy home-style, budget-friendly *monjayaki*.

(4) *Kyoto* Enter vegetarian heaven.

(5) *Osaka* Take to the streets to try *takoyaki*.

(6) *Hiroshima* Flip out on delicious savory pancakes.

(7) *Kyushu* Get your fill of Japan's best ramen.

(8) *Okinawa* Go crazy for all things pork.

Hiroshima *Okonomiyaki* (savory pancakes) are common all over Japan, but the way Hiroshima makes them is extra special. The key is the addition of noodles, and the gradual layering of ingredients before the pancake is lathered in a savory sauce.

Kyushu For many ramen aficionados, Hakata ramen from Fukuoka is the best. With a milky broth that comes from pork stock, it has slightly thinner noodles than other ramen and is topped with sliced roast pork and chopped green onions.

Okinawa Pork is highly prized as an ingredient on menus in Okinawa; local specialities include *mimiga* (vinegared pig ear) and *tonsoku* (simmered pigs' feet). Arguably the most Okinawan dish of all, however, is *goya champuru*—a filling stir-fry of firm *shima-dofu* (island tofu), egg, Spam, and a bitter local gourd that's known as *goya*.

TOKYO'S *MONJAYAKI* IS THE EPITOME OF *B-KYU GURUME*— SIMPLE, SOULFUL FOOD.

SAKIZUKE

Kaiseki-ryori menus vary, but usually feature set dish types. They often begin with the *sakizuke* course—a small appetizer or amuse-bouche.

SUIMONO

This light, clear soup, presented with minimal garnishes, is served as a refreshing palate cleanser.

HASSUN

The most attractive and artistic of all *kaiseki-ryori* components, the *hassun* is a seasonal platter of four or five hors d'oeuvres.

MIZUMONO

The meal concludes with a dessert, such as seasonal fruit, ice cream, or a traditional sweet.

SHOKUJI

A trio of dishes—rice, miso soup, and pickles—that are served together toward the end of the meal.

SUNOMONO

The *sunomono* course is a small vinegar-based dish designed to cleanse the palate. It usually features vegetables or seafood.

OTSUKURI

The *otsukuri* course is comprised of a selection of sashimi *(p182)*, which varies by season and by region.

TAKIAWASE

A lightly simmered vegetable dish served with fish, meat, or tofu.

YAKIMONO

A grilled dish that showcases seasonal fish (either freshwater or from the sea) or meat such as local *wagyu* (beef).

AGEMONO

A deep-fried dish, often featuring tempura and served with a dipping sauce or salt seasoning.

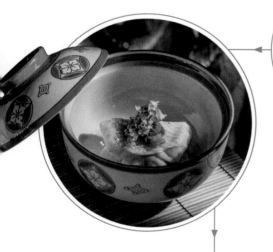

MUSHIMONO

This steamed dish can contain fish, chicken, or vegetables, and may also include a savory custard.

会席料理

KAISEKI-RYORI

A traditional tasting menu

Nothing demonstrates the intricacies of Japan's culinary arts like *kaiseki-ryori*. Prepared by specialized restaurants and also served at dinner in *ryokan* (traditional inns), *kaiseki-ryori* typically features 10 to 12 dishes enjoyed over the course of a couple of hours. From the traditional teahouse-like interiors to the kimono-clad staff and the tranquil atmosphere, it's a deeply Japanese experience before you even begin to eat. While the exact course progression and dishes served will vary, one thing you are guaranteed is a focus on seasonal ingredients. Dishes appear like works of art, served on fine lacquerware and ceramics, and delicately garnished with seasonal motifs like a cherry blossom bud in spring.

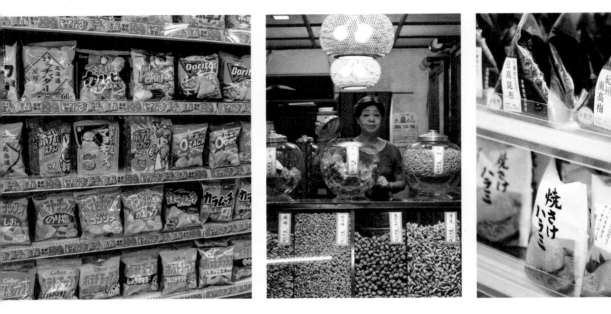

∧ *Left to right:*
Konbini stock a
mind-boggling array
of snack options;
rice crackers come
in many varieties.

おやつ

SNACKS

Eating on the go

Whether it's *senbei* (rice crackers) in front of the TV or a sneaky *melonpan* (sweet bun) in the office, Japan loves to snack. Visit any convenience store and the variety and volume of *oyatsu* (snack) options might leave you wondering how the Japanese got their reputation for being svelte and healthy.

Alongside daily necessities, ready-made meals and drinks, *konbini* (convenience stores) like 7-Eleven, Family Mart, and Mini-Stop are where kids with a few spare yen can grab cheap gum, candy, and classics like Umaibo, a puffed corn stick that comes in cheese, corn potage, teriyaki, and many other variations. Sharing the aisles with that are chocolates and chewy treats—the likes of Pocky chocolate-covered biscuit sticks and fruit-flavored Hi-Chew—as well as local chip brands with flavors that run from standard salt to consommé, pizza, pickled plum *(ume)*, salted seaweed *(nori shio)*, and fish roe *(mentaiko)*. Then come the more traditional savory options in the shape of *senbei*, hard rice crackers that usually have a soy tang to them but can also be sweetened, wrapped in seaweed, or flavored with sesame. Like *wagashi (p195)*, they are often eaten with tea.

NOTHING LIKE THE CREPES YOU FIND IN FRANCE, THE JAPANESE VERSION IS ALL ABOUT EXCESS.

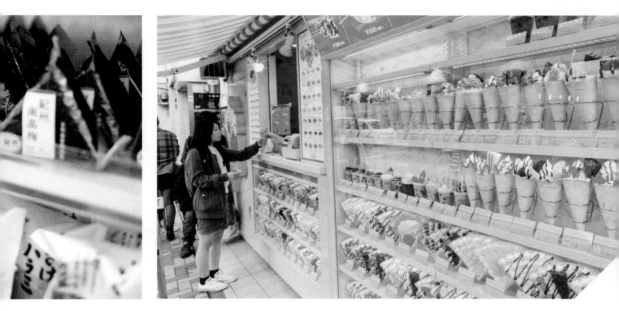

Overlapping the culinary middle ground between snack and meal, convenience stores also sell rice balls known as *onigiri*. Although they aren't actually balls—most are triangular—*onigiri* are ideal for a cheap lunch or a quick refuel, functioning as a Japanese equivalent to a sandwich. Typical single fillings inside the dried seaweed-wrapped rice include *konbu* seaweed, pickled plum, salmon flakes, and tuna with mayonnaise.

Away from the *konbini*, cake shops and bakeries offer a treasure trove of sweet treats. Creamy mille-feuille and red bean paste–filled donuts (*an-donatsu*) are common goodies, but arguably the most sumptuous offerings are crepes. Nothing like the crepes you find in France, the Japanese version is all about excess. They are best typified by the colorful creations you find at Café Crepe in Harajuku, Tokyo—crepe wraps bursting with whipped cream and fruit then lathered in chocolate and caramel sauce, some with a chunk of cheesecake or a scoop or two of ice cream squeezed in for good measure.

TASTE THE REGION

One trend you will notice while in Japan is regionality. Popular snack brands often create region-only versions based on local produce to tap into Japan's unrelenting custom of *omiyage*—bringing souvenirs home for friends, family, and co-workers. The epitome of this is Kit-Kats, with regional flavors including *hojicha* tea in Kyoto, lip-tingling *shichimi* spice mix in the Shinshu region, and wasabi in Shizuoka, as well as Japan-only varieties like sake and *matcha*. The brand initially became popular in Japan because the Japanese pronunciation sounds like *kitto katsu*, or "good luck," making it a suitable gift to give a little encouragement.

∧ *Left to right:* Onigiri *are a common sight in* konbini *throughout Japan; Japanese crepes are a popular street food and come in hundreds of flavors.*

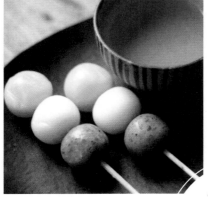

SEASONAL SHAPES

Wagashi served in teahouses are often fashioned in forms that reflect the season.

PERFECT PAIRING

The sweetness of *wagashi* is intended to balance the bitterness of green tea.

BEAUTIFUL CREATIONS

Wagashi are designed to be appreciated as much for their appearance as for their taste.

わがし

WAGASHI

Exquisite confections

Delicately sculpted works of edible art, *wagashi* (traditional sweets) are typically served with a soothing cup of green tea. They are a time-honored component of the tea ceremony (*p198*), but you can also find them in supermarkets, convenience stores, and candy shops to enjoy at any time.

Wagashi come in countless variations, but many share certain characteristics. Rarely creamy or chocolatey, they frequently feature ingredients like *anko* (sweetened azuki bean paste) and *mochi* (glutinous rice cake), and flavorings like tea, sesame, and fruits. One of the most common types is *daifuku*, a small round of *mochi*, most often stuffed with *anko* or a whole strawberry. Another classic *wagashi* is *yokan*, a firm jelly block typically made with *anko*, sugar, and Japanese agar, though also look out for non-*anko* versions such as green tea, chestnut, and plum. *Dango* is an essential delicacy to try if you visit the old Shibamata area of northeastern Tokyo—these little dumplings made of rice flour are never better than when skewered, basted with a sweet and sticky sauce, and then finished on a grill. Other highlights include *manju* (a small steamed bun with an *anko* filling), *dorayaki* (a kind of spongy sandwich), *warabimochi* (a wobbly bracken-starch jelly coated with sweet toasted soybean flour), and *karinto* (an airy, deep-fried mix of brown sugar, flour, and yeast).

‹ *The shape, texture, and flavor of* wagashi *vary greatly, with some forms only available in certain regions or seasons.*

お茶

TEA

Japan's favorite pick-me-up

It is served in business meetings, comes hot or cold in bottles and cans in vending machines across the land, and is the perfect accompaniment to sweet treats or the comforting warmth of a *kotatsu* heated table. Full of goodness and caffeine, green tea is a Japanese institution.

It was first brought to Japan from China by Buddhist monks, and the earliest reference to tea drinking in Japan dates to the early 800s. Just over 1,200 years later, green tea is a firm feature in everyday life. It's a healthy habit to acquire—green tea is not only packed with vitamin C, but also contains antioxidants. Research has linked regular consumption of green tea to numerous health benefits, including reduced risk of cardiovascular disease and strokes, lower levels of bad cholesterol, and potential anticancer effects.

Tea is sipped everywhere, from Tokyo's cool cafés to elaborate tea ceremonies in temple gardens *(p198)*. While drinking green tea straight—either hot or cold—is by far the most common approach, you'll

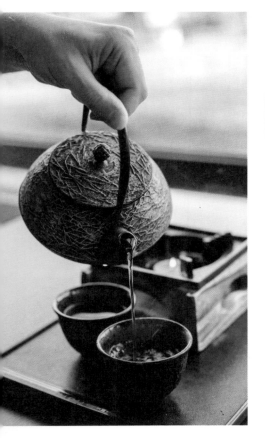

⌄ Tea is traditionally brewed and served in a handcrafted teapot.

YOU CAN EVEN FIND GREEN TEA NOODLES, CREAM DESSERTS, AND LIQUEURS.

TEA VARIETIES TO TRY

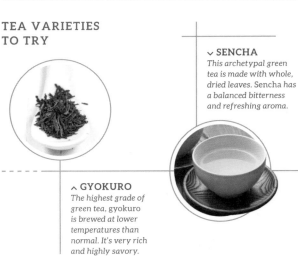

⌄ SENCHA
This archetypal green tea is made with whole, dried leaves. Sencha has a balanced bitterness and refreshing aroma.

⌃ GYOKURO
The highest grade of green tea, gyokuro is brewed at lower temperatures than normal. It's very rich and highly savory.

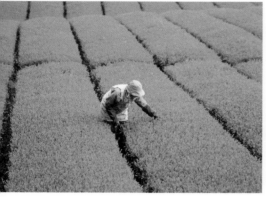

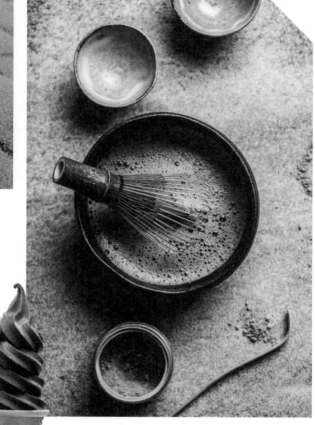

also find it in chilled lattes and milkshakes. And green tea's reach goes far beyond drinks. Kit-Kats, Pocky, Oreo, and many other sweet snack brands have green tea varieties, and you often can spot *matcha* ice cream in convenience store freezers. Visit a tea center like the town of Uji in Kyoto Prefecture—along with Shizuoka Prefecture one of the top tea-producing areas in Japan—and you'll soon discover green tea noodles, cream desserts, sweet *mochi* (rice cake) dumplings, and liqueurs. Tea is simply everywhere.

MATCHA ICE CREAM

⌃ *Left to right: Shizuoka is known as the green tea capital of Japan; matcha tea is made with powder.*

⌄ **MUGICHA**
Cold-brewed from roasted barley, toasty mugicha is especially popular in summer.

HOUJICHA
The leaves are roasted, producing a rich, nutty tea with a reddish-brown color.

⌃ **MATCHA**
A finely ground powder that is whisked with hot water, this is the tea used in tea ceremonies. It's rich, almost creamy, and full of flavor.

GENMAICHA
Dried green tea leaves are mixed with popped brown rice to give a nutty flavor.

茶の湯

TEA CEREMONY

The way of tea

The Japanese tea ceremony is a highly choreographed ritual, perfected over centuries to clear the mind by focusing on the moment. The exact way to whisk powdered green tea and hot water into a frothy *matcha*, the placement of tea utensils, even the vocabulary—all are strictly prescribed. Rooted in the tenets of Zen and the spiritual discipline of the samurai, the tea ceremony is based on principles laid out in the 16th century by Japan's most famous tea master, Sen No Rikyu. Crafts relating to its accoutrements—*ikebana (p75)*, calligraphy *(p92)*, ceramics *(p86)*, and landscape gardening *(p78)*—have all been profoundly shaped by this philosophy.

A ceremony that includes a *cha kaiseki* meal can last up to four hours, but you can take part in shorter versions lasting from 20 to 90 minutes. For a beautiful garden setting head to Gyokusen'en in Kanazawa (Ishikawa Prefecture), or, for full immersion in all things tea, make your way to Matsue (Shimane Prefecture) for the annual October Grand Tea Ceremony. Kyoto is home to the headquarters of the tea ceremony training school Urasenke, which provides in-depth courses.

ETIQUETTE

Conversation should be limited and respectful, centered on the beauty of the tea bowl, the excellent flavor of the tea, and the garden view or *ikebana*.

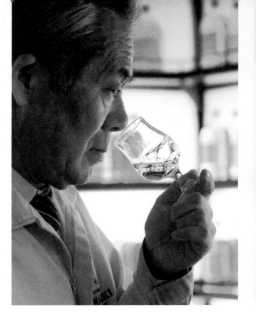

ウィスキー

WHISKY

Award-winning spirits

Whisky production is a relatively new craft in Japan, but the country's distillers have wasted no time in making their mark on the industry. Today heralded as world-class, Japanese whiskies have won countless accolades and praise—not bad for a country with only a handful of distilleries.

SCOTTISH ORIGINS

In 1854, armed American ships opened up Japan after more than two centuries of self-imposed isolation. The Americans brought gifts with them, including casks of whisky. However, it wasn't until 1920, when chemist Masataka Taketsuru returned from studying whisky-making in Scotland, that the brown spirit's distilling secrets arrived in Japan. In 1923, Taketsuru helped set up the Yamazaki Distillery before later establishing his own, the Yoichi Distillery. The companies behind each one—Suntory and Nikka, respectively—still dominate the Japanese whisky industry today.

A LOCAL TWIST

Japan's distillers typically adhere to Scotch methods, but the country's distinct seasons have a significant impact on the maturation process—the cold winters slow the aging of the spirit, while the humid summers speed it up. A variety of casks are used in the aging process, but the country's indigenous lumber, most famously *mizunara* (Japanese oak), ages unique whisky that's subtle, yet strong. Unlike their Scottish counterparts, Suntory and Nikka distil a mind-boggling array of whiskies in-house, giving them great control over their products and enabling them to experiment with different whisky-making techniques.

> SUNTORY AND NIKKA DISTILL A MIND-BOGGLING ARRAY OF WHISKIES IN-HOUSE.

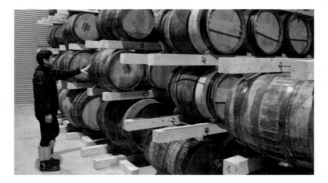

‹ *The Yoichi Distillery was founded in 1934.*

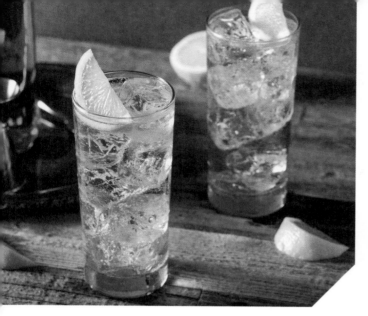

< *Left to right: Suntory's blenders sample up to 250 whiskies a day; whisky highballs are a refreshing mix of whisky and fizzy water.*

JAPAN'S FAVORITE WHISKY DRINK

Japanese whiskies can be drunk either straight or on the rocks, but the most popular way to enjoy them in Japan is as a whisky highball. Three parts carbonated water and one part whisky (cheap blends work well), highballs helped to power the spirit's national ascent in the decades after World War II. Adding soda knocked down the high alcohol percentage, creating a refreshing beverage the country loved. After whisky fell out of favor in the early 1980s, being overshadowed by clear spirits like *shochu* (sweet potato, barley, or rice liquor), it was highballs that brought Japanese whisky roaring back in the 2000s. The highball won't overpower your food, making it ideal for pairing—soul foods, like *takoyaki* (octopus balls) and *okonomiyaki* (savory pancakes) are particularly good companions, as is *yakiniku* (grilled meat).

Commemorative bottles celebrate events like the Year of the Pig.

WHISKY BOTTLE

TAKE A TOUR

Learn about whisky-making and taste the wares at these top distilleries.

① *Yoichi Distillery (Yoichi, Hokkaido Prefecture)* Perhaps the most beautiful distillery in Japan, Yoichi is the only whisky distillery in the world to have coal-fired pot stills.

② *Kirin Fuji Gotemba Distillery (Gotemba, Shizuoka Prefecture)* Kirin's whisky distillery sits at the foot of Mount Fuji, which provides the water for its whisky.

③ *Yamazaki Distillery (Shimamoto-cho, Osaka Prefecture)* Founded in 1923, the Yamazaki Distillery is the oldest in Japan.

日本酒

SAKE

The quintessential Japanese tipple

The Japanese call it *nihonshu*, in English it's sake—whatever the terminology, it's estimated that some form of fermented rice has been drunk in Japan for almost 2,000 years. From its earliest days being brewed at temples and shrines (where sake still plays a role in many rituals) through the first sake breweries in the Muromachi Period (1333–1573) to now, sake has become Japan's national drink.

> ## SOME FORM OF FERMENTED RICE HAS BEEN DRUNK IN JAPAN FOR ALMOST 2,000 YEARS.

AN ANCIENT PROCESS

The basic process followed by Japan's 1,200 sake breweries, who between them produce roughly 37 million gallons (168 million liters) annually, has remained largely unchanged for generations. First, rice is polished, washed, and steamed, then mixed with yeast and *koji* (rice cultivated with a mold) and allowed to ferment over several days of mixing before being added to water for three or four weeks of full fermentation. Pressing, filtration, pasteurization, and maturation take place before bottling; then it's ready to pour into a glass, give a *kampai* (cheers), and drink.

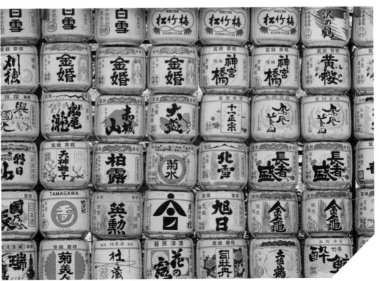

⌃ Above: High-quality rice is essential for good sake. Right: Sake is matured in wooden casks made of cypress.

MAKING THE GRADE

The grade is a key part of a sake. At the most refined end of the scale comes *junmai daiginjo*, where the rice has been polished down to at least 50 percent. This is done because the outer part of the rice grain contains fats, proteins, and other things that can produce undesirable flavors or interfere with fermentation; the innermost core is where all the starches are found, and it's these that ferment into top sake in the brewing process. The more the rice is milled, the more refined, fragrant, and light on the palate the final brew will be. And what makes *junmai daiginjo* extra special is the *junmai* (pure rice) part—no extra alcohol is added; the only ingredients are rice, water, *koji*, and yeast. With low-grade sake, brewed sake is mixed with large amounts of distilled spirits.

MANY CHOICES

For aficionados, each sake is defined by its intricacies—where it was brewed and by whom, what rice was used and how extensively the rice was milled, what *koji*

or yeast was employed and at what temperatures. For the average drinker, choices are made from much simpler criteria. With a standard form of sake, do you want something that is dry (*karakuchi*) or sweet (*amakuchi*)? And what temperature? For a standard sake, room temperature is common, as is chilled (*reishu*), but on a cold night a gently warmed sake (*atsukan*) is very appealing. It all comes down to your personal taste rather than rules or etiquette.

Sake is usually enjoyed with food. Whatever type of sake you opt for, in most restaurants and *izakaya* (pubs) you usually order it in a measure called an *ichigo* (6 fl oz / 180 ml), which comes in a small decanter along with a very small glass or a ceramic cup (called a *choko*). Sometimes your sake will be served in a *masu*, a little wooden box with a glass inside that's filled until it spills over into the box. Sake pairs beautifully with Japanese cuisine, but you can also try it with Western food, from cheese to steak and fries.

∧ *Sake is frequently served in delicate ceramic cups.*

健康な日本

HEALTHY JAPAN

The Japanese are among the longest-living people on earth, attributed in part to a healthy traditional diet. Looking inward, there's a degree of mindfulness that could also play a part in Japan's exceptional culture of wellness and longevity. The importance of the group and appreciating every connection helps ward off the feelings of isolation that can afflict people struggling through the daily grind of modern life. Meanwhile, the concept of *ikigai* (purpose) asks us to find our reason for getting up in the morning, and encourages the older generations of Japan to continue to get out and stay active. There are also ways of thinking ingrained in Japanese culture that provide a different perspective from Western thought, many adopted from ancient, spiritual principles. Shinto, for example, fosters a love of the outdoors with its nature worship and deities residing in every aspect of the world around us. Natural extensions of those principles include *shinrin-yoku* (forest bathing) to help reduce the stress of urban living, and, most pleasurable of all, soaking in Japan's *onsen* (hot springs).

地図の上から

ON THE MAP

Exploring healthy Japan

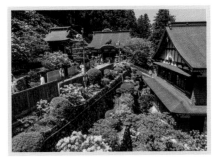

It's easy to absorb some of the country's healthy lifestyle in your everyday experiences in Japan—especially taking in the traditional diet of fish, rice, and fermented foods. For some exercise, join in with the weekend joggers running the course around Tokyo's Imperial Palace, or take it one step further by following an ancient pilgrimage or hiking in a stunning national park. With Japan's strong Shinto belief in celebrating nature, spending time in the great outdoors has always been important here, and one of the best ways to get out and unwind is to take a dip in a natural hot spring, to soak your cares away and give your skin a healthy glow.

LOVE IT OR HATE IT

Natto, fermented soybeans with a slimy texture, may be good for you, but even many Japanese don't like it.

∧ SHIKOKU PILGRIMAGE

It can take up to 60 days to trek this 870-mile (1,400-km) circular route connecting 88 Buddhist temples (p215). On your journey you'll take in rugged coastlines, steep mountains, and rural landscapes.

EXERCISE WITH A VIEW

Spectacular vistas of alluring beaches and the island-studded sea are just some of the highlights of the 45-mile (70-km) Shimanami-Kaido, a bike path that hopscotches across the Seto Inland Sea in southern Japan.

❯ HEALTHY DIET

Okinawa Prefecture has one of the world's highest percentages of centenarians (p212), but they're also incredibly healthy, living on a plant-based diet that balances their love of fatty pork. Typical dishes are served in Yunangi and are taught in cooking classes at Taste of Okinawa, both located in the city of Naha.

SETO INLAND SEA

SHIKOKU

BEPPU

KAGOSHIMA

KAGOSHIMA

OKINAWA

THE HELLS OF BEPPU

Beppu is a traditional resort town with more hot springs than anywhere else in Japan (p208). The Hells (jigoku) are seven springs with unique features: some different colors, and one a home to crocodiles.

HAKODATE ●────────────────────

LONGEVITY

Life expectancy is 87 years for women and 81 for men, and Japan has over 65,000 centenarians.

∨ HEAVENLY CHERRY BLOSSOMS

Ichi-go ichi-e is a Japanese concept that urges us to appreciate the moment and cherish every meeting (p219). Make your own treasured memories and enjoy the fleeting beauty of spring by gathering with friends at Goyokaku Park in the town of Hakodate or a cherry-blossom viewing party.

NIIGATA

TOKYO

> BACK TO NATURE

Shinrin-yoku, or forest bathing (p219), is a way for stressed urbanites to unplug and immerse themselves in the healing power of nature by letting the sights, smells, and sounds of the great outdoors fill their senses. Even sprawling Tokyo offers respite at nearby Mount Takao.

> HOT AND COLD

Grab your skis and enjoy the dozens of ski resorts in Niigata Prefecture. Warm up afterward in a hot spring, from the milky-white waters of Tsubame to the grass-green Tsukioka.

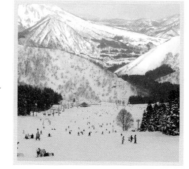

TATTOOS

Tattoos are associated with the Japanese mafia, so people with inked skin are banned from many *onsen* in Japan. Check the rules before booking.

温泉

HOT SPRINGS

An essential Japanese experience

With over 100 active volcanoes and more than 27,000 thermal springs, Japan has developed a unique culture around bathing that centers on the country's much-loved hot springs, known as *onsen*. The fondness for these warm, natural pools has turned what would otherwise be just an ordinary bathing routine into a cultural and social experience, and the Japanese soak in *onsen* to heal aches and pains, escape the rigors of daily life, and socialize with friends and family. The Japanese are such *onsen* fans that dedicated *onsen* resort towns have been developed, where guests can wander around in their *yukatas* (cotton kimonos) and dine on local cuisine between baths. There are even *onsen* just for pets—and wild animals also get in on the act, with Japanese macaques blissfully soaking away in Jigokudani Snow Monkey Park (Nagano Prefecture).

TYPES OF BATHS

There are several types of baths to choose from in every resort town. A *sento* is simply a public bath with artificially heated tap water, while the authentic *onsen* use natural springs. A thermal bath that is located outdoors is called a *rotenburo* and is loved by Japanese as a way to connect with nature, sometimes offering unparalleled views of the countryside or a peaceful garden.

ROTENBURO

Many *rotenburo* provide spectacular views you couldn't access any other way. Visiting in winter makes a particularly beautiful experience.

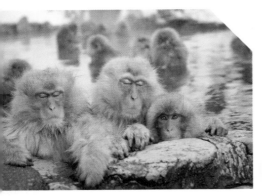

‹ In the north of Japan, the macaques live in the coldest climate of all wild primates.

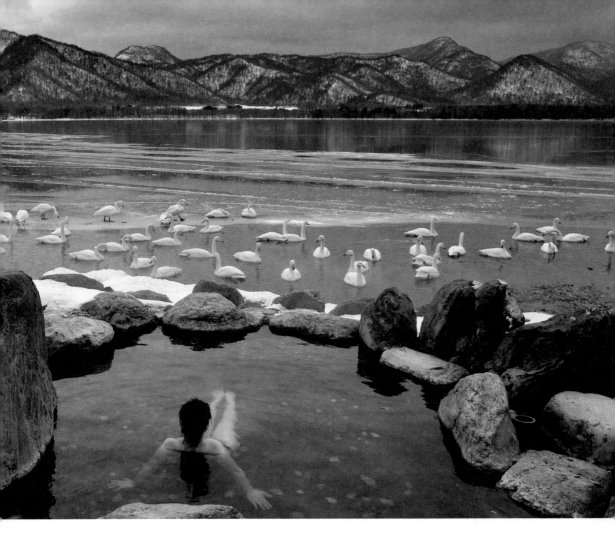

NATURAL REMEDIES

Although any *onsen* can stimulate blood circulation and metabolism, most also contain minerals considered beneficial as treatment for arthritis, diabetes, neuralgia, and other ailments. There's even a word—*toji* (balneotherapy)—for the treatment of health problems by bathing in mineral springs.

A key bonus of *onsen* comes from the water's sodium chloride, which encourages perspiration, thereby ridding the body of waste. This helps produce the feeling of silky-smooth skin much prized by Japanese women, as well as being good for skin ailments such as eczema, abrasions, burns, and dermatitis.

On a trip to a resort town, the Japanese may make several trips between soaking in the natural baths and cleaning themselves at the taps, but they usually end with one last dip in the *onsen* to take full advantage of the water's medicinal qualities.

∧ *There's nothing more peaceful than sitting in a warm* rotenburo *surrounded by snow.*

JAPAN HAS A UNIQUE CULTURE AROUND BATHING THAT CENTERS ON *ONSEN*.

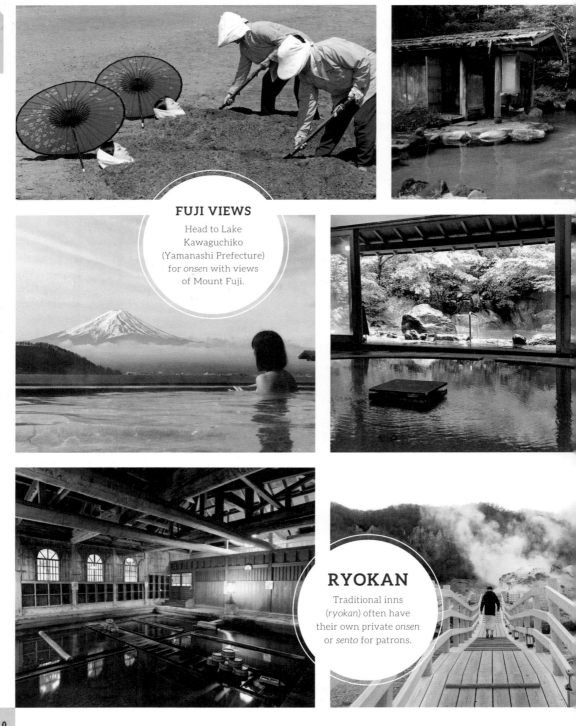

FUJI VIEWS

Head to Lake Kawaguchiko (Yamanashi Prefecture) for *onsen* with views of Mount Fuji.

RYOKAN

Traditional inns (*ryokan*) often have their own private *onsen* or *sento* for patrons.

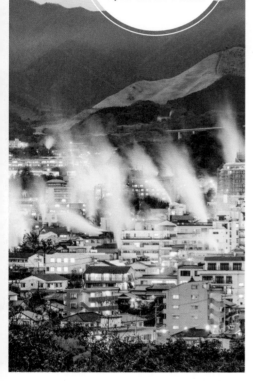

SPLIT BATHS

Baths are usually separated by gender, with a blue curtain signifying the men and a pink one for women.

温泉で楽しむ

ENJOYING THE ONSEN

Healing powers and stunning views

More than 3,000 *onsen* towns dot Japan's mountain ranges, river valleys, and coastlines, offering a unique cultural experience and some of the most breathtaking views of Japan from the waters of outdoor *rotenburo*. Don't miss a chance to enjoy this quintessential Japanese custom, as *onsen* are the perfect place not only to rejuvenate but also to meet Japanese people on weekend getaways or on extended stays for balneotherapy.

Whether it's a *sento* or *onsen*, etiquette is the same. With few exceptions, bathing is done in the nude, and customers must soap up and rinse off from head to toe at one of the taps lining the wall before entering the bath. Washcloths, provided free or for sale, should never touch the bathwater (it's a good idea to drape it over your head to keep track of it).

For a unique experience beyond the typical *onsen*, there are other spa treatments to discover—some of which allow patrons to be clothed or wear swimsuits. At Yunessun Spa Resort in Hakone (Kanagawa Prefecture) you can swim in pools filled with wine or sake, each claiming to have specific health benefits. On Ibusuki beach (Kagoshima Prefecture) customers dress in *yukatas* (cotton kimonos) and are buried up to their necks in the hot, black sand, supposedly to improve fertility and help with weight loss.

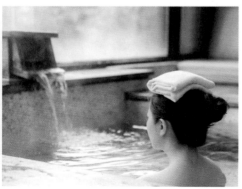

‹ *Clockwise from top left: Ibusuki beach (Kagoshima Prefecture); Nyuto Onsen (Akita Prefecture); Beppu (Oita Prefecture); washcloth etiquette; Hell Valley (Hokkaido Prefecture); Hoshi Chojukan ryokan (Gunma Prefecture); Kawaguchiko (Yamanashi Prefecture); Hakone (Kanagawa Prefecture)*

∧ *Exercise is integrated into the daily routine for many commuters.*

食生活、運動、長寿

DIET, EXERCISE, AND LONGEVITY

How to reach 100

∨ *Edamame and other soy products are thought to reduce the risk of all kinds of diseases, from diabetes to depression.*

Healthy living is practically ingrained into the everyday through the traditional diet of fish and rice, and by the common practice of incorporating exercise into the morning routine. With more than 2 million people currently aged over 90, Japan certainly must be doing something right when it comes to wellness.

EAT THE TRADITIONAL DIET

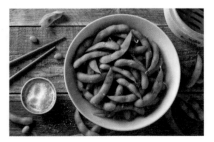

Japan's advanced public health system is certainly one factor that contributes to the nation's reputation for healthy living and longevity, but another key element is the classic Japanese diet. Typical meals are lean and balanced, consisting of a bowl of rice, miso soup, a piece of meat or fish, with vegetables and green tea. These and other time-honored foods help protect against heart disease, obesity, and many other disorders. The Japanese are also major consumers of heart-healthy fish and soybeans, from fresh edamame and tofu to fermented *natto*, which offers probiotic qualities if you can get over its slimy texture. Both fresh and pickled vegetables are a staple, as is seaweed, which contains essential nutrients and antioxidants. Dessert tends to be fruit or foods containing *anko* (sweet bean paste).

Even the Japanese style of dining— consisting of several small dishes rather than a single plate piled high with food— is said to encourage mindful eating.

EXERCISE BECOMES PART OF THE DAILY ROUTINE WITH RADIO CALISTHENICS.

KEEP ACTIVE

For older Japanese people, exercise has been part of the daily routine since *rajio taiso* (radio calisthenics) was introduced by national broadcaster NHK in the 1920s. The program is still going today, providing an early-morning workout that takes listeners through 15 minutes of movements to kick-start the day.

Of course, a 6:30am workout is often the last thing on busy minds in the morning these days, and *rajio taiso* is not as popular as it once was. Still, about one-third of the population walks or takes to their bicycles as part of their morning commute or daily errands, so staying active is still integrated into many people's routines.

OKINAWA'S CENTENARIANS

Japan is well known for its long-living and healthy elderly population, something which has made Okinawa Prefecture particularly famous. The warm climate of this tropical island chain is definitely a factor here, as is the traditional, plant-based diet—but it's also the lifestyle and essential culture of wellness that have made the Okinawans global icons. Even in their 90s and beyond, many of the elderly are still fishing and farming as they always have. This idea of *ikigai* (having a reason to get up in the morning) and contributing to the community make the centenarians of Okinawa a real inspiration. Try adopting some of their traditions for your own well-being, like following the rule of "*hara hachi bu*"—which means you stop eating when your belly is 80 percent full.

TOKYO ON FOOT

If you want some exercise in Japan, put on your running gear and head to Tokyo's Imperial Palace. The 3-mile (5-km) route looping around the grounds—uninterrupted by stoplights or crossings—is one of the most popular jogging spots in the city and a venue for numerous running events during the year. Tokyo also has its own major marathon in the spring, which has close to 500,000 applicants for only 35,000 spots.

⌄ *Okinawa is designated as one of the world's five "blue zone" regions, where people live exceptionally long and healthy lives.*

∧ *Left to right:*
Gokurakuji in Kamakura
(Kanagawa Prefecture)
is a stop on the Shikoku
88 Temple Pilgrimage;
pilgrims traditionally
dress in white.

巡礼の旅と道筋

PILGRIMAGES AND PATHWAYS

Seeing Japan from a new perspective

With mountains covering most of Japan, travel was historically done mostly on foot. During the Edo Period (p31), feudal lords were required to travel to Edo (present-day Tokyo) every two years—arduous journeys that included long processions of samurai retainers and attendants traveling on official roads like Nakasendo and Tokaido. For commoners, travel was mostly forbidden, but an exception was made for religious pilgrimages to sacred sites, making these routes wildly popular. Today you can set out on one of these pilgrimage routes as a way to connect with Japan's past and experience the islands' varied countryside—and maybe even get in touch with your spiritual side as well.

STEP INTO SPIRITUAL JAPAN

Pilgrimages today are as much about the journey as the destination. On the Kumano Kodo in the Kansai region you can hike a 1,200-year-old network of trails in the dense forests of the Kii Mountains, following in the footsteps of religious pilgrims and members of the imperial family, who considered Kumano a "Buddhist Pure Land." Listed as a UNESCO World Heritage Site, the Kumano Kodo's various routes offer many options, including visits to the Grand Shrines of Kumano or Ise Jingu (p62), sleeping in a Buddhist temple atop Mount Koya, relaxing at an *onsen*, or seeing natural wonders like Japan's tallest waterfall.

KOBO DAISHI

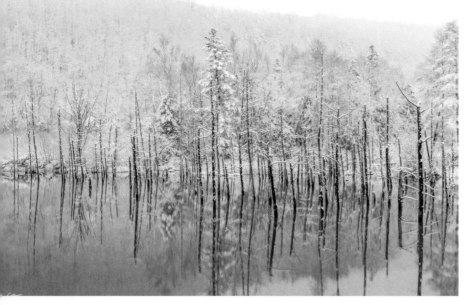

< *Daisetsuzan National Park in Hokkaido is Japan's largest national park.*

Shikoku's 88 Temple Pilgrimage honors charismatic Buddhist monk Kobo Daishi, who in the 9th century established the Shingon sect of Buddhism on Mount Koya. The pilgrimage links 88 temples on a 870-mile- (1,400-km-) long circuitous route that takes up to 60 days. *Ohenro-san* (the name for the pilgrims on this route) are traditionally clad in white with cone-shaped hats and walking staffs, topped with a little bell to help keep their mind on the present. Nowadays many *henro* complete the circuit on chartered buses, but for a truly unique travel experience, set out on the trail on foot.

EMBARK ON A LONG-DISTANCE WALK

There's no better way to see the country beyond the big cities than to put on your hiking boots and set out for a long walk. There are all kinds of landscapes to explore, so take your pick of the trails crisscrossing the country and enjoy the breathtaking landscapes they offer. For a little bit of everything, Daisetsuzan is Hokkaido's most spectacular national park, full of volcanic peaks, forests, river gorges

laced with waterfalls, and the challenging 34-mile- (55-km-) long Grand Traverse trail. Meanwhile, the 435-mile (700-km) Michinoku Coastal Trail is Japan's newest footpath, hugging Tohoku's coastline with its rugged cliffs, marine scenery, beaches, and fishing villages. In central Honshu's Japan Alps, Kamikochi is a popular base for day and extended hikes, while the stretch of the old Nakasendo highway between Tsumago and Magome is like taking a step back in time, as you journey though old post towns that once catered to feudal lords and samurai.

˅ *Kamikochi's wild scenery attracts hikers from all over Japan.*

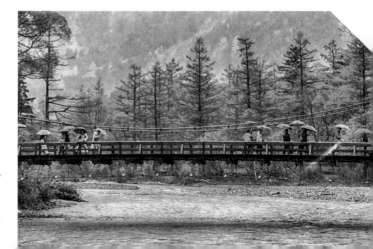

吉田口トレイル

THE YOSHIDA TRAIL

A hike to the top of Mount Fuji

A site of pilgrimage since the 7th century, Mount Fuji *(p52)* continues to attract climbers, though most people undertaking the ascent today do so for recreational purposes rather than spiritual ones. During the July to September climbing season, some 250,000 people from Japan and all over the world make the laborious trek to the top, motivated by the satisfaction of having climbed Japan's highest peak—not to mention the reward of the awe-inspiring views. There are numerous routes of varying lengths and difficulties, the most popular of which is the roughly eight-hour Yoshida Trail. It's easily accessible, with lots of facilities along the way. For a truly unforgettable experience, make the climb by night—or start in the afternoon and sleep in a mountain hut before an early start—to ensure that you arrive in time to catch the breathtaking sight of sunrise from the peak.

GORAIKO

The Japanese have a special word for the sunrise from the top of Mount Fuji: *goraiko*.

日本人の哲学

JAPANESE PHILOSOPHIES TO LIVE BY

Finding inner contentment

While most Japanese people would hesitate to identify themselves as religious, the influence of ancient spiritual beliefs winds through many aspects of modern society and the way the Japanese view the world around them. The idea that objects are ingrained with a spirit is a core tenet of Shinto *(p60)*, and this manifests in all kinds of common rituals. The introduction of Buddhism *(p65)* brought such concepts as life's transience, mindfulness, and the positive state of *mu* (nothingness): a void filled with meaning and possibilities. Confucianism arrived in Japan around the 6th century and centered on the teachings of the Chinese philosopher Confucius,

and while the religion itself gradually disappeared after World War II, some of the concepts it emphasized are still key elements of Japanese culture: loyalty, duty, and consideration of others in the pursuit of harmony. This group dynamic is also inherent in the Japanese concept of *wa*, which prioritizes solidarity of community over individual interests.

The legacy of these beliefs is ever present throughout life in Japan: from the importance of team spirit in school to the mindfulness of *ikebana (p75)* and the tea ceremony *(p198)*. It's also why a Japanese person today can find great satisfaction in a job well done—as their success isn't purely personal but helps the whole group—or why they can be awestruck by the beauty of spring cherry blossoms, appreciating the bittersweet fleetingness of this perfect moment.

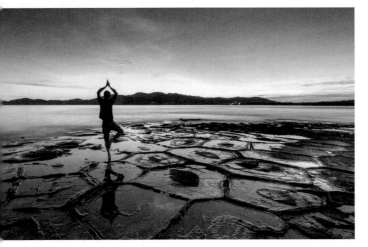

‹ *Mindfulness and an appreciation of nature are central to Japanese philosophy.*

< Spending time with friends should be cherished as a moment that will never be repeated.

DE-STRESS

For a step toward inner peace, try *shinrin-yoku* (forest bathing)—just find a green space and unlock your senses.

CHERISH THE MOMENT

This awareness of life's transience perhaps inspired the proverb *ichi-go ichi-e*, which means "one time, one meeting." The idea urges us to treasure any encounter with a stranger or friend as a once-in-a-lifetime opportunity. Be mindful of how each gathering with friends and family is unique, and how meeting people you'll never see again is a special moment in time when your paths have been destined to cross. To really get the feel for *ichi-go ichi-e* in Japan, join in a tea ceremony, where each experience is valued as one that can never be replicated.

FINDING HAPPINESS

In modern society, it's easy to get wrapped up in the daily routine of commuting, working, and household chores. This is one reason why the Japanese concept of *ikigai* has become more important than ever. Your *ikigai* is the reason you get up in the morning; intensely personal, it's about doing what you love and what you're good at, whether it's work or a hobby. Finding your *ikigai* gives you inspiration and confidence and purpose, so take some time to figure it out. It may even help you to live longer—*ikigai* could be a contributing factor to Japan's famous long-living communities *(p213)*, as continuing to get out and enjoy their *ikigai* helps the older generations stay happy and active.

^ Escaping the urban sprawl with forest bathing is a great way to rejuvenate.

219

INDEX

ACKNOWLEDGMENTS

The publisher would like to thank the following for their kind permission to reproduce their photographs:

Key: a-above; b-below/bottom; c-centre; f-far; l-left; r-right; t-top

123RF.com: coward_lion 44br; primagefactory 211bl.

4Corners: Susanne Kremer 6-7.

Alamy Stock Photo: Aclosund Historic 133cla; Aflo Co. Ltd. 177tl, / Kazunori Araki 49tl, / Nippon News 142crb, 154bl, 173br, / Naho Yoshizawa 102crb; Andia 47bl; ArcadeImages 109tr; Arcaid Images / Richard Bryant 119tl; Arif Iqball Photography - Japan 143bl; ART Collection 83cr; Art Directors & TRIP / Helene Rogers 109cr; Artokoloro 82-3t, / Quint Lox Limited 110cl, 133tc; Patrick Batchelder 108-9; Bazza 102clb, 159tr; BFA / FUNimation Entertainment 169br; Jeffrey Blackler 119br; Phillip Bond 104-5t; Paul Brown 202br; carlos cardetas 138tc; Berengere Cavalier 40cl; Felix Choo 173cr; Chronicle 70-1ca; Stephen Chung 125c; Classic Image 29cb; Collection Christophel / Toho company / Jewell entreprises Inc 168cla; Courtesy Everett Collection Inc 136bl, 137br, 139bl, / Ron Harvey 111crb, / Sony Pictures Television 106tr; Maurice Crooks 109bc; Danita Delimont / Rob Tilley 77tc; Rajiv Dasan 46bl; Joshua Davenport 188-9t; dpa picture alliance archive / Joerg Carstensen 156tl; Samuel Drayton 109ca; Entertainment Pictures 109crb; Malcolm Fairman 69cl, 71bc; Florilegius 85cla; Ilya Genkin 46cr; Robert Gilhooly 155t, 192tc; hemis.fr / FRUMM John 210tl; Heritage Image Partnership Ltd / Fine Art Images 84b; Thomas Kyhn Rovsing Hjørnet 125tc; Geoff A Howard 66tl; Alex Hunter 103tr; INTERFOTO 151cr; Rich Iwasaki 46tr; Japan Stock Photography 47tl; Gina Kelly 75tl; Hideo Kurihara 97c; Lebrecht Music & Arts 133tl; Andrew Lloyd 51tr; Iain Masterton 104tl; mauritius images GmbH / Jose Fuste Raga 99cra, / Jutta Ulmer 37bl, / pepperprint 24bc; Tony Mcnicol 202clb; Mint Images Limited 89br; Trevor Mogg 85cr; Gianni Muratore 108bl; Newscom 153cr, / BJ Warnick 97ca, 97cra, 135bc, 138c, 213cr; Oleksiy Maksymenko Photography 67br; christian ouellet 175br; Pacific Press Service / Ben Simmons 213br; PAINTING 85ca; Sean Pavone 148tr; PersimmonPictures.com 210bl; Photo 12 134tr; Photo 12 / 4 Kids Entertainment 137tl; Photo 12 / Itami Productions 171cla; Photo Japan 105tr; Janusz Pieńkowski 133tr; Prisma by Dukas Presseagentur GmbH / TPX 96bc; Feije Riemersma 130tr; RosalreneBetancourt 6 192tl; S. Parente - Best of Travel - RM 8-9; galit seligmann 114br; Image Source 96cra; John Steele 206tr; StockShot / Tony Harrington 41cla; Sunshine Pics 183t; jeremy sutton-hibbert 101cb, 131tl; 143tc, 200tr; Arakawa and Madeline Gins *Reversible Destiny Lofts Mitaka – In Memory of Helen Keller* © 2005 *Estate of Madeline Gins*. Reproduced with permission of the Estate of Madeline Gins. Nine Residential Apartments (two unit types), with a total floor area of 8,196 sq ft / 761.46 m², Mitaka, Tokyo, Japan 101bl; The Picture Art Collection 85fcra; Tribaleye Images / World Illustrated / J Marshall 210cr; Uber Bilder 28cc; V&A Images 85tr; Steve Vidler 193tr; VOISIN / PHANIE 124-5t; WaterFrame_tro 55cr; Richard Watkins 193br; WENN Rights Ltd 107bl; Wietse Michiels Food Stock 192-3t; Chris Willson 103cb; Wire.Dog 138cla.

AWL Images: Jan Christopher Becke 218bl.

Benesse House: Naoharu Obayashi / Yayoi Kusama *Pumpkin* 122-3.

Bridgeman Images: De Agostini Picture Library / A. Dagli Orti 86cla; Freer Gallery of Art and Arthur M. Sackler Gallery, USA / Gift of Charles Lang Freer 86cra; Pictures from History 28cla, 132bl, 176tl; Private Collection / Christie's Images / Takashi Murakami *Multicolour Flowers, 2012* (acrylic & platinum leaf on canvas) © 2012 Takashi Murakami/Kaikai Kiki Co., Ltd. All rights reserved 121tl; Private Collection / Peter Newark Pictures 146bl; Universal History Archive / UIG 176cr.

Dorling Kindersley: Quentin Bacon / Masaharu Morimoto 203cra.

Dreamstime.com: Baoyan 10cla; Phurinee Chinakathum 46cla; Cowardlion 61, 63bl, 214bl; Kobby Dagan 149cl; Eagleflying 176br; F11photo 26ca; Foodio 212bl; Kain Glover 212t; Katinka2014 214tl; Phillip Maguire 64-5cb; Naruto4836 131cla; Niradj 100-1t; Sean Pavone 45tr, 60cl, 63tr, 98-9, 117tl, 211tl; Rolf52 78br; Sonyakamoz 197tr; Hiroshi Tanaka 190bc; Jens Tobiska 116tr; Zts 102bc.

Getty Images: AFP / Bertrand Guay 128bl, / Jiji Press 31cr, 157bl, / Mandy Cheng 154br, / Stephane De Sakutin 149bl, / Tiziana Fabi 133cra, / Toru Yamanaka 115cb, / Toshifumi Kitamura 147tr, 162-3t, / Yoshikazu Tsuno 161t, 161br; Apic / RETIRED 152t; Art Media / Print Collector 148c; B.S.P.I. 62tl, 79bl; Krzysztof Baranowski 158cl; Bettmann 30cr; Bloomberg / Yuriko Nakao 138cra; BLOOMimage 74bl; Burstein Collection 134tl; Buyenlarge 59br; Joey Celis 194br; Yiming Chen 191tc; Mongkol Chuewong 44bl; David Clapp 135tl; Chris Cole 174bl; Matteo Colombo 4-5; COOLMEDIA / Peter Sabok / NurPhoto 149tl; Corbis / VCG Wilson / Fine Art 29br; cyoi 194tl; DAJ 14-5, 89tr; DE AGOSTINI PICTURE LIBRARY 87crb; DEA / A. DAGLI ORTI 29cr, 93cr, / DE AGOSTINI 177cl, / BIBLIOTECA AMBROSIANA 30cb, 174tr, / DEA PICTURE LIBRARY 86fcla; Eiichi Onodera / Emi Kimata 184bl; Greg Elms 159tl; EyeEm / Hara Taketo 207cr, / Lay Koon Lim 210cl, / Sren Pedersen 80-1, / Supalerk Laipawat 20-1t; GYRO PHOTOGRAPHY / amanaimagesRF 41cra;

Ernst Haas 150cr; Taylor Hill 128-9b; Hulton Archive 30br, 107tr, 148tl, / Keystone 153tl; I.Hirama 90bl, 207bc; imagenavi 88cla, 90tl, 194cr, 194bl, 195bl; Ken Ishii 156tr; Robbie Jack 147tl; Wolfgang Kaehler 88tr; Taro Karibe 214tr; Brian Kennedy 26cla; Keystone-France / Gamma-Keystone 31bc; Onnie A Koski 26cra, 130cra; Nobutoshi Kurisu 219cr; Yuga Kurita 49bl; Kyodo News 200bl; John S Lander 58clb, 100tc, 145br; Sean Marc Lee 27ca; David Lefranc 160bl; Puripat Lertpunyaroj 114cra; LightRocket / Leisa Tyler 181bl; MamiGibbs 90tr; MediaNews Group / Orange County Register via Getty Images 191cl; Michael H 72bl, 74tl; Mint Images 66-7t, 142tr; Mitsushi Okada / orion 50b; MIXA 195cl, 210tr; Moviepix / Movie Poster Image Art 168tr; Ippei Naoi 197tl; Paolo Negri 54bl; NurPhoto 64-5ca, / Cris Faga 32-3, / Richard Atrero de Guzman 148br; Tomohiro Ohsumi 106bl, 162bl; Kiyoshi Ota 173tl; Yanis Ourabah 45cr; Peter Fehrentz / Picture Press 73tl; Photo Atelier Ryunoshin 90cr; photography by Izumi05 194tr; Print Collector 28br; PYMCA 131crb; Nils Reucker 93tc; robertharding / Michael Runkel 40tr; Matt Roberts 172tr; Ryouchin 27tr, 74br; Yuji Sakai 144; Sankei Archive 166tr; Max shen 88tl; simonlong 143crb; Morten Falch Sortland 104bc; South China Morning Post / K. Y. Cheng 190tr, 190cla; South China Morning Post / Warton Li 191tr; Alexander Spatari 196bl; Matthew Sperzel 124tc, 126tl, 129tr; TASS / Valery Sharifulin 148bl, / Yuri Smityuk 58tr; The Asahi Shimbun 31crb, 71cr, 97bc, 125tr, 146br, 156b, 168tl, 174-5b, 180tr, 181cra, 186t, 201bc; Time Life Pictures / Department Of Defense (DOD) / The LIFE Picture Collection 31clb; totororo 73br; Universal History Archive / UIG 30clb; Glenn Waters 177bl; Yagi Studio 118tr; Chip Yates 126bl.

iStockphoto.com: 9Air 69tl; alphabetMN 1, 2-3; aluxum 130tl, 160br; ansonmiao 197cb; ArtSklad 140crb; azuki25 111t, 214-5t; BernardAllum 91cl; bhofack2 201tl; bonchan 195tl, 197br; supawat bursuk 102cl; Jui-Chi Chan 76-7t; Bobby Coutu 27cra, 92-3t; Jonathan Austin Daniels 110bl; DaphneOliveros 25tr; DavorLovincic 86fcra; Dinkoobraz 56cl, 204cb; DronG 184cl; duncan1890 10bl; Elinalee 56cr; enviromantic 90br; filo 56bc; FotoGraphik 25tl; fotoVoyager 24bl; georgeclerk 62-3t; Goddard_Photography 157tl; Graphyrider 52-3; gyro 196br; Hakase_ 186bl; Helen_ Field 38cl, 38bl, 94crb, 94bl, 112crb, 140fcrb, 178crb, 204bc; ilbusca 94cb, 178bl; ume illus 77bc; isaxar 140clb; Joy10000Lightpower 92cr; karimitsu 206cb; katyau 140cr; kazoka30 187cr; KerinGordon 68tr; kicia_papuga 91tl; kitzcorner 183crb; kokkai 133ca; kokouu 16-7t; kumikomini 185bc; LauriPatterson 184clb; lisegagne 150cl; Lisovskaya 185t; luza studios 109cb; Manmarumaki 68tl; martinhosmart 180crb; master2 45tl; Materio 196cb; MediaProduction 176bl; merc67 203bl; Tom Merton 91bl; MrNovel 46tl, 47cl; Nachosuch 64cl; Natle 178bc; Nikada 22-3t, 41bl; ntrirata 207cra; Ola_Tarakanova 112bc,

140c; oluolu3 198-9; Joaquin Ossorio-Castillo 24-5b; PamelaJoeMcFarlane 27tc; David Aparicio Pasamontes 164-5; paulrommer 38-9cb; petesphotography 54-5t; PhotomanRichard 74tr; Phurinee 68b; piyato 194cl; platongkoh 48t; powerofforever 59cla; Rawpixel 28tr; RichLegg 26tr; ririe777 10-1, 12-3, 38-9, 40-1, 56-7, 58-9, 94-5, 96-7, 112-3, 114-5, 140-1, 142-3, 178-9, 180-1, 204-5, 206-7; riya-takahashi 72cr; rockptarmigan 51tl; Satoshi-K 218-9t; SeanPavonePhoto 18-9t, 42-3b, 163tr; Shoko Shimabukuro 126-7; SireAnko 112bl; tabuday 38cla, 112cla; TatayaKudo 188bl; the.epic. man 26tc; Thoth_Adan 56fcr; undercrimson 208bl; Val_Iva 204crb; vanbeets 69bl; VanessaVolk 190crb; VII-photo 178cl; JianGang Wang 42-3t; winhorse 27cla; xavierarnau 42tl; yajimannbo 187tl; Yuji_ Karaki 27tl; z10e 182-3t; Shi Zheng 197c; zzorik 178cb.

Japan House: Lee Mawdsley 36-7t.

Koji Fujii/Nacasa and Partners Inc.: 117br.

Kusatsu Onsen Tourism Association: 46br.

Nendo: Akihiro Yoshida 118bl.

Rex by Shutterstock: 20th Century Fox / Kobal 170bl; AP / Jim Cooper 167crb; Daiei / Kobal 170cla; Dentsu / Ntv / Studio Ghibli / Kobal 171tr; EPA / Everett Kennedy Brown 103br, / Franck Robichon 106cb; EPA-EFE / Ayano Sato 131bc; Madhouse / Sony / Kobal 170cb; Moviestore 138bl, 170tr, 171bl; Sedic / Rpc / Dentsu / Kobal 167tl; Ray Tang 139t.

Science Photo Library: Peter Menzel 107cla.

Shutterstock: amnat11 215br; Andreas H 78-9t; Ece Chianucci 34-5t; AKKHARAT JARUSILAWONG 106cla; Nackoper 216-7; Carolyne Parent 181cb; simpletun 210br; tasch 115cr.

SuperStock: age fotostock / Lucas Vallecillos 26tl, 208-9t; Mint Images 75cl, 75bl; Desiree Ultican 74cr.

The Hakone Open-Air Museum: 120b.

Endpapers:
Front and Back: iStockphoto.com: ririe777.

Cover images:
Front, Back and Spine: iStockphoto.com: alphabetMN.

For further information see: www.dkimages.com.

Penguin Random House

Contributors Brian Ashcraft, Rob Goss, Rebecca Hallett, Tim Hornyak, Carol King, Michelle Mackintosh, Andrew Osmond, Beth Reiber, Simon Richmond, Gianni Simone, Steve Wide, Matthew Wilcox, Dr. Jessie Voigts
Consultant Noe Kosuma
Proofreader Stephanie Smith
Indexer Hilary Bird
Project Editors Elspeth Beidas, Robin Moul
Project Art Editors Bess Daly, Tania Gomes
US Executive Editor Lori Hand
Picture Researcher Harriet Whitaker
Cartographic Editor Casper Morris
Jacket Designer Tania Gomes
Senior DTP Designer Jason Little
DTP Designer George Nimmo
Senior Producer Stephanie McConnell
Managing Editor Rachel Fox
Art Director Maxine Pedliham
Publishing Director Georgina Dee

First American Edition, 2019
Published in the United States by DK Publishing
1450 Broadway, Suite 801, New York, NY 10018

Copyright © 2019 Dorling Kindersley Limited
DK, a Division of Penguin Random House LLC
19 20 21 22 10 9 8 7 6 5 4 3 2 1
001–294544–Jul/2019

All rights reserved.
Without limiting the rights under the copyright reserved above, no part of this publication may be reproduced, stored in or introduced into a retrieval system, or transmitted, in any form, or by any means (electronic, mechanical, photocopying, recording, or otherwise), without the prior written permission of the copyright owner.
Published in Great Britain by Dorling Kindersley Limited

A catalog record for this book
is available from the Library of Congress.
ISBN 978-1-4654-9206-7

Printed and bound in Malaysia.

A WORLD OF IDEAS:
SEE ALL THERE IS TO KNOW

www.dk.com

MIX
Paper from responsible sources
FSC™ C018179

Every effort has been made to ensure that this book is as up-to-date as possible at the time of going to press. Some details, however, such as telephone numbers, opening hours, prices, gallery hanging arrangements and travel information, are liable to change. The publishers cannot accept responsibility for any consequences arising from the use of this book, nor for any material on third party websites, and cannot guarantee that any website address in this book will be a suitable source of travel information. We value the views and suggestions of our readers very highly. Please write to: Publisher, DK Eyewitness Travel Guides, Dorling Kindersley, 80 Strand, London, WC2R 0RL, UK, or email: travelguides@dk.com